Angelheaded Hipster

now it's jazz, the place is roaring,
all beautiful girls in there, one mad
brunette at the bar drunk with her
boys - one strange chick I remember
from somewhere, wearing a simple skirt
with pockets, her hands in there
short haircut, slouched , talking
to everybody - Up and down the stairs
they come -- The bartenders are the
regular band of Jack, and the heavenly
drummer who looks up in the sky with
blue eyes, with a beard, is wailing
beer-caps of bottles and jamming on the
cash register and everything is going
to the beat -- It's the beat generation,
it's be'at, It's the beat to keep, it's
the beat of the heart, it's being beat and
and down in the world and like oldtime
lowdown and like in ancient civilisations
the slave boatmen rowing galleys to a
beat and servants spinning pottery to
a beat.

Angelheaded Hipster

A Life of Jack Kerouac

Steve Turner

VIKING

Viking

Published by the Penguin Group
Penguin Books USA Inc.,
375 Hudson Street, New York,
New York 10014, U.S.A.
Penguin Books Ltd,
27 Wrights Lane, London W8 5TZ, England
Penguin Books Australia Ltd,
Ringwood, Victoria, Australia
Penguin Books Canada Ltd,
10 Alcorn Avenue, Toronto, Ontario,
Canada M4V 3B2
Penguin Books (N.Z.) Ltd,
182-190 Wairau Road, Auckland 10, New Zealand

Penguin Books Ltd,
Registered Offices:
Harmondsworth, Middlesex, England

First published in 1996 by
Viking Penguin,
a division of Penguin Books USA Inc.

10-9-8-7-6-5-4-3-2-1

Copyright © Steve Turner, 1996
All rights reserved
(for individual picture copyright © holders,
see appendices page 218)

Picture research by Steve Turner
Simulated Kerouac manuscript pages created
by Simon Jennings

CIP data available
ISBN 0-670-87038-2

Printed in Italy by Artegrafica SPA, Verona
Set in Trixie-Text and Courier
Designed by Simon Jennings

Page (ii),
photograph of Dexter Gordon
by Herman Leonard.
The Royal Roost, New York City 1948.
Tenor saxophonist Dexter Gordon epitomized
the bebop style of the mid-to-late-1940s
which inspired Jack's fluid improvisatory
style of prose. Text overprint from
Desolation Angels written between
1956 and 1961, and published in 1965.

Page (iii),
photograph by Carolyn Cassady.
San Francisco 1951.

Pages (v) and (vi),
photographs by Jerome Yulsman.
Greenwich Village, New York City 1957.

Page (viii),
photograph by Ken Regan/Camera 5
Lowell, Massachusetts, October 1975.
During the Rolling Thunder Tour of 1975, Bob
Dylan came to Jack's grave to pay homage.

End papers
by Simon Jennings.
Palimpsest(detail), 1991,
Acrylic on board, 55x40 cms.
Painting inspired by *The Scripture of the
Golden Eternity*, Jack Kerouac 1960.

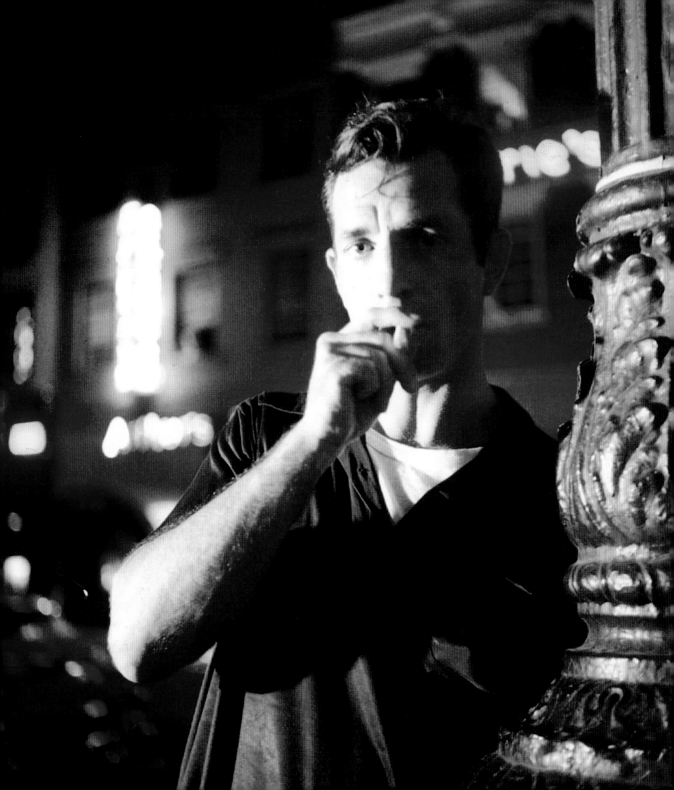

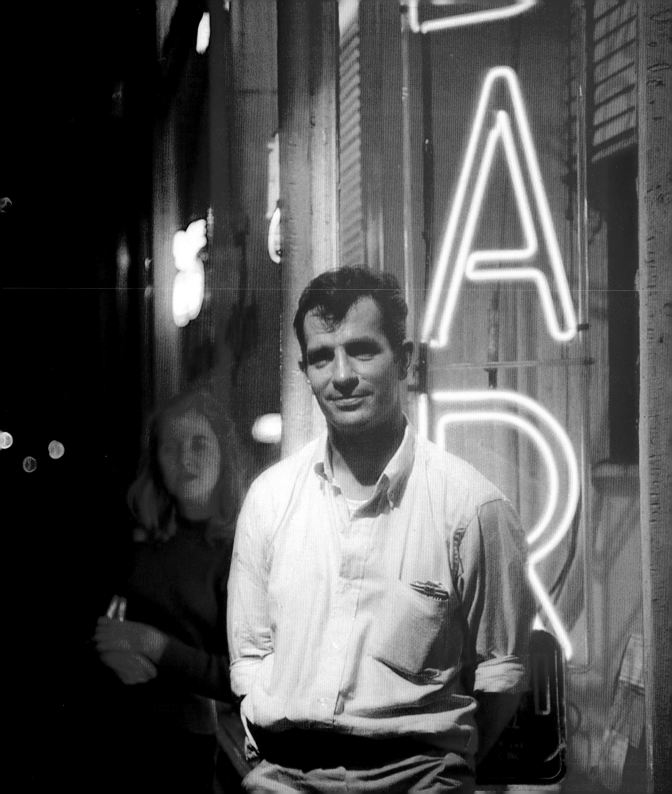

Contents

'I read *On the Road* in maybe 1959.
It changed my life like it changed
everyone else's.'
Bob Dylan.

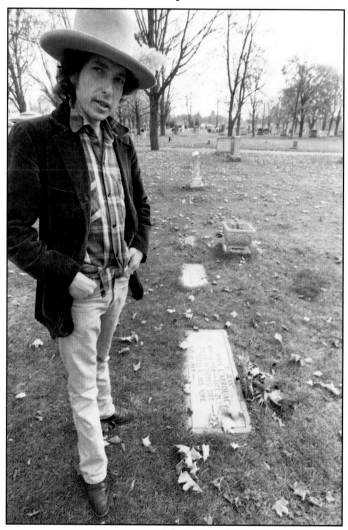

To Bob Dylan,
who put the beat behind the Beat

Acknowledgements One of the great pleasures of working on this book has been to find myself thrown together with other Beat lovers. Simon Jennings, himself a veteran hitchhiker of the 1960s, got into the mood to design the book by listening to tapes of Kerouac reading, and even resurrected his 1960s' manual typewriter for the project. David Stanford, who handled the project for Viking in New York, has worked on several Beat-related projects. Ruth Logan, who handled the rights for Bloomsbury in London, was able to bring a special enthusiasm to the project because of her own passion for Kerouac's writing.

Bloomsbury Publishing made it possible for me to travel to America, where I visited many of the places mentioned in Kerouac's books, interviewed those who had known him, and looked through the letters and notebooks held by Columbia University's Butler Library and the New York Public Library's Berg Collection.

In Lowell, I had two great hosts; Roger Brunelle, who took me to all the Kerouac sites, and John Sampas, who supplied me with useful contacts and drove me around. Jim Sampas and his mother, Betty, also showed me hospitality for which I was very grateful.

In New York, Althea Crawford opened up Allen Ginsberg's photographic archive for me, and Suzanne Hines set up my meeting with Herbert Huncke. In San Francisco, Bob Sharrard of City Lights arranged my interview with Lawrence Ferlinghetti, and Kush of Cloud Street Poetry Archives gave me useful guidance. In Los Angeles, Geoff Gans was helpful with photo research, and Cindy of Rhino Records supplied me with a copy of the excellent 3-CD box-set *The Jack Kerouac Collection*.

I have listed my interviewees separately in the appendices, but there were other people who were helpful in giving me access to written sources of information or in setting up interviews. I would particularly like to thank Kevin Ring, editor of the quarterly magazine *Beat Scene*, who got me started with a list of contacts; Steve Dalachinsky who loaned me rare first editions and tapes of Kerouac talking; Barbara Connolly of the Horace Mann School, who supplied me with photocopies and made me very welcome at the Theresa H. Loeb Library; Charles Shuttleworth who shared with me his unpublished manuscript *Portals of Possibility*; Dan Landrigan of the *Lowell Sun*, who filled me in on the local scene; Martha Mayo of the University of Lowell, who made available materials kept in their Local History Collection; and Dave Moore, Founding Editor of The Kerouac Connection, who shared his encyclopedic knowledge with me and was invaluable in alerting me to the existence of certain photos. Though many people helped me in various ways, almost none of them saw the final text before publication. The ideas and any errors that may exist are strictly my own.

Dave Moore, Carolyn Cassady and Ann Charters each read the manuscript before publication and offered helpful comments. Mick Brown read the sections which deal with Buddhism.

Thanks to my British editor, David Reynolds, for seeing potential in my idea for a Jack Kerouac book and for giving me so much freedom in preparing it.

Introduction

On November 5 1965 I skipped school during the lunch break, met up with my friend Andy, and together we hitchhiked the eighty miles to London. I had told my parents that I would be staying overnight with Andy, but not that we would be in another city and without accommodation. Andy and I went to a reading of work by William Blake and the Buddhist poet Milarepa, neither of whom we had ever heard of. When the reading finished we drifted into Soho where we sat around in coffee bars until dawn.

Had I not read *On the Road* while on holiday in North Wales that summer, this small schoolboy adventure might never have happened. By taking rides in giant trucks; hearing poetry spoken for the first time; wandering though city streets at night; witnessing fist fights; being stopped by the police; and talking to the various beatniks, down-and-outs, failed songwriters and hustlers who congregated beneath Soho's neon, I felt I was grabbing raw chunks of experience in the way that Jack Kerouac had described in his novel.

My story is perhaps typical of the way that a lot of people first encountered Kerouac at that time. Many teenagers around the world felt restricted by family and school, and *On the Road*, tame as it may seem today, suggested to us a world of adult excitement and freedom. Like the novel's narrator, Sal Paradise, I was destined to become a writer, so the interest in Kerouac and other poets and novelists affiliated with the Beat Generation deepened over the years.

When I began writing and performing my own poetry I looked to the Beat Generation poets for inspiration, because they spoke in an accessible language about a world

I recognized. Later, writing about rock music and related subjects, I came to realize Kerouac's importance in shaping the landscape of popular culture.

Angelheaded Hipster was inspired by my curiosity about someone who was not only a literary forefather, but also a significant influence on post-war lifestyles, especially among the young. It is an illustrated biography - the first ever on Kerouac - because as well as being a literary movement, the Beat phenomenon was a revolution in lifestyle that can be traced through its changing images.

Because of this visual dimension, I haven't tried to duplicate what has already been done so well by biographers such as Ann Charters, Tom Clark and Gerald Nicosia. *Angelheaded Hipster* doesn't attempt to be an exhaustive account, and I am aware that I haven't had the space to explore Kerouac's life in minute detail. Also, the careers of other Beat writers such as Allen Ginsberg and William Burroughs are mentioned only inasmuch as they affected the main story of the Beat movement.

My particular interest has been in Kerouac as a writer with spiritual concerns. For years this was virtually ignored, but critics are now recognizing that religion was one of the most powerful forces in his life. This was certainly the way he saw himself, but drugs and rebellion always made a better story for newspapers and magazines.

As students of Beat will already know, the book's title is borrowed from Allen Ginsberg's poem *Howl* (1956), which was dedicated to: 'Jack Kerouac, new Buddha of American prose . . .', though Kerouac had yet to publish *On the Road*. I don't know whether Ginsberg had him in mind when he coined the phrase angelheaded hipster, but it encapsulates perfectly the unique combination of street wisdom and heavenly-mindedness that was Jack Kerouac.

Iwas smelling flow~~rs~~ers in the yard, and
when I stood up I took a deep breath and
the blood all rushed to my ~~head~~ brain an I woke up
dead on my back in the grass. I had ~~apparently~~
apparently fainted or died, for about sixty seconds. My
neighbor saw me but he thought I had just
suddenly thrown myself on the grass to enjoy the
the sun. During that timeless moment of
unconsciousness Isaw the golden eternity. I saw
heaven. In it nothing had ever happened, the
events of a million years ago were just as phantom
and ungraspable as the events of now or of a
million years from now, or the events of the next
ten minutes. It was perfect, the golden solitude,
the golden emptiness, Something-or-Other, something
surely humble. There was a rapturous ring of
~~silen~~ silence abiding perfectly. There was no question
of being alive or not being alive, of likes
and dislikes, of near or far, no question of giving
or gratitude, no question of mercy or judgement,
or of suffering or its opposite or anything.
It was the womb itself, aloness, alaya vijnana
the universal store, the Great Free Treasure, the
Great Victory, infinite completion, the joyful
mysterious essence of Arrangement. It seemed
like one smiling smile,, one adorable adoration,
one gracious and adorable charity, everlasting
safety, refreshing afternoon, roses, infinite
brilliant immaterial golden ash, the Golden Age.
The 'golden' came from the sun in my eyelids
and the 'eternity' from my sudden instant

(12)

1.

The
James Dean
of the
Typewriter

Jack had the looks as well as the attitude of a folk hero: handsome Gallic features, an athlete's body and a uniform of open-necked shirts, Levi jeans and work boots. He had also come up with a phrase to describe the people he identified with and wrote about. They were, he said, members of

'THE BEAT GENERATION'.

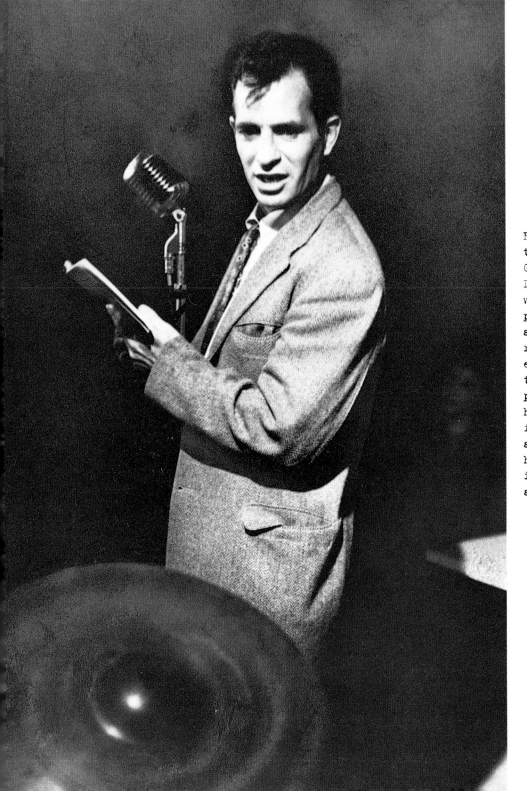

Reading his work at the Village Vanguard, Greenwich Village, December 1957. Jack was a reluctant performer but his appearances and records helped re-establish story-telling and poetry as performing arts. In his writing he aimed for: 'The raciness and freedom and humour of jazz instead of all that analysis.'

The cinema of the 1950s had James Dean and Marlon Brando.
Popular music had Elvis Presley. The American novel had Jack Kerouac. He wasn't the most influential author of his generation, and he certainly wasn't the most critically revered, but no one else so accurately captured the restless uncertainties of the post-war generation whose struggle to break through the bland modernist conformity of the Eisenhower era sowed the seeds of the social revolution of the 1960s.

In novels like *The Subterraneans*, *Desolation Angels* and *On the Road*, Kerouac portrayed young people who were hungry for experience, not simply in order to satiate themselves, but in the hopes of discovering a new vision. They meditated, smoked dope, listened to jazz, made love, bummed around and generally 'dug' life – hoping to discover for themselves a way of living free from such bourgeois considerations as moderation, respectability, security, and self-control.

Fortunately for the media, Jack had the looks as well as the attitude of a rebel hero: handsome Gallic features, an athlete's body and a uniform of open-necked shirts, Levi jeans and work boots. Well-educated, he spoke in enigmatic sentences and had enjoyed a colourful life of carefree travel during which he'd worked as, among other things: a security guard; a scullion; a gas station attendant; a construction worker; a sailor; a railroad brakeman; a baggage handler; a synopsizer of film scripts; a soda jerk; a short-order cook; a dishwasher and a sports journalist. He had also come up with a phrase to describe the people he identified with and wrote about. They were, he said, members of 'the Beat Generation'.

Later, there were complaints and disputes about the tag – What exactly did it mean? Who qualified as a member? – but it was more of a blessing than a curse. Writers who would have probably remained relatively obscure without a corporate identity suddenly became hot property. Allen Ginsberg, William Burroughs, Gregory Corso and Jack were interviewed and photographed by the likes of *Time*, *Life* and *Mademoiselle*. Jack appeared on television with Steve Allen, and live on stage in Greenwich Village. By the late 1950s Beat was the happening movement, a recognized indicator of artistic change in a culture whose foundations were being vigorously shaken.

James Dean, Elvis Presley and Jack Kerouac never met, but in heeding their instincts, rather than external codes, they were representative of the same wave of youthful dissent which challenged old certainties about race, sex, family, religion, authority and even

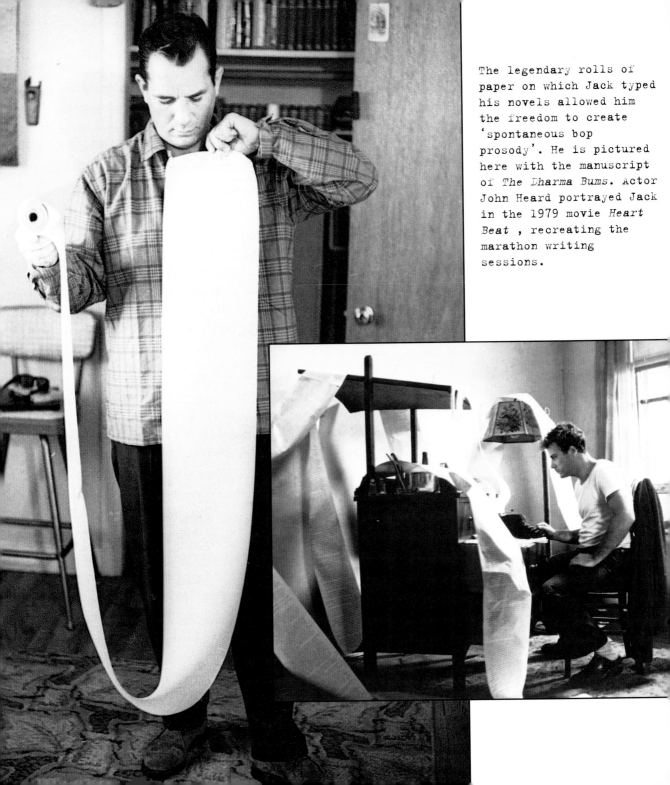

The legendary rolls of paper on which Jack typed his novels allowed him the freedom to create 'spontaneous bop prosody'. He is pictured here with the manuscript of *The Dharma Bums*. Actor John Heard portrayed Jack in the 1979 movie *Heart Beat*, recreating the marathon writing sessions.

the dominance of the rational mind. Each communicated a new sense of abandon and independence which reflected the emerging spirit of their times.

Both Elvis Presley and Jack Kerouac lived long enough to be bemused by the social revolution which they had been credited in part with starting. They thought of themselves as God-fearing, mother-loving Americans, and resented being blamed for everything from juvenile delinquency and campus rebellion to the growth in drug dependency and the breakdown of the family.

Like James Dean and Elvis Presley, Jack Kerouac has remained an icon throughout the latter half of the twentieth century. No other post-war American novelist has stimulated such widespread interest and devotion, although it must be acknowledged that some of the interest is more in his lifestyle than his art. As William Burroughs once cynically observed: 'Kerouac opened a million coffee bars and sold a million Levis.'

It is now possible to subscribe to Jack Kerouac magazines, listen to Jack Kerouac CDs, interact with a Jack Kerouac CD-ROM, wear a Jack Kerouac T-shirt and even enroll in summer courses at the Jack Kerouac School of Disembodied Poetics in Boulder, Colorado. He has been portrayed on film (*Heart Beat*), on stage (*Angels Still Falling* by Richard Deakin), and referred to in songs (*Jack and Neal* by Tom Waits and *Hey Jack Kerouac* by 10,000 Maniacs). The Gap clothing company thought him enough of an icon to feature a 1957 photograph of him in a 1993 advertising campaign for its Khaki line (others in the campaign included Marilyn Monroe and Andy Warhol); and in 1994 Hollywood movie star Johnny Depp paid $10,000 for one of his old raincoats.

On the Road, still the best known and most widely read of Kerouac's novels, is essentially a young person's book, just as *The Wild Ones* and *Rebel Without a Cause* remain young people's films. It appeals to the adolescent desire to cut loose, experience the forbidden and live outside the law, and it was *On the Road* that established Jack as the archetypal Beat – hitching between cities in search of passionate, life-affirming moments.

The hero of the book is Dean Moriarty, car thief, sex addict and would-be intellectual – a character based on Jack's friend Neal Cassady. Jack is Sal Paradise, Dean's faithful sidekick, and the four sections of the book are based on the duo's adventures from December 1946 through to the summer of 1950, travelling back and forth between New York and San

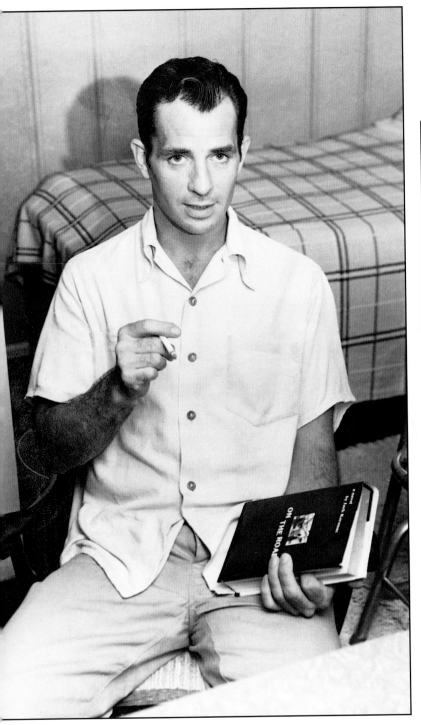

Although he published
sixteen books during his
lifetime, it was *On the
Road* that was to create
Jack's image as a traveller
of the American highways.
The movie *Heart Beat*
(above), based on Carolyn
Cassady's memories of the
same period, featured Nick
Nolte as Neal Cassady and
Sissy Spacek as Carolyn.

Francisco with stops in various locales, including Denver and Mexico City.

Paradise does not view himself as an aimless drifter but as a writer in search of new experiences to enrich his future work. He lives vicariously through the 'live fast, die young' exploits of Moriarty, and the reader is encouraged to do the same. Years after the book was written, when the first Kerouac biographies came out, we learned that this was the way Jack worked: setting himself up in the eye of the storm with a notebook and pen. Neal Cassady was by far his favourite creator of storms.

Jack made writing sound exciting. His wasn't a world of chewed pencils, dusty libraries and literary prizes, but of music, fast cars and the search for meaning. 'I was a young writer and I wanted to take off,' Sal says at the beginning of *On the Road*. 'Somewhere along the line I knew there'd be girls, visions, everything; somewhere along the line the pearl would be handed to me.'

One of the achievements of Jack Kerouac and his Beat contemporaries was in making literature, whether spoken or printed, as 'sexy' as movies, jazz and rock 'n' roll. Along with Dylan Thomas and Kenneth Rexroth, they were largely responsible for a revival of interest in public readings during the 1950s. They helped liberate poetry from the captivity of the page and took it to places more commonly associated with music or art or stand-up comedy – the jazz club, the art gallery and the coffee bar. As Glenn O'Brien recently observed in his essay 'The Beat Goes On': 'The Beats were about the word. Bringing the written word back into live breath and musical time. Poetry was performed, not filed away. Word was stood by.'

Jack always had a strong affinity with musicians. He wrote with an ear for the music of common American speech, and saw himself as the creator of a 'spontaneous bop prose' style which embodied the techniques of riffing and improvisation that were used by jazz musicians such as Charlie 'Bird' Parker and Lester 'Prez' Young. He wanted to 'blow' phrases like Bird blew music, and he felt closer in spirit to black musicians who translated their joys and pains into pure sound than he did to the white writers of the post-war literary establishment, whose work he considered to be full of 'dreary self-imposed cant and bombast'. His interest in be-bop coincided with the poetry and jazz experiments taking place in San Francisco that would later compound Beat's connection with jazz. Jack recorded two albums of poetry and prose with

jazz accompaniment and took part in New York's first poetry and jazz show.

One of the motivators behind the union of poetry and jazz was poet Kenneth Rexroth, who was often dismissive of Jack's work but nevertheless shared his vision of a living literature. 'It's very important to get poetry out of the hands of the professors and out of the hands of the squares,' he once wrote. 'If we can get poetry out into the life of the country it can be creative. Homer, or the guy who recited Beowulf, was [sic] show business. We simply want to make poetry a part of show business.'

Poetry *was* to become a part of show business, but in ways that Jack Kerouac and Kenneth Rexroth could never have anticipated. In the late 1950s, when Jack was sitting next to his radio singing along with Frank Sinatra on the radio, it would have been hard to convince him that the next revolution in popular music would draw its rhythms from Ginsberg's 'negro streets' and a large part of its lyrical inspiration from the poetry and prose of the Beats.

Bob Dylan, the most innovative lyricist of the 1960s, discovered Jack's poetry as a teenager in St Paul, Minneapolis, and later admitted that 'it blew my mind'. Four years later Dylan met Allen Ginsberg, who introduced him to the work of the French symbolist poet Arthur Rimbaud. It is not difficult to detect the influence of Jack's writing in Dylan's work; in style, subject matter and language. You can hear the titles of Jack's books reflected in Dylan's song titles: *Desolation Row* drawing from *Desolation Angels*, *Subterranean Homesick Blues* referring to *The Subterraneans* and *Visions of Johanna* echoing *Visions of Gerard*.

Dylan was the first songwriter to attach the language and interests of the Beats to the power and influence of rock 'n' roll, and by following his example many who loved both Elvis Presley and Jack Kerouac, Little Richard and Allen Ginsberg or Chuck Berry and William Burroughs were able to conceive a reconciliation of their passions. It is well known that Dylan in turn affected the songwriting of John Lennon and Paul McCartney, but Lennon was certainly already aware of the Beat writers from his days at Liverpool Art College. His fellow student Bill Harry specifically remembers Lennon reading *On the Road* and the short story *The Time of the Geek*, which was published in an anthology called *Protest* in 1960. 'He loved the idea of open roads and travelling,' says Harry. 'We were always talking about this Beat Generation thing.' In June 1960 the Beatles had played behind London poet Royston Ellis in a

poetry and music set. Ellis claims that it was at his suggestion that the group, then known as the Beetles, changed the spelling of its name. 'I wanted to bring them to London to play for me on some TV programmes,' says Ellis. 'I asked them how they spelled their name and they said "B E E T L E S". At that time I was known as Britain's Beat poet, and so I said, "Why don't you spell it B E A T L E S?" And so they did!' Thus, in a roundabout way, the greatest rock group of the sixties adapted the name of Beat and took it to the whole world.

Many other innovative rock musicians have paid tribute to Jack's work. Van Morrison mentions *The Dharma Bums* and *On the Road* in his song *Cleaning Windows*; David Bowie credits *On the Road* with showing him as a teenager that 'I didn't have to spend my life in Bromley' (the South London surburb he grew up in); and while writing his classic songs for the Doors Jim Morrison read every Beat volume he could get his hands on. Bruce Springsteen, who shared with Jack a working-class East Coast Catholic upbringing, also shared his love of fast cars and the open American landscape. It is hard to imagine Springsteen existing without Jack. Even his stage clothing of a check shirt and blue jeans – once unthinkable attire for a performer – are straight out of *On the Road*.

Everything that the archetypal rock 'n' roll star of the 1960s and 1970s experienced – marijuana, amphetamines, hallucinogenics, homosexual experimentation, orgies, alcoholism, drug busts, charges of obscenity, meditation, religious engagement – had already been experienced by the Beats during the previous two decades. 'Think what a great world revolution will take place when East meets West finally, and it'll be guys like us that can start the thing,' says Japhy Ryder in *The Dharma Bums*, published in 1958. 'Think of the millions of guys all over the world with rucksacks on their backs tramping around the back country and hitchhiking and bringing the word down to everybody.'

A decade later, when the hitchhikers were flooding into San Francisco and Kathmandu, and the Beatles were spreading the gospel according to Krishna, Jack was an exhausted old man of forty-five who spent most of his time at home drinking beer and watching daytime television. He claimed to see no connection between his writings and the new generation which revered him as a Founding Father. In 1969, the year of his death, he wrote an article for the *Chicago Tribune Magazine* in which he attempted to answer the question, 'What does the author of *On the Road* and *The Subterraneans* think of the hippie, the drop-out, the war protester, the alienated radical?'

By the mid-1960s Jack had become a beer-drinking reactionary. Bob Dylan adapted the Beat style and outlook for the rock 'n' roll generation. This photo by Larry Keenan, showing Dylan flanked by poets Michael McClure and Allen Ginsberg, was taken at Dylan's instigation in December 1965 as a potential album cover for *Blonde on Blonde*.

'I've got to figure out,' he responded, '. . . how I could possibly spawn Jerry Rubin, Mitchell Goodman, Abbie Hoffman, Allen Ginsberg and other warm human beings from the ghettos who say they suffered no less than the Puerto Ricans in their barrios and the blacks in their Big and Little Harlems, and all because I wrote a matter-of-fact account of a true adventure on the road (hardly an agitational propaganda account) featuring an ex-cowhand and an ex-footballer driving across the continent north, northwest, midwest and southland looking for lost fathers, odd jobs, good times, and girls and winding up on the railroad.'

On the Road may not have been agitational propaganda, but its characters showed a refusal that was shared by hippies and radicals to accept uncritically 'traditional' values which put a high premium on career, marriage, status and possessions. Could the middle-aged Jack Kerouac not remember writing (in the character of Sal Paradise) that he felt that 'the best the white world had offered was not enough ecstasy for me, not enough life, joy, kicks, darkness, music, not enough night!' And wasn't this precisely the mood of the counter-cultural revolution? *On the Road* was a search for soul in an America that appeared to be losing its essence to materialism; for Jack Kerouac was essentially a writer with spiritual preoccupations – 'waiting for God to show his face', as he once put it to an interviewer who wanted to know what the Beats were looking for. In his writing is a sense of imminent collapse – both the collapse of Jack Kerouac, who he knows is inevitably moving towards 'disease, decay, sorrow, lamentation, old age, death, decomposition' (*Desolation Angels*), and the collapse of the American Dream.

Almost all of his books burn with the age-old question, 'What must I do to be saved?', and he claimed in his famous *Playboy* article 'The Philosophy of the Beat Generation' that Beatdom evidenced a deep religiosity, 'the desire to be gone, out of this world (which is not our kingdom), high, ecstatic, saved, as if the visions of the cloistral saints of Chartres and Clairvaux were back with us again . . .' It was not without careful thought that he named himself Paradise in *On the Road* – could Sal have been an abbreviation of Salvation?

'I think that (spirituality) was our primary thing,' Allen Ginsberg told me, 'because we all had some kind of visionary experience that pushed us out of the notion of art as just some career or commerce. We suddenly realized that actually art did influence people, that it had

consequences and could clarify consciousness, could bring one to other modes of awareness. Realizing that opened up a whole world of possibility.'

Jack felt that Beat religiosity indicated a spiritual revival in American life, and even saw parallels between what was happening among his contemporaries and the mass conversions happening at the crusades of the then-young evangelist Billy Graham. 'I have never heard more talk about God, the Last Things, the soul, the where-are-we-going, than among the kids of my generation,' he said in 1958. 'And not the intellectual kids alone. All of them.'

But were the Beats a part of the problem or a part of the solution? Did they save us from hypocrisy and craven materialism or did they help undermine the Judaeo-Christian ethic that had helped build the fabric of American culture and replace it with a rationale for self-indulgence and irresponsibility? Jack Kerouac and Allen Ginsberg saw themselves as liberating Americans from soulless uniformity – generating an interest in mysticism, ecology, indigenous cultures, freedom of expression, altered states of consciousness and alternative sexual lifestyles – but critics of the Beat movement regard what they did as the start of the rot which has led ultimately to crack, AIDS, sexual promiscuity, family breakdown, religious cults, rising crime, pornography and disrespect for authority.

Though there is still debate over the ultimate significance of the writings of some Beat authors, academic evaluation and endorsement of the Beats is now underway, and the recent 'Beat revival' confirms the ongoing appeal of the work itself. Even one critical of Beat writing would have to concede that their work and the media reportage of their lifestyles was pivotal in the development of post-war popular culture. There is now more discussion of Jack Kerouac and his work than ever before, particularly with the recent release of material that had been hidden in his archives for years.

Many of Jack's original diaries and notebooks are now on deposit in the New York Public Library's Berg Collection. Here, among the hastily scribbled addresses, expense accounts, reminders and ideas for future works, it is possible to perceive the man behind the icon. For example, you can read his notes (from 1953) as he played with titles for the book which wouldn't come out for another four years but which would make his name: *The Mystery of the Open Road*, *The Road Opens*, *The Angel of the Road*.

In one notebook he copied out a sizeable quote from D. H. Lawrence's essay on Whitman, 'Studies in Classic American Literature' (1923), which could have come straight from his own pen: 'The great home of the Soul is the open road,' Lawrence had written. 'Not heaven, not paradise. Not "above". Not "within". The soul is neither "above" nor "within". It is a wayfarer down the open road.

'Not by meditating. Not by fasting. Not by exploring heaven after heaven, inwardly, in the manner of the great mystics. Not by exaltation. Not by ecstasy. Not by any of these ways does the soul come into her own. Only by taking the open road.

'Not through charity. Not through sacrifice. Not even through love. Not through good works. Not through these does the soul accomplish herself. Only through the journey down the open road.

'The journey itself, down the open road. Exposed to full contact. On two slow feet. Meeting whatever comes down the open road. In company with those that drift in the same measure along the same way. Towards no goal. Always the open road.'

Jack didn't spend all his life in transit, and he treasured his moments of ecstacy and meditation. But his travels 'on the open road', which began in the 1940s, were an essential part of his life and work, and inspired many to set out on journeys of their own.

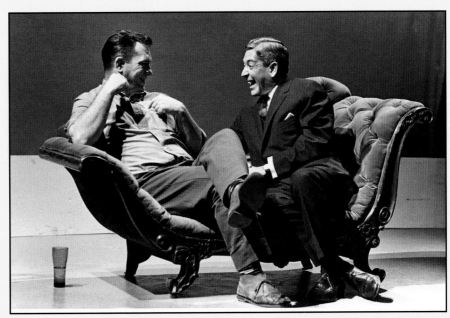

Jack rarely appeared on television. On March 7 1967 he was interviewed in French by Fernand Séguin in CBC's Montreal studio. English subtitles were provided.

(26)

2

Ghosts of the Pawtucketville Night

He came to believe that the only perfection humans ever experience is before birth, and/ that we spend our lives hankering after that bliss. Unable to return to the womb, the closest we can come to it is in the warm memories of childhood.

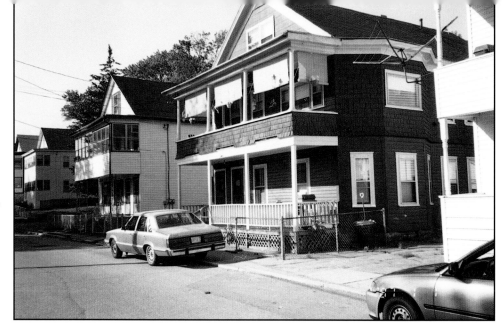

Jack's birthplace and the Pawtucket Falls in Lowell. 'I was born ... on Lupine Road, March 1922, at five o'clock in the afternoon ... as the river rushed with her cargoes of ice over reddened slick rocks.'

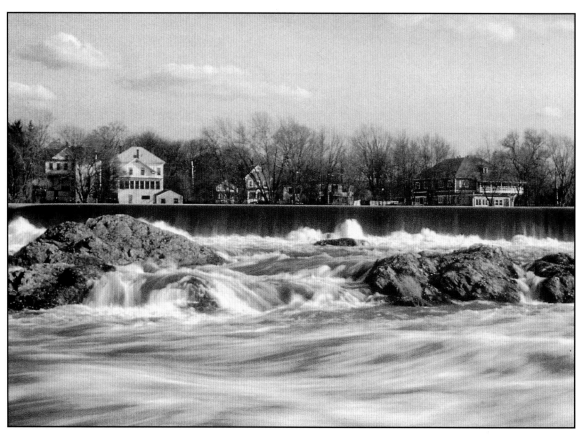

Lowell, Massachusetts is an early nineteenth-century
textile town built on the banks of the Merrimack River, thirty miles
north of Boston. Settled largely by Polish, Irish, Portuguese, Greek and
French immigrants, it was a resolutely working-class town, where the men
worked five-and-a-half days a week and walked home for lunch, while the
women cleaned, cooked and reared the children in Greek Orthodoxy or
Roman Catholicism.

Each ethnic group formed a close-knit community. There were five
French parishes alone in Lowell, a French language newspaper and schools
where all the lessons were in French. 'Everybody lead a very happy life
in those days,' remembers Reginald Ouellette, a neighbour of the
Kerouacs in the 1920s. 'There would be parties every Saturday night, and
after church on Sundays there would be family gatherings where everyone
dressed in their best clothes. The families had come to Lowell to better
themselves and they worked hard.'

Jack was born here at 9 Lupine Road on March 12 1922, the third
child of Leo and Gabrielle Kerouac, brother to Gerard and Caroline. He
was baptized at St Louis de France Church on March 19 as Jean Louis, and
became known as Ti Jean (little Jack).

The First World War was fresh in the memory of most, and the modern
age which was to shape Jack's art was almost as young as he was. This
was the year that saw the publication of T.S. Eliot's seminal poem *The
Waste Land*, James Joyce's ambitiously detailed *Ulysses* and F. Scott
Fitzgerald's *Tales of the Jazz Age*. Franz Kafka was in Prague writing
The Castle and, in Germany, Herman Hesse had published *Siddhartha*, his
novel based on the life of the Buddha. There was a new pope in Rome,
Pope Pius XI, and in Washington President Harding established the
Federal Narcotics Control Board. The population of America stood at 104
million.

Of these innovations, only the creation of a new Pope would have
caused much of a ripple in Lowell, where hard work and religious
observance were valued far more than art and literature. The only famous
artist the town had produced was the painter James McNeill Whistler, and
he had left with his parents when he was nine to live in Russia. One of
the characters in Jack's first novel dismisses it as a place with ugly
grey houses where no one is interested in truth and beauty. 'It was a
depressed industrial town,' admits George Constantinides, an old Lowell
friend of Jack's. 'If you wanted to become an artist or a writer the
only way to go was out.'

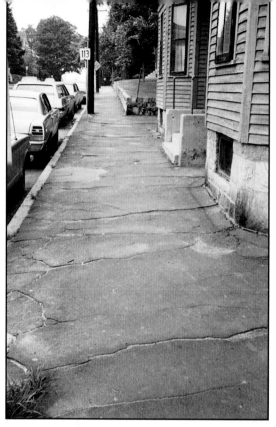

Scenes from Jack's Lowell childhood. The 'wrinkly tar sidewalk' (left) is mentioned in *Doctor Sax*, as is the Catholic grotto on Pawtucket Street (right). A top-floor apartment above the Textile Lunch on Moody Street (below) became home to the Kerouac family in 1936.

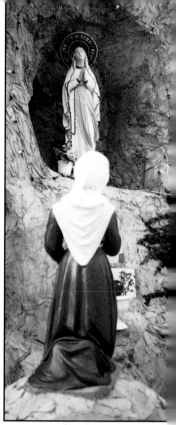

Drab, small-minded, Philistine, ethnically segregated and intensely religious, it was the ideal town to reject, and yet Jack never cut his emotional ties with Lowell. In his later years on the road his mind would constantly return to the streets of his childhood. Almost half the novels published during his lifetime used Lowell as a setting. 'I have a recurring dream,' he said in 1963, 'of simply walking around the deserted twilight streets of Lowell, in the mist, eager to turn every known and fabled corner. A very eerie, recurrent dream, but it always makes me happy when I wake up.' As he grew older he kept coming back, hanging around his old haunts as though nothing had changed. His third marriage was to Stella Sampas, a local girl he'd known as a teenager and corresponded with for years.

He came to believe that the only perfection humans ever experience is before birth, and that we spend our lives hankering after that bliss. Unable to return to the womb, the closest we can come to it is in the warm memories of childhood. 'Isn't it true that you start your life a sweet child believing in everything under your father's roof?' he says in *On the Road*, consciously depicting home as the paradise he was forced to leave.

'He felt safe, warm and comfortable here,' says Kerouac scholar Roger Brunelle, who grew up in Lowell a generation later. 'He came from a little French neighbourhood where we were able to lead our own lives, speak our own language and have our own culture. I think that when he went out on the road he was really rather afraid of a lot of what he saw because he was rather provincial. He could be all over the place but his heart would be tugged back here to Lowell.'

Leo and Gabrielle Kerouac were French Canadians who had emigrated to America as children – their forebearers having come to Québec from Brittany. Leo was a printer and Gabrielle had worked as a sales assistant in a shoe store. Up until the age of five Jack spoke nothing but French, and even during his teenage years he had trouble understanding English if it was spoken too fast. He was aware at an early age of being a foreigner in his own country, and the theme of alienation, of searching for his true home, would pervade his writing.

As he grew older he became obsessed with his origins, developing fanciful theories that his family were Irish Celts who'd moved from Ireland to Cornwall before settling in Brittany, and even that he had Iroquois blood from his mother's side of the family. In London during the 1950s and Paris during the 1960s, he spent time in the national

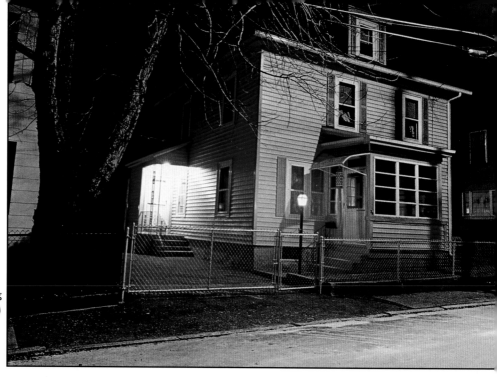

The death of his young brother Gerard (below) while the family were living at 34 Beaulieu Street (above right) affected Jack deeply. It was Gerard who had first walked Jack past the Stations of the Cross (right) and awakened his sense of the spiritual. Years later, Jack discovered that his family motto (above) was: 'To love, work and suffer.'

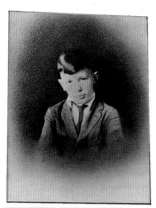

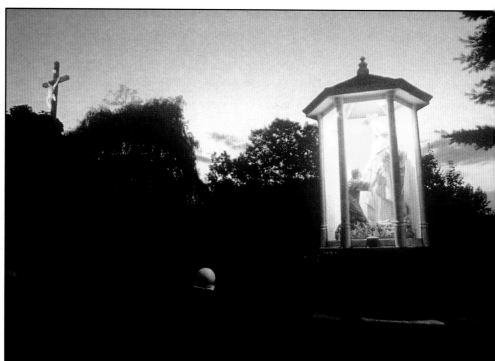

libraries researching the Kerouac genealogy. He was always bothered by the question of who he was and where he belonged.

Death, another major concern in his work, first touched his life in 1926, when his brother Gerard died of rheumatic fever. It is now impossible to determine the truth about Gerard's short life, because few of his contemporaries are alive, but in Jack's mind he was an almost saintly child who communicated with animals and could see angels. This is the version of Gerard's life that Jack later recorded in *Visions of Gerard*, where he portrayed nuns surrounding the sick boy's bed taking notes of his words as he passed away, so impressed were they at his godliness and quiet confidence. As Jack was only four years old at the time, these were clearly not solely his own memories – although he may well have remembered being taken to the Pawtucket Street grotto and passing slowly by the line of twelve glass kiosks containing sculptures of the stations of the cross while Gerard explained the crucifixion story. The stories of Gerard's piety – his love of prayer, his tears over the suffering Christ – must have been told him by Gabrielle, who was herself a particularly devout Roman Catholic. Jack's father, best known for arguing with priests or trying to get them drunk, is unlikely to have encouraged the myth.

Reginald Ouellette's brother Roger was a playmate of Gerard's when the family lived at 34 Beaulieu Street, and feels that Jack embellished the story of his brother's life. 'To me, Gerard was just a normal kid,' he remembers. 'The only difference was that he was very sickly, which meant that he had to stay at home a lot. Because he was at home, Jack grew very close to him. Mrs Kerouac would often ask me in to play with Gerard, but Jack never liked the idea of anyone else playing with his brother. He used to throw tantrums.'

Whatever the truth, the impression of Gerard as a saintly child stayed with Jack throughout his life, and he would later credit him with awakening his interest in spirituality. Possibly because his mother eulogized him so much, Gerard became an ideal against which Jack measured his own life as well as a lost brother for whom he would search in all his adult relationships with men. 'I have followed him ever since,' he once confessed, 'because I know he's up there guiding my every step.'

The experience of Gerard's death merged with the pictures of death Jack saw all around him in the Catholic church. The image of the bleeding, life-size Christ that hung on a wooden cross at the grotto

Jack's education began at St Louis de France School (right) and continued at St Joseph's Parochial School, where he was pictured (below, second from left) in a play where the children had to dress as they imagined themselves in the future. While attending Lowell High School (top left) Jack's closest friends were G. J. Apostolos (second left), Sebastian 'Sammy' Sampas (third left) and Joseph Henry 'Scotty' Beaulieu.

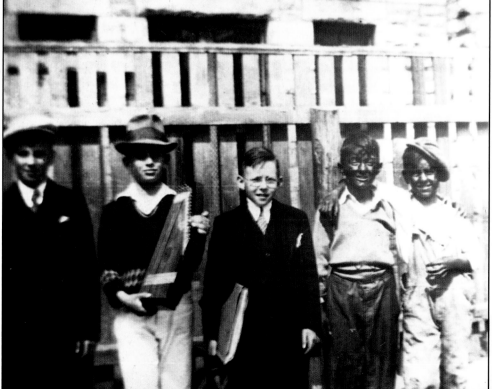

joined with that of the suffering boy whose white casket lay in the front room of his home before his funeral. Jack became frightened of darkness and shadows and wanted to know how he could get to heaven and be reunited with his brother. For a short time after his brother's death, Jack wondered whether Gerard, like Christ, would return in some resurrected form, 'huge and all-powerful and renewed'.

He was crossing the Merrimack River with his mother some years later, over the Moody Street Bridge, when a man walking just ahead of them suddenly dropped dead of a heart attack. The image of the fallen man, his urine-soaked trousers and the dark rushing waters below confirmed Jack's fear of sudden destruction, and would haunt him for ever.

Jack was first taught by nuns at St Louis de France School, and then by Jesuits at St Joseph's. He was sensitive and introspective as a child, and was easily overlooked because of his extreme shyness. 'I don't think anyone knew Jack well in those days,' says Roger Ouellette. 'He lived in his own world. In school everyone would talk to their neighbours between classes but Jack would never join in.'

The first obvious stirrings of his imagination came when the Kerouac family moved in 1932 to 16 Phoebe Avenue in the town's Pawtucketville district. His father had developed health problems, due in part to his heavy drinking, and there was friction in the home because of his loose grip on money. Reginald Ouellette remembers: 'Mr Kerouac was big on cards, big on horses and big on boozing. I think Jack's mother paid dearly for her husband's sins, because she never had any money and that's the reason that they lived quite meagerly.'

Jack coped with the heated atmosphere at home by developing an interior world over which he had supreme control. He spent endless hours in his bedroom racing his toys, writing up mock-newspaper reports on the races, composing stories and drawing cartoons. 'At the age of eleven, I wrote whole little novels in nickel notebooks,' he once said. '(I also wrote) magazines, in imitation of *Liberty Magazine*, and kept extensive horse racing newspapers going.'

Because of the move to Pawtucketville, Jack transferred from St Joseph's School to Bartlett Junior High School where, for the first time, all his lessons were in English. It was here that he entered the childhood period which he would most often revisit in his dreams, and met the boys who, under other names, would populate his Lowell fiction – Scotty Beaulieu, Freddy Bertrand, Roland Salvas, George J. Apostolos, Sebastian Sampas, Mike Houde and Pete Houde.

The Shadow

A Street & Smith Publication Twice a Month

10¢

APR. 15, 1940

THE PRINCE OF EVIL

complete novel and other features

The Phantom Detective

10¢

JULY

A FULL-LENGTH NOVEL FEATURING THE WORLD'S GREATEST SLEUTH

A THRILLING PUBLICATION

ROBERT WALLACE
EDMOND HAMILTON
J. LUKE BROWN

DEALERS IN DEATH

DECEMBER #5

OPERATOR 5

10¢ **AMERICA'S SECRET SERVICE ACE**

LEGIONS OF STARVATION
FULL-LENGTH OPERATOR 5 NOVEL

(36)

The Houde brothers introduced Jack to the first English language writing to inspire him, in comic books such as *The Green Hornet, Operator 5, Phantom Detective* and *The Shadow*. He particularly identified with the mysterious character of The Shadow, 'the shrouded, unseen observer, black-cloaked and black-hatted,' who cleaned the city of crime and whose only calling-card was a hysterical cackle. 'The Shadow's aim was certain,' ran a typical story introduction of the period. 'The attacking gunmen were clear targets for his unerring marksmanship. For cowardly murderers The Shadow had no quarter. Snarling, bestial fiends fell with dying curses on their evil lips.' Although it appeared with a comic book cover, each bi-weekly edition of *The Shadow* was a novel-length story of 60,000 words, written under the pen-name Maxwell Grant. Most of the episodes that Jack read would have been written by the prolific Walter Gibson, who was responsible for 285 *Shadow* comics in the 1930s.

In fact, Gibson's description of how his *Shadow* stories were composed sounds exactly like Jack's later descriptions of what he would call 'spontaneous prose'. 'By living, thinking, even dreaming the story in one continued process, ideas came faster and faster,' Gibson once said of his 30,000 words-a-week output. 'Sometimes, the typewriter keys would fly so fast that I wondered if my fingers could keep up with them. And at the finish of the story I often had to take a few days off, as my fingertips were too sore to begin work on the next book.'

This ferocious work schedule resulted in a breathless prose which was studded with colourful descriptions of fog-enshrouded cities and lingering evil, in which Jack half recognized his own dreams and fears. 'Strangest of all was the ghostly shape that glided through the neighbouring streets like the stalking figure of death itself,' read the start of one of Gibson's tales. 'It seemed to be a human shape plucked from night's own blackness, visible only where it stirred the mist, disappearing in the grimy background beyond the swirls of fog. The Shadow was seeking an arch-foe whom he had never seen nor heard of, but whose existence was a matter beyond all doubt: Professor MacAbre, the brain of Voodoo crime!'

Jack began to create his own adventures involving The Shadow, and with Pete and Mike Houde he would take to the streets with a cape draped across his shoulders to act out crime-busting fantasies - occasionally scaring local residents with their high-pitched screams as they hid behind hedges and climbed up tall trees. It was out of these fantasies

In his teenage years Jack was
renowned in Lowell as a star of the
High School football team and as an
all-round athlete.

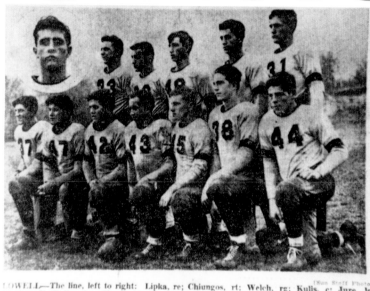

LOWELL—The line, left to right: Lipka, re; Chiungos, rt; Welch, rg; Kulis, c; Jure, lg
Dowling, lt; Ruiter, le. The backfield: Sorota, fb; Zoukis, lhb; Kouchalakos, rhb; Kerouac
rhb; Coughlin, qb. Insert: Art Coughlin, Lowell captain.

Here is Lowell high's' 1938 starting team which faces Greenfield today. Left to right: Warren Longtin, re;
Duke Chiungos, rt; Bernie Welch, rg; Joe Kulis, c; Don Sullivan, lg; Jim Dowling, lt; Charlie Ruiter, le. Back-
field: Joe Sorota, fb; Art Coughlin, qb; Jack Kerouac, rhb, and Chris Zoukis, lhb.

that Jack created the characters Dr Sax and Count Condu, representations of his haunted childhood: 'I first saw (Dr Sax) in his earlier lineaments in the early Catholic childhood of Centralville.' Dr Sax embodied Jack's confusion over death and religion. Despite being spoken of as a saviour, the Christ of Jack's Catholic upbringing was almost always portrayed as either suffering or dying. Images of bleeding hearts, flayed flesh and shattered bones obscured the love, peace and 'abundant life' Christ was supposed to bring; and so Kerouac could reflect on the 'horrors of the Jesus Christ of passion', who came in 'vestments of saddest doom', in the way that Martin Luther could remember Christ having been 'a stern judge from whose face I wanted to flee, and yet couldn't'.

Jack began to see himself as the central character in a private drama – a perception that was to become crucial to his later writing. Alone at home, he would play records and act out scenes in his bedroom, and while walking to school he would imagine that cameras were turned on him and he was starring in a movie about his own life, called *The Complete Life of a Parochial Schoolboy*. Duke Chiungos, a seventh grade class mate of Jack's at Bartlett, remembers seeing his writing talent emerge. 'He wrote a story called "An Irish Cop on the Beat" for an English class,' he says. 'It was so good that the teacher wouldn't believe that he had written it himself. Jack was furious. When we were walking back home after school he said to me, "Can you believe it? She wanted to know where I'd copied it from."'

His talent was encouraged in the eighth grade by Miss Mansfield, the school librarian, who ran an after-school discussion group in her home. George Constantinides recalls her playing an important role in Jack's development. 'She had paid for the library herself and encouraged people to take books out,' he says. 'She was a marvellous role-model, and she not only encouraged Jack to write but she also encouraged people to go on to college.'

In 1936, Jack graduated from Bartlett to Lowell High School. Again, he was remembered as a quiet boy, but he was now gaining a reputation as a football player, a baseball player and a track star. He wasn't tall and heavy, but he had powerful legs and an aggressive style of playing. At school he would practise running up and down the stairs to develop his thighs and calves. Duke Chiungos played in the football team with him and remembers, 'He was a good player, a real tough boy. He was like a rubber ball. You could hit him and he'd bounce right back again.'

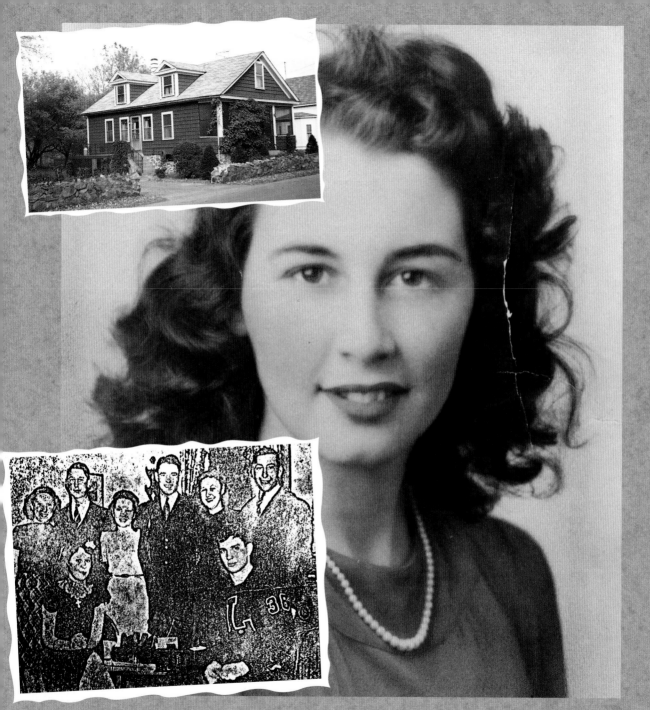

Mary Carney (main picture), was later celebrated in the novel *Maggie Cassidy*. The couple frequently met at the Carney's Billerica Street home (top) and, in March 1939, were pictured together in a local newspaper story on Jack's seventeenth birthday party.

In the same year that Jack graduated, the Merrimack overflowed and parts of Lowell were badly flooded. Leo Kerouac's printing business was damaged and because he had no insurance he was forced to put it into receivership in order to pay his creditors. It was a savage blow for a man whose finances had never been in great shape, and this may have been what first caused Jack to doubt the notion of the American Dream.

There is evidence in *The Town and the City* of the father's growing disenchantment as he talks about the frontier days, 'when America was America, when people pulled together and made no bones about it'. He bemoans the loss of honesty, character and good living. 'Those pioneers were the men who made this country great, before it started to fall apart in the last thirty years, they were the fellows who took it upon themselves to leave comfortable communities and strike out with their wives and kids to build a new country. And now! Now you can see what all that sweat and suffering is coming to.'

By this time Jack was reading more widely, progressing from *Huckleberry Finn* and *The Last of the Mohicans* to the novels of H. G. Wells and the poetry of Emily Dickinson, and had developed an interest in journalism. Damon Runyon's streetwise New York columns, full of hoodlums and showgirls, impressed him, as did the sports writing of Dan Parker and Jimmy Cannon that he found syndicated in local newspapers.

It was during this period that Jack's passion for jazz was aroused. The swing era had just been introduced by a young clarinettist called Benny Goodman, whose drummer was the flamboyant, gum-chewing Gene Krupa. This was one of the first indications of white music becoming directly influenced by black music. British music critic Tony Palmer has noted that Goodman, Artie Shaw and Woody Herman were the first band leaders to introduce America as a whole to music that was 'black in origin, black in design, and black in spirit'.

While in his final year at Lowell High, Jack met Mary Carney, the pretty Irish girl he would later celebrate in his novel *Maggie Cassidy*. He first saw her at the Rex Ballroom, where she was dancing with Ray St Louis, who was the closest thing to a hipster to prowl the streets of Lowell in 1939. St Louis and his friend Ray McNulty were both jazz nuts who knew all the latest jive-talk and had experimented with soft drugs. They had long hair, pegged pants and knew how to jitterbug. Kerouac was attracted to what he called 'their strange, serious, interesting looks', in the same way that he would later be attracted to Neal Cassady.

Fortunately, St Louis had already tired of dancing with Mary, and

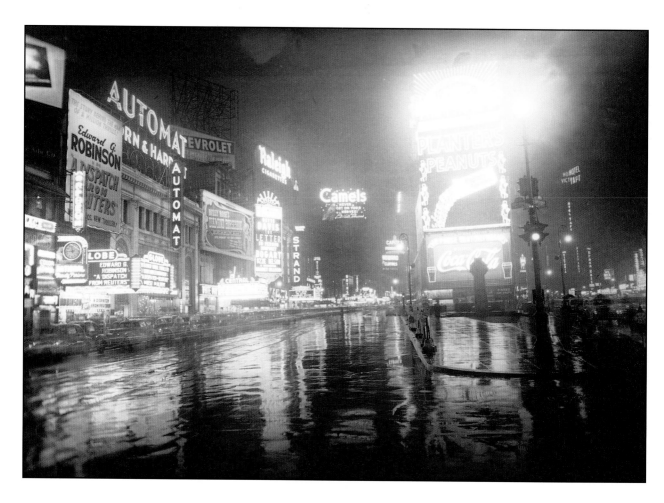

Broadway, New York, at the time when Jack
first encountered it: 'Sparkling Manhattan,
shows, restaurants, newspaper scoops. Times
Square, Wall Street, Edward G. Robinson
chomping on a cigar in Chinatown.'

he passed her on to Kerouac, who was smitten almost immediately by her femininity. During the spring and summer of that year they conducted an innocent romance, which largely consisted of necking and talking while her parents were out of the house. It became a serious and special relationship to both of them, but they knew it was doomed because their aspirations were so different. She wanted to settle in Lowell and raise a family, while Jack wanted to go to New York and become a writer.

Perhaps because he knew his relationship with Mary was doomed, Jack also dated Peggy Coffey, a fellow student at Lowell High, who was very different from the rather demure Mary. 'She was a singer and quite a personality,' remembers Duke Chiungos. 'She was almost too much to be the type of girl that you thought Jack might team up with.' He continued seeing Peggy back in Lowell for some years, but nothing matched the feelings he had for Mary, whom he idiolized as his perfect woman. He carried on seeing her periodically throughout the rest of his life – despite the fact that she married twice – and was convinced even in his final years that she was the only girl he had ever loved. There were times in his life when he wondered whether he should ever have left Lowell, in spite of its ghosts and its small-mindedness. Maybe he would have found more happiness if he'd stayed there and raised a family as most of his friends did.

However, in 1939 he made the decision that was to set the course of his life. He'd been spotted by football coaches from both Boston College and Columbia University and was offered scholarships to both. His father wanted him to go to Boston and, because the company he worked for printed all Boston College's material, Leo was told that he would lose his job if Jack didn't accept the offer. But his mother wanted him to go to Columbia, and Jack chose to do so because it would take him to New York, the city of The Shadow and of Damon Runyon – the city he'd seen so often in the movies. When he accepted, his father was summarily dismissed from his job.

Jack left Lowell with mixed feelings; which he later expressed in the character of Peter Martin in *The Town and the City*. There was the 'drowsy fear' of leaving the house that had always been 'the comfortable basis of life', yet this was countered by the 'drowsy excitement' of venturing towards 'railroad depots, coffee counters, new cities, smoke and furor and windsmells strange and new, to sudden unimagined vistas of river, highway, bridge and horizon, all sensationally strange under unknown skies, and the smoke, the smoke'.

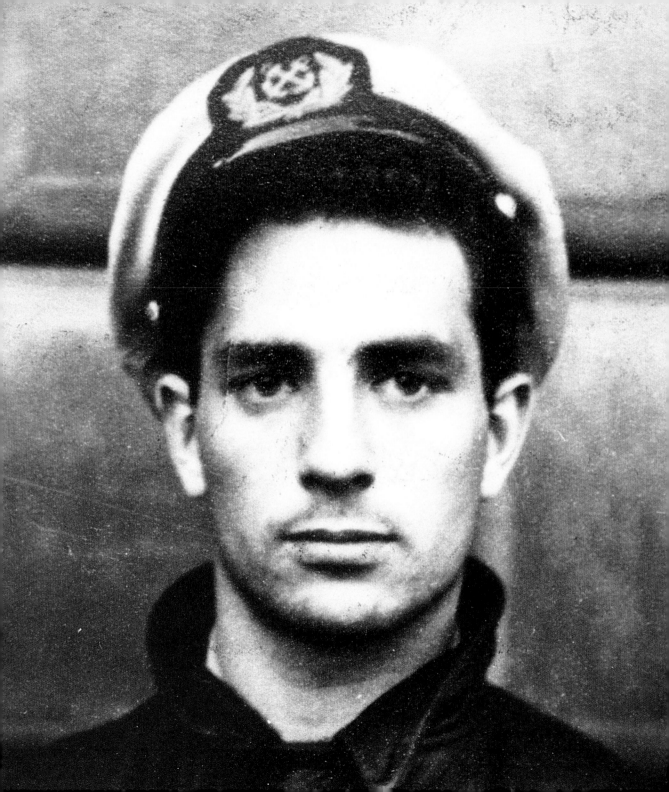

3

Waking Up to America

There was another America out there that remained unsung: a rawer, more primitive America where the spirit had not been tamed and moulded by the relentless machine of modern materialism.

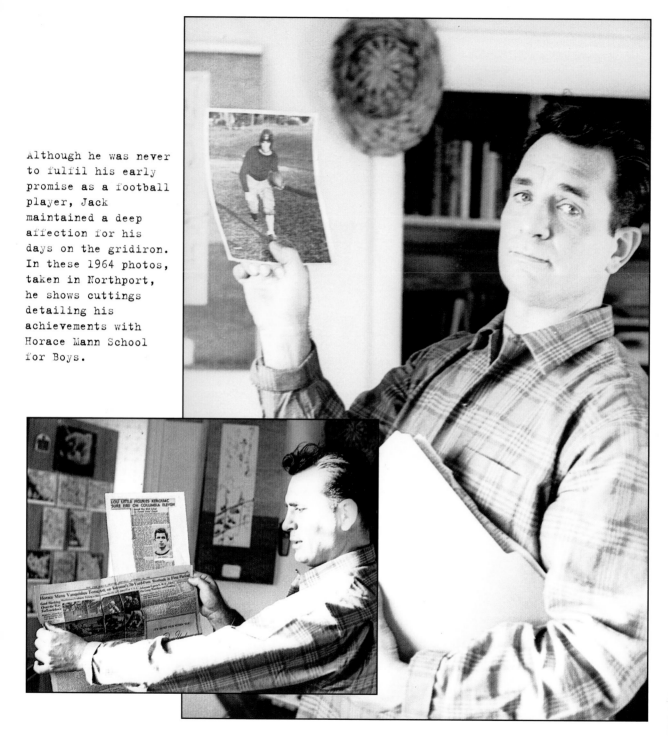

Although he was never to fulfil his early promise as a football player, Jack maintained a deep affection for his days on the gridiron. In these 1964 photos, taken in Northport, he shows cuttings detailing his achievements with Horace Mann School for Boys.

One of the conditions of Jack's acceptance into Columbia
University was that he spend a year at an affiliated preparatory
school, Horace Mann School for Boys, in order to improve his grades in
both French and math. This meant re-sitting the final year of High
School, but this time in significantly different surroundings.

Horace Mann was New York's leading private school. Situated on
246th Street in the affluent suburb of Riverdale, it was only a
twenty-minute drive away from the heart of Harlem, but culturally it
was another world. Large, detached period-style houses were set way
back off tree-lined streets, and expensive cars were parked in long
driveways. Gardeners busied themselves clipping hedgerows and tending
lawns. The majority of the boys at the school were from rich, Jewish
families that lived on Manhattan's Upper West Side. Some of them had
summer homes on Long Island. Some were brought to school in chauffeur-
driven limousines. Most would go on to Ivy League universities and
then follow their fathers into becoming doctors, bankers, lawyers and
businessmen.

Jack's home when he started school on September 22 1939 was a
room in the home of his mother's stepmother, at 293 State Street,
Brooklyn, a two-and-a-half-hour subway journey away from Riverdale on
the Broadway IRT. Later, he would use his travelling time to do
homework, but on his first day he was mesmerized by the excitement of
New York – the screeching wheels of the trains, the flow of early
morning workers, the signs for Times Square, Penn Station and Harlem's
125th Street – which conjured up a world he knew only from newspapers
and movies.

He was known at Horace Mann as a 'ringer', one of a dozen or so
boys taken in to boost the prospects of the school's football team.
However, he soon proved that he was more than just an athlete. As the
yearbook would later report, 'Brain and brawn found a happy
combination in Jack.' Joe Kennedy (later to be fictionalized as Mike
Hennessy in *Vanity of Duluoz*), remembers him being 'absolutely
overwhelmed' by New York – not just by the pace of the city, but also
by the affluence that surrounded him. 'You can imagine what a Lowell
boy would think, coming down to the big city and suddenly finding
himself with these rich Jewish kids,' he says. 'He was playing on the
same teams as these people, he was mixing with them socially and he
was coming to realize that he had a brain that was at least the equal
of any of the other guys in the school.'

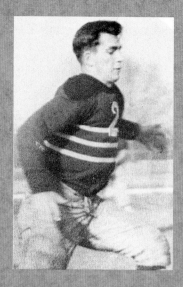

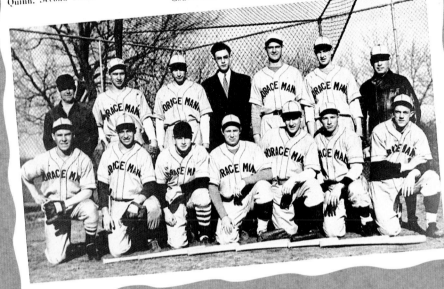

During his year at Horace Mann there were few clues that a Bohemian was in the making. His old classmates remember him mostly for his reserved nature, his diligent work and his prowess on the sports field.

JOHN L. KEROUAC . . . Brain and brawn found a happy combination in **Jack**, a newcomer to school this year. A brilliant back in football, he also won his spurs as Record reporter and a leading Quarterly contributor. Was an outfielder on the Varsity nine.

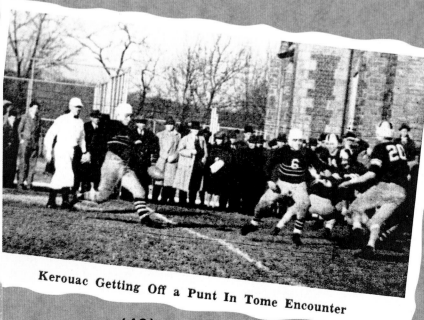

Kerouac Getting Off a Punt In Tome Encounter

Jack's new classmates found him to be affable but reserved. His hair was cut short, he wore a necktie and sports jacket, and he dedicated himself to sport and work. His reputation as an essay writer was so impressive that he was often asked to ghost-write other students' papers in return for cash. His own grades were good: ninety per cent in English, eighty-seven per cent in French, seventy-nine per cent in geometry, eighty-five per cent in algebra and seventy-seven per cent in science. (In *Lonesome Traveler* he claimed a ninety-two per cent average at Horace Mann, but eighty-two per cent is the correct figure.) 'I would describe him as quite an understated guy,' says Dick Sheresky, one of Kerouac's close friends at Horace Mann. 'In fact, the two things that stand out in my mind about him are that he was very quiet and that he was a tremendous football player. He could handle the biggest guy in the class with ease but he never threw his weight around.' Burt Stollmack, another Horace Mann classmate, also remembers him mostly for his football. 'He was just a regular, fun fellow who was very bright and picked up the ways of us New Yorkers very quickly,' he recalls.

The Horace Mann football team, coached by 'Ump' Tewhill, won four of their five games during the 1939–1940 season. In the final game of that season they beat their greatest rivals 6–0, and the yearbook credited Jack with 'one of the most remarkable individual performances ever seen on the Maroon and White gridiron'. He was also one of three players singled out in the yearbook for special mention: 'Kerouac, who climaxed the season's accomplishments with his brilliant performance against Tome, was the team's most speedy back.'

Although Jack spent most of his time with the athletic crowd, he was a good mixer, visiting boys in their Manhattan homes on the weekends and turning up for their lavish parties. 'He was a handsome guy,' remembers Joe Kennedy, 'and the girls were naturally attracted to him. There would be a lot of good-looking Jewish girls at the parties, and he could see that his prospects of going out with them were now as good as anyone else's. He could see himself moving into another social strata.' Kennedy, whose family also had New England Catholic roots, detected the first stirrings of Kerouac's non-conformity. 'I think he was always looking for something which I'm not sure he ever found,' he says. 'He was always exploring instead of accepting what seemed obvious and right up against his face. If something appeared logical that was not good enough for Jack. He had to find something out there. He thought everyone else was in a rut and that he was smart enough to go out and find what was missing.'

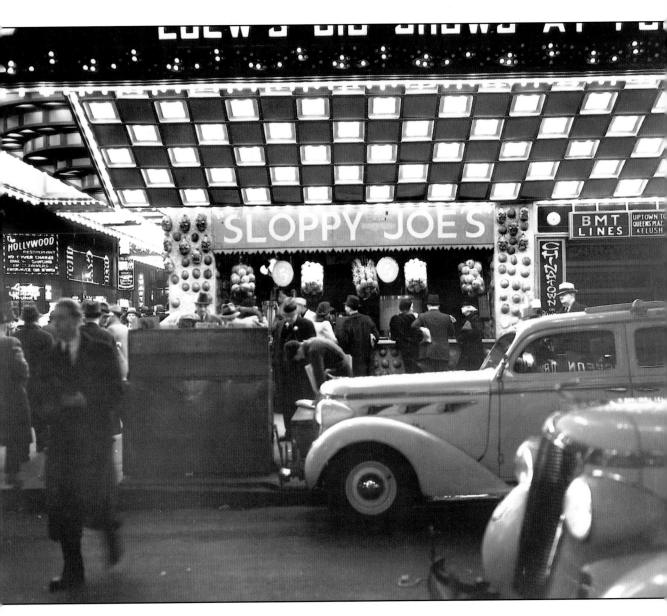

Broadway, 1939. Living in Brooklyn allowed the
teenaged Jack to explore the streets of Manhattan by
night. Here, he took in movies, listened to the latest
jazz and developed a fascination for low-life.

Unbeknown to his classmates at Horace Mann, it was during this year that Jack smoked his first marijuana and lost his virginity. He was introduced to marijuana, the use of which, for non-medical purposes, had been outlawed in 1937, during visits to jazz venues in nearby Harlem. The first time he had sex was with a Manhattan prostitute in December 1939. He enjoyed getting out of the subway at Times Square and watching the pimps, whores and hustlers doing business on 42nd Street. The quiet boy from Lowell was acquiring a taste for the forbidden.

Jack's friends were aware only that he had unusual interests for a football player. He liked reading books, wrote short stories and, at a time when few white teenagers knew anything about it, was a fan of 'negro' style jazz music. Jack himself knew of only three other boys in the school who were into jazz. Seymour Wyse was a British student in his class who had met the Duke Ellington band on board the *Ile de France*, the liner that had brought him to America. Donald Wolf was a younger boy who not only knew his way around Harlem's jazz clubs, but had met Count Basie, Lester Young and Coleman Hawkins. Aram 'Al' Avakian (also known as Albert) was the fifteen-year-old son of Armenian immigrants, whose brother George was already producing jazz records.

'Jack started knowing nothing about jazz, while I knew a great deal,' says Wolf. 'I was sort of taking him by the hand. I used to find out what the recording dates were and we'd go along. There was no security in those days, no backstage passes or anything. We'd sit down on a chair, keep our mouths shut and that was the end of it. Every time I met a jazz musician and Jack was with me I would introduce him.' Wyse, who took him to the Apollo, the Savoy and the Golden Gate, remembers that they were usually the only white faces in the audience. 'We were taking our lives in our hands,' he says. 'It was a pretty dangerous area. I had a lot of hair-raising experiences there, including being held up once or twice. But once you were inside the clubs you were all right.'

Jack's enthusiasm for jazz motivated him to start writing for the school newspaper, the *Horace Mann Record*. He interviewed George Avakian in Nick's jazz club during an afternoon set by Muggsy Spanier; wrote an appreciation of Count Basie ('the last word in hot music'); and then, with the paper's editor, Morton Maxwell, managed an interview with Glenn Miller backstage at the Paramount Theatre ('a clean-cut, fine-looking young man with an engaging personality'). 'Stars like Glenn Miller didn't usually give interviews to high school newspapers, but my father was a

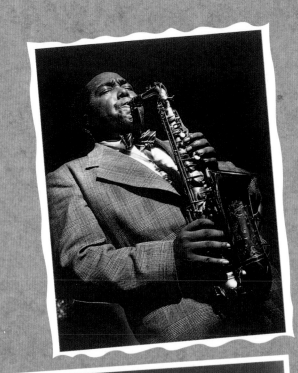

Jack's 1940 graduation outfit (far left) offered some clues as to his changing tastes. He was listening to Charlie Parker (left), reviewing jazz for the school magazine (below) and paying visits to the Savoy in Harlem (bottom).

Page 4

Real Solid Drop-Beat Riffs And Kicks Are Plentiful In George Avakian's Unique Album Of Chicago Style Jazz

By Jack Kerouac and Albert Avakian

Have you ever been thrilled by the stirring movements of a vast symphony orchestra, played with the mastery and skill of seasoned musicians?

If so, what do you Tschaikowsky as playe...

low in rapid order—Freeman, Sullivan, and Russell. Joe and Pee Wee turn in their usual inspiring music—both of them really lost in another world as they play.

SOMEDAY SWEETHEART—Decca 60071: Immediately, Sullivan's piano

GEORGE WETTLING'S CHICAGO RHYTHM KINGS: George Wettling (drums), Charley destling (trumpet), Joe Marsala (tenor sax), Danny Polo (clarinet), Jess Stacy (piano), Artie Shapiro (bass), Jack Bland (guitar), Floyd O'Brien (trombone)

...igor.

Last D

"Vel..

(52)

physician who had show business patients, so he managed to set it up for us,' remembers Maxwell. 'We met him in his dressing-room after the show and we must have spent an hour together with him. Jack was a real authority on jazz and Miller was very cordial to us both.'

Despite their brevity, the articles Jack wrote for the *Record* showed him developing his musical tastes and his artistic theories. Though slightly stilted, his description of Muggsy Spanier's playing in the Avakian piece was a precursor of his writing about jazz in *On the Road*. 'The notes poured out of the glistening trumpet,' he wrote, 'each of them bearing its own poignancy and meaning and all of them in one beautiful quality of tone.'

In praising the passion and spontaneity of *Chicago Jazz* – the first jazz album ever, produced by George Avakian – Jack was showing the preference for informality which would shape his own art a decade later. 'What is real jazz?' he asked. 'It is the outburst of passionate musicians, who pour all their energy into their instruments in the quest for soulful expression and super-improvisation. A real jazz band is a small group of musicians gathered together informally, with the express purpose of satisfying their souls by means of the language of music.'

Swing music, with its considered orchestration, was no longer the real thing for Jack. He dismissed it as 'carbon copy jazz'. He preferred music that was wild and earthy. 'Jazz wasn't just an intellectual pursuit for Jack,' says Seymour Wyse. 'It was something he responded to physically. He moved to the music. He was essentially a shy and reserved person and I suppose it may have helped to loosen him up.'

The fiction he was writing at the time, however, had more of the deliberation of swing than the spontaneity of jazz. In a short story entitled 'The Brothers', which was published in the fall 1939 issue of the *Horace Mann Quarterly*, the protagonist is not so snappily described as: 'a man of extreme calm, of stone-like imperturbability. He reminds one of Oriental patience at the zenith of its fortitude.' His second story, 'Une Veille de Noël', used less ornate language, and told the story of an angel (or could it be the risen Christ?) who drops in on a city bar.

After graduating in July 1940, Jack returned to Lowell and reinstated his friendship with Sebastian 'Sammy' Sampas, the young Greek-American who had introduced him to Miss Mansfield's discussion group. Sebastian had similar ambitions to Jack but, unlike Jack, was an extrovert who would leap onto a café table and recite Byron or break

(53)

into a chorus of *Boulevard of Broken Dreams*. He was to Jack 'a comrade, a confidante in the first glories of poetry and truth'. 'I had never met anyone of his age who had read so much,' remembers George Constantinides of Sebastian. 'He wrote poetry. He wanted to be a playwright. He had read Proust at the age of fifteen and was far in advance of his contemporaries. He played an important role in encouraging Kerouac. He recognized his ability early on. He told me that Jack was a great writer and that he was going to become famous. He could never stop praising him.'

Jack and Sebastian began talking on a level which Jack had never before experienced. He was the first boy Jack had met who loved books for their own sake, and who was interested in ideals such as truth and beauty. Their friendship 'opened up into a springtime of wonder and knowledge'. Sebastian introduced him to the works of William Saroyan and Thomas Hardy and also to a biography of the novelist Jack London, which Jack eagerly devoured. He adopted some of London's self-improvement techniques, such as writing out unfamiliar words and taping them to his bedroom mirror for revision.

Through Sebastian, he met and began to mix with a new set of Lowell boys from different ethnic backgrounds, all of whom were high achievers. Like Jack, they would each eventually transcend their class and culture and make a mark in their professions. Jim O'Dea became a brilliant lawyer in California, George Constantinides travelled the world as a CIA operative and Connie Murphy became a nuclear physicist and then retrained as a doctor. 'The old class divisions were all broken down in our generation, thanks to people like Sebastian,' says Constantinides. 'He felt we needed to rise above all this and if he spotted a unique individual he would bring them together with other unique individuals.'

In September 1940, Jack returned to New York and enrolled at Columbia University on Broadway at 116th Street. Because he had entered on an athletics scholarship, he was obliged to take part in daily football practice as well as study. In his first week he found himself having to read Homer's *Iliad* and *Odyssey*; wash dishes in the kitchen in return for meals; and be ready for training at four o'clock each afternoon. When he complained he was told: 'Well, this is the Ivy League, son.'

He played his first freshman football game, against Rutgers University, on October 12 1940, but spent the first half on the bench. Although Columbia lost 18-7, Jack's performance when he was brought on

was impressive enough to warrant his inclusion in the team for the next game, against St Benedict's Preparatory School. During that game he was sent off with what he thought to be a bad sprain but was actually a cracked tibia. It was this injury which would eventually end his football career.

A broken leg meant more time for reading and seeing films and plays. Amongst others, he saw Saroyan's play *My Heart's in the Highlands*, listened to records by Frank Sinatra (a great favourite), and took in French films staring Louis Jouvet and Jean Gabin. On the advice of Sebastian Sampas, he began reading the novels of Thomas Wolfe; and it was Wolfe's descriptions of the American landscape – the Mississippi, the Shenandoah, the pale-green flaky look of old buildings, the railroads, the Indian trails – that opened up his imagination. 'He just woke me up to America as a poem instead of America as a place to struggle around and sweat in,' he later wrote. 'Mainly, this dark-eyed American poet made me want to prowl, and roam, and see the real America that was there and that "had never been uttered."'

Wolfe gave Jack the impetus to cut free from the conventional American life that he felt he was training to join. Like most of his male contemporaries born in the aftermath of World War I and raised during the Depression, he had envisaged graduating from college and becoming someone in a grey felt hat carrying a briefcase, who would drive home each night to his detached home surrounded by a white picket fence to be met by his slim blonde wife and their two happy children. After reading Wolfe, Jack's American Dream changed. His ambition was no longer to climb the career ladder and gain possessions and respect, but was to explore the great continent and gain knowledge, experience and insight. There was another America out there that remained unsung: a rawer, more primitive America where the spirit had not been tamed and moulded by the relentless machine of modern materialism.

He returned for his second year at Columbia in September 1941, and again squabbled with coach Lou Little, who he felt was holding him back in preference to lesser talents. Seeing no hope of being a regular player under Little, he stormed out into what he would later call 'the Thomas Wolfe night, the American darkness' and took a Greyhound bus down to Washington, DC. There, he took a room for the night in a run-down section of the city and wrote of his sadness and loneliness in a letter to Sebastian.

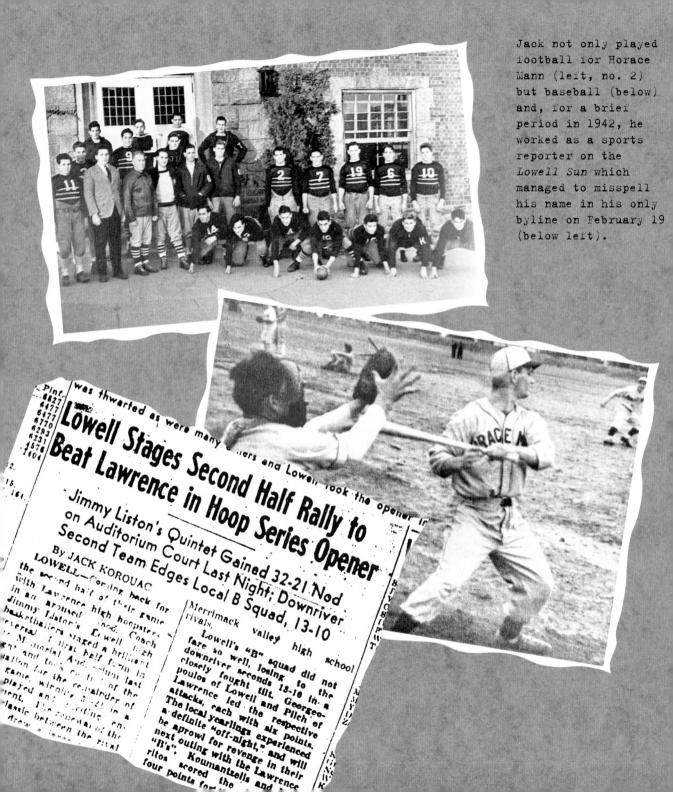

Jack not only played football for Horace Mann (left, no. 2) but baseball (below) and, for a brief period in 1942, he worked as a sports reporter on the *Lowell Sun* which managed to misspell his name in his only byline on February 19 (below left).

was thwarted as were many others and Lowell took the opener fr

Lowell Stages Second Half Rally to Beat Lawrence in Hoop Series Opener

Jimmy Liston's Quintet Gained 32-21 Nod on Auditorium Court Last Night; Downriver Second Team Edges Local B Squad, 13-10

By JACK KOROUAC

LOWELL—Coming back for the second half of their game with Lawrence high hoopsters in an aroused mood, Coach Jimmy Liston's Lowell high basketballers staged a brilliant reversal of first half form in Memorial Auditorium last night and took control of the game, winning 32-21 in a classic between the rival

Merrimack valley high rivals.

Lowell's "B" squad did not fare so well, losing to the downriver seconds 13-10 in a closely fought tilt. Georgeopoulos of Lowell and Pilch of Lawrence led the respective attacks, each with six points. The local yearlings experienced a definite "off-night," and will be aprowl for revenge in their next outing with the Lawrence "B's". Koumantzelis and ritos scored the four points for

This was only to be a twenty-four-hour trip. Jack's parents had recently moved from Lowell to West Haven, Connecticut, and he returned the next day to their new home. But it made him feel like an adventurer. He was impressed to be in the real South – the South of Thomas Wolfe – and felt a frisson of danger at meeting poker-playing 'negroes' and sleeping on a mattress full of bedbugs. He considered the decision to quit Columbia the most important of his life so far and his letter to Sebastian the best thing he'd ever written. His parents were shocked that he'd given up a first-class education in a fit of pique. His father was so angry that Jack left them and went to join a friend in nearby Hartford. He found temporary work in a local garage for $27.50 a week, and a cheap apartment, where at night he wrote short stories in the styles of Saroyan and Hemingway.

In January 1942, his parents moved back to Lowell, and Jack took work as a sports reporter on the *Lowell Sun*, a job which lasted a little over two months, ending when he backed out of an arranged interview at the last minute. Again, he boarded a bus and headed down to Washington, DC, but this time in the knowledge that he would have company there, in the form of his boyhood friend G. J. Apostolos. Stopping off in New York, he caught Frank Sinatra, who had just left Tommy Dorsey's band, in a show at the Paramount. It was one of the first performances where Sinatra was mobbed by screaming young 'bobby soxers'.

In Washington Jack first became a construction worker on the new Pentagon building in Arlington, Virginia, and then found work as a soda jerk and short-order cook in a diner. One of the highlights of his time on the Pentagon site was hearing a black labourer singing the blues. He was so entranced that he put down his shovel and followed the man around as he worked.

He was by now sexually promiscuous, going out every night hunting for 'quiff'. Apostolos noticed a big change in the boy he'd grown up with who had always respected women. Jack had now taken part in 'gang bangs' – both with girls he knew in Lowell and with prostitutes in New York. During his six-week stay in Washington he moved in with a waitress from Macon, Georgia, who had initially attracted his attention by showing him a pack of pornographic playing cards.

Once more, Jack was impressed at being in the South, and had plans to hitchhike down to Wolfe's birth place, Asheville, North Carolina. However, with America now at war, he decided to return to Lowell and sign up with the United States Marines. He was accepted and sworn in, but

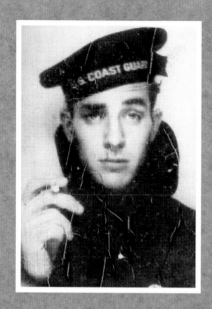

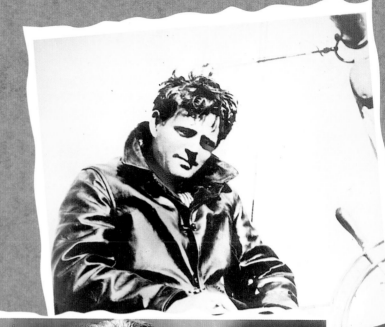

Jack (above) was inspired by the life and work of American novelist Jack London (top right) and loved to sing along with recordings of Frank Sinatra, who had recently left Tommy Dorsey to become a solo artist.

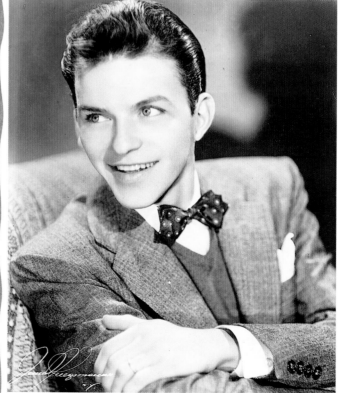

instead of waiting for his call-up papers he signed on with the Merchant Marines who soon found him work as a dishwasher on the *S. S. Dorchester* which was sailing to Greenland carrying earth-moving equipment, dynamite and 500 civilian construction workers. Although the *Dorchester* wasn't a warship, the journey into the North Atlantic was perilous enough to warrant destroyer escorts. During the three-month voyage the ship faced two torpedo attacks from German submarines, and her sister ship, *S. S. Chatham*, was sunk off Belle Isle Strait. The *Dorchester* returned to Boston Harbour in October 1942, where Jack left her. The *S. S. Dorchester* was not so lucky on her next voyage. She was sunk in Baffin Bay with over 1,000 lives lost.

Back in New York, Jack decided to pick up where he'd left off at Columbia and catch up with his grades. The be-bop revolution was happening at clubs like Minton's Playhouse on 118th Street and Monroe's Uptown House on 133rd Street, and he saw Charlie 'Bird' Parker and Dizzy Gillespie, both of whom fulfilled Jack's criterion of 'soulful expression'. Sebastian Sampas, who was by now a drama student, came down to visit and Jack took him on a trawl of bars and clubs, introducing him to hookers and showgirls and taking him into Harlem. Sebastian was amazed by the change in Jack. 'When Sebastian came back to Lowell he told me that he was very disturbed by the environment that Jack was now in,' remembers George Constantinides. 'He didn't like the drink and drugs. He said that Jack was trying everything, that he was out to "experience life in every form" as he put it. He told me that although Jack was very heterosexual he had given homosexuality a try. That was the way Sebastian put it to me.'

His old Horace Mann classmate Joe Kennedy was also concerned. 'From my perspective there was something happening to Jack and he was going downhill,' he says. 'I could see he was drinking too much, and God knows what else he was doing. I wasn't into his scene at all, although I still liked him and we would still see each other at the West End Bar on Broadway. At the time, I used to think that he was being led in the wrong direction. But that didn't turn out to be the case. *He* was doing the leading.'

It seems that Jack had his first homosexual experience in 1942, when hitchhiking on the road from Lowell to New York dressed in his naval uniform. A man picked him up and during the journey pulled the car over and asked Jack to let him give him a blow-job. With his new desire to experience every sensation possible, Jack allowed the man to do what

he wanted and then they drove on. Jack related the incident a short while later to Morton Maxwell, when he bumped into him in the crowd at a Columbia University football game. 'We were like kids, confiding everything in each other, and then he told me about this incident,' says Maxwell. 'That sort of thing was totally alien to us in those days and it came as such a shock to me that Jack had let a man do this to him, but then he said, "It felt real good," and I said, "Really? And it was a man?", and he said, "Yeah," and we both started laughing!' I'm certain that he hadn't had any homosexual experiences before that, and I don't think that he was homosexual. It was as if he had just let it happen to see what it felt like.'

Back at Columbia, Jack became reacquainted with Henri Cru, an old classmate from Horace Mann who was living on 116th Street and who was about to leave for naval duty in the Mediterranean. Cru had been casually dating a girl called Frankie Edith 'Edie' Parker, whose grandmother had an apartment in the same building. She was an adventurous and liberated art student from an affluent home in Grosse Pointe, Michigan, and Cru sensed that she and Jack would click. Just before leaving America, he arranged a successful meeting between his two friends and they began dating.

In December 1942, Jack argued with coach Lou Little once more, because he wasn't getting regular games at Columbia. In what was becoming a behavioural pattern, when he didn't get his own way, he walked out. He returned home, and expected to be called up into the armed services before his twenty-first birthday in March 1943. Back in Lowell, he took a job parking cars at The Hotel Garage on Middlesex Street. In the evenings he worked on his first full-length work – a novel provisionally titled *The Sea is My Brother* – handwriting every word of the 'gigantic saga' of the lives of the Martin brothers. His later view of it was 'a crock as literature but as handprinting – beautiful'.

With Sebastian Sampas, Jack developed romantic ideas of a non-Marxist collectivist society. They derided the bourgeoisie, declared themselves the enemies of newspaper magnates such as William Randolph Hearst, and planned to bring beauty into the lives of common people. Jack was not party political, although he hated Russian Communism. He saw himself as a solitary radical with the single message of 'no exploitation'.

In March 1943 Jack was ordered to a Naval 'boot camp' in Newport, Rhode Island. As a twenty-one-year-old who had already been to sea, he found it difficult being around eighteen-year-old high school graduates. He found their humour puerile and their behaviour adolescent. But that was not the only source of discomfort for him. He didn't like taking orders from his superiors. One day, during drill, he laid down his rifle, calmly walked off the drill ground and went to the library, where he was promptly apprehended.

He was taken to a psychiatric hospital and kept there until May, when he was discharged. He realized his wish to serve with the Merchant Navy the following month, when he set sail on the *S. S. George Weems*, bound for Liverpool, England, with a cargo of bombs. At night he would lie in his cabin, either working on *The Sea is My Brother* or reading the novels of Marguerite Radclyffe Hall, Hugh Walpole, Sir Philip Gibbs and John Galsworthy in preparation for his first experience of England. It was Galsworthy's *The Forsyte Saga* which planted in his mind the idea of one day creating a series of novels which would detail the legend of his own life.

The *S. S. George Weems* docked in Liverpool on Friday, July 23 1943, and after a weekend of duties on board the ship, Kerouac took the train to London for two days' leave. He visited an exhibition of modern art, went to a Tchaikovsky concert at the Royal Albert Hall, conducted by Sir John Barbirolli, and hooked up with a lady in a fur coat who kept him warm during his night in London.

Back on the ship as it returned to America, his thoughts returned to the saga that he would write. 'I saw it,' he said later. 'A lifetime of writing about what I'd seen with my own eyes, told in my own words . . . put all together as a contemporary history record for future times of what really happened and what people really thought.'

When the *S. S. George Weems* arrived in New York in October 1943, the first thing Jack did was to take the subway up to Columbia University and race along to Apartment 62, 421 W. 118th Street, where Edie Parker was now living with a friend named Joan Vollmer Adams, an intelligent and vivacious Barnard drop-out whose husband was away in the army. It was here that the most significant period of Jack's life would take shape.

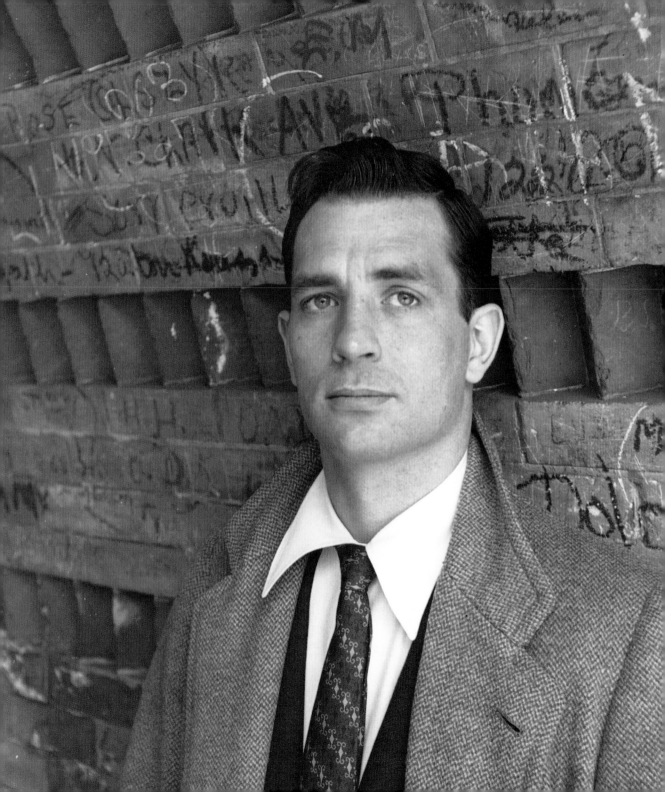

4

A
Beat
Generation

Jack and Ginsberg became willing pupils in
Burrough's hands — gazing open-mouthed at his
bookshelves, which groaned with European classics, and
drinking in his worldly wisdom. They both adhered to the
lists of suggested reading he gave them which included
Kafka, Cocteau, Apollinaire, Nietzche and Oswald Spengler.

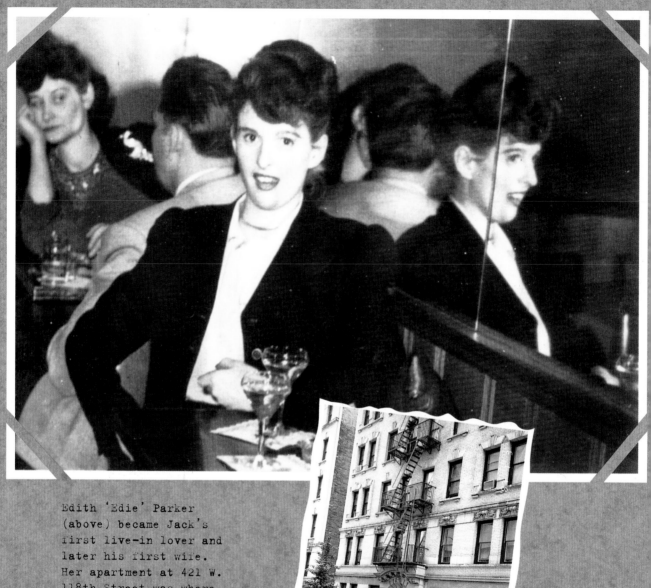

Edith 'Edie' Parker
(above) became Jack's
first live-in lover and
later his first wife.
Her apartment at 421 W.
118th Street was where
the Beats discovered
each other.

Between 1943 and 1945, Edie Parker's sixth-floor apartment
off Amsterdam Avenue became the birthplace of the Beat Generation. Here,
the nascent Beats would have their first encounters – fall in love, read
books, discuss ideas, evade the police, experiment with drugs and even
hide stolen goods. Jack, who never found commitment easy, began living
with Edie, but neither of them abandoned their casual affairs. His
parents were now living in Ozone Park, a Long Island surburb close to
Idlewild (now Kennedy) Airport, and Jack would frequently leave Edie to
stay with them and work on *The Sea is My Brother*.

Gabrielle and Leo had met Edie, but they pointedly refused to fuss
over her. She was too direct and earthy for Jack's mother, who blamed
her for leading him into sin, and his father thought that almost
everyone his son was associating with was responsible for his moral
decline. 'If she really likes you,' his mother would say, 'why doesn't
she save her money and make a nice clean little home for you when you
come back home from sea? From what I hear the place is always a mess.
All she does is throw parties and hang around in bars.' They would, no
doubt, have been horrified to learn that Jack had already made Edie
pregnant and that while Jack was away at sea Edie had had an abortion.
Had it lived, the child would have made Jack a father at the age of
twenty-two.

Both Edie and Jack loved jazz and would travel up to Harlem or down
to 52nd Street to catch the giants of the era in action. Through Seymour
Wyse they got to know Lester Young at Minton's and, much later, Jack was
introduced to pioneer jazz producer Jerry Newman, who suggested Jack's
name to Dizzy Gillespie as a title for an album track. (It was released
as *Kerouac* even though Gillespie had never met Jack.) Billie Holiday
recognized them as familiar faces when they attended her club dates, and
would sit and talk to them between sets.

Jack and Edie's listening extended beyond jazz. They liked the pop
songs of the day, played records by Huddie 'Leadbelly' Ledbetter, and
befriended folk singer Burl Ives, who was living in the Village at that
time. Beethoven, Bach and Debussy were their favourite classical
composers.

Changes came in the autumn, with the arrival of Lucien Carr, a
nineteen-year-old, blond-haired Columbia student from St Louis,
Missouri. Carr was well-bred but precocious. He had been a difficult
student as a child and teenager, but had made it through two semesters
at the University of Chicago before going on the road for two months.

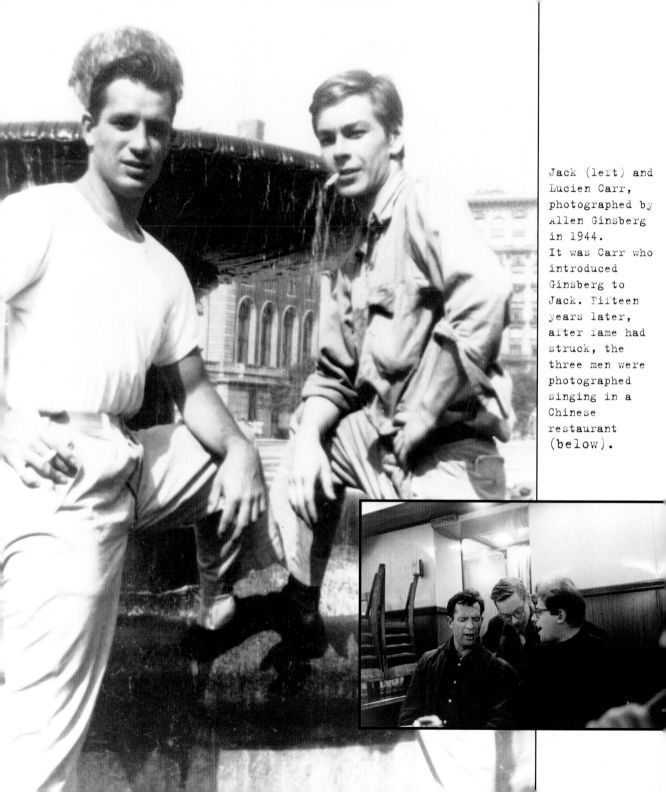

Jack (left) and Lucien Carr, photographed by Allen Ginsberg in 1944. It was Carr who introduced Ginsberg to Jack. Fifteen years later, after fame had struck, the three men were photographed singing in a Chinese restaurant (below).

Edie first met him at an art class. They got to talking, and she invited him back to the apartment where he met the mysterious merchant seaman who read poetry and was writing a novel. Jack was initially suspicious of Carr, worrying that he might pose a threat to his relationship with Edie, but warmed to him when he discovered that he was only nineteen and already in love with a girl from Barnard.

Carr had a sense of abandon about him which both Jack and Edie were attracted to. They never knew what he would do or say next. He dressed in brightly coloured shirts and wore a red bandana and enjoyed getting drunk. He also had an impressive knowledge of literature and talked to Jack about Shakespeare, Flaubert and Rimbaud.

Columbia's halls of residence had been taken over by the Navy, so Carr had been given accommodation at Union Theological Seminary on 122nd Street and Broadway. One night in December 1943, when most students had already left for the Christmas vacation, Carr heard a knock on his door. He opened it to find a skinny Jewish boy with large ears and a pair of glasses standing there, who asked Carr what classical music he was playing. The boy's name was Allen Ginsberg, and he was a seventeen-year-old freshman student. The son of a poetry-writing schoolteacher (Louis Ginsberg) and a paranoid schizophrenic (Naomi), Allen Ginsberg had come to Columbia to gain the qualifications he needed to become a labour lawyer. His father was a socialist, his mother a communist and, inspired by their beliefs, Ginsberg wanted to devote his life to helping working-class Americans. His required courses in English were taught by the celebrated professors Mark van Doren and Lionel Trilling.

Carr invited Ginsberg in, and over the next few months a friendship developed between the outgoing Southern teenager and the naive boy from Paterson, New Jersey. Inevitably, Carr suggested that Ginsberg would enjoy meeting Jack, and gave him the address of Edie's apartment. Ginsburg turned up unexpectedly one afternoon in May 1944 to find Jack sitting in an armchair eating breakfast. Ginsberg was homosexual, though a virgin, and Jack, who was his physical opposite, was the strong, athletic type of man he found attractive. They talked briefly while Jack finished his food and then went for a walk around the Columbia campus. While walking, the men discovered that they were kindred spirits. They both felt that they had seen ghosts, and had both stared into the night sky and sensed the meaninglessness of human life in the face of the universe. These feelings had prompted both to ask spiritual questions.

Like Jack, Lucien Carr was attractive to many homosexuals. One of

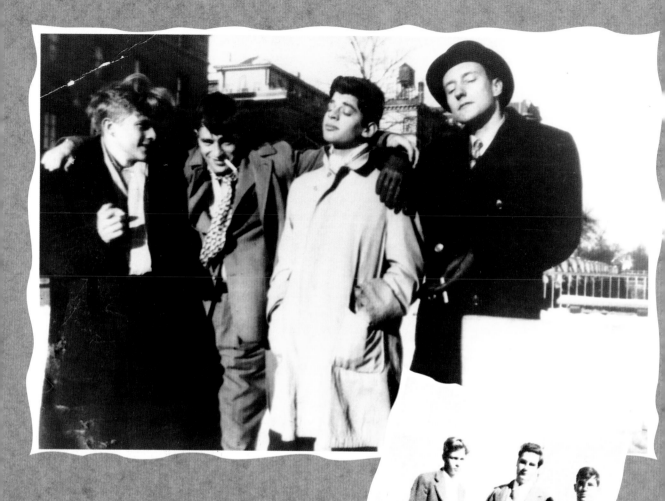

The first Beat Generation photo (above) showing Hal Chase, Jack, Allen Ginsberg and William Burroughs in 1944, the year that they met each other. During the same period Jack was photographed with Hal Chase and their mutual friend John Kingsland (right).

his childhood teachers, a thirty-three-year-old man named Dave Kammerer, had pursued him over the years – even moving from city to city as Carr changed schools. In 1944, knowing that Carr was at Columbia, Kammerer, an M. A. graduate from Washington University, St Louis, had moved to New York, taking a room at 48 Morton Street, off Seventh Avenue, and finding work as a janitor. Carr remained friendly with him but avoided any contact that might be misconstrued. He introduced Ginsberg to him, and it was at the Morton Street apartment on a subsequent visit that Ginsberg met a friend of Kammerer's from St Louis called William Seward Burroughs, a tall, thin, thirty-year old with flattened-down hair and little round spectacles.

Burroughs had a sharp intellect, a dry, iconoclastic wit and a small private income which had allowed him to move to New York with no particular goal in life other than to pursue his love for reading and satisfy his fascination for guns, knives, drugs, criminals and low-life in general. For a teenager like Ginsberg, who was just poking his head out into the world, Burroughs was a stimulating discovery. Here was a man who had studied literature and anthropology at Harvard, psychology at Columbia and medicine in Vienna, and who had opted to work as a bartender in the Village in order to be closer to the rough edges of city life.

The key ideas that would characterize what would become known as Beat thinking were slowly coming together. When Jack met Burroughs at Edie's apartment, he was already aware that this mild-looking man had turned his back on a respectable mid-Western background in order to hang out with petty criminals, hookers and junkies in the more dangerous parts of New York City. It was probably a conscious rejection of his upbringing and his Ivy League education that led to Burroughs' fascination with these social outcasts. Jack recognized that he shared this interest himself – he believed that only by 'slumming it' was it possible to grab the whole variety of human experience. Both men felt that those forced to live outside the law were purer than those who conformed because they had resisted the demands of a corrupt society. Jack was later to accord a special reverence to the poor and discarded – the 'desolation angels' and 'fellaheen' – because he believed that they were open to revelations that others weren't.

Burroughs' thinking had been influenced by the French symbolist poets Rimbaud and Baudelaire, who escaped their bourgeois Catholic backgrounds during the nineteenth century by revelling in decadence.

STUDENT IS SILENT ON SLAYING FRIEND

Held Without Bail After He Listens Lackadaisically to Charge in Stabbing Case

Clasping a copy of "A Vision," a philosophic work by W. B. Yeats, under one arm, Lucien Carr, 19-year-old Columbia sophomore, listened lackadaisically to the proceeding as he was arraigned yesterday morning before Magistrate Anna M. Kross in Homicide Court. He was held without bail for a hearing on Aug. 29.

The pale, slender youth showed little interest as Detective James O'Brien presented a short affidavit charging him with homicide for having fatally stabbed on Monday David Kammerer, 33-year-old former instructor at Washington University, St. Louis, with whom he had been friendly. His attorney, Vincent J. Malone, told the court that the defendant had nothing to say.

Court Asks Psychiatric Test

Magistrate Kross asked Mr. Malone whether he had any objection to having Carr sent to Bellevue Hospital for psychiatric observation at this time. Mr. Malone replied that he did object and would prefer to have the case follow the usual channels. Jacob Grumet, a⸻

HELD FOR HOMICIDE

Lucien Carr as he was arraigned yesterday.
The New York Times

day. Appearing greatly concerned at the high bail set, he pleaded with Judge Sullivan to reduce it to a point that his parents, who live in Ozone Park, Queens, might⸻

Columbia Student Kills Friend And Sinks Body in Hudson River

By FRANK S. ADAMS

A fantastic story of a homicide, first revealed to the authorities by the voluntary confession of a 19-year-old Columbia sophomore, was converted yesterday from a nightmarish fantasy into a horrible reality by the discovery of the bound and stabbed body of the victim in the murky waters of the Hudson River.

For twenty-four hours previously the police and the district attorney's office, balked by the absence of ⸻

But with the discovery of the body yesterday afternoon, which the slender, studious youth unshakingly identified as it was lifted from the water, and after he had led detectives to the spot where he had buried his victim's eye glasses in Morningside Park, the investigators knew that they were dealing with a real homicide and not the imaginings of an overstrained mind.

Lucien Carr, 19 years old, son of ⸻ prominent in ⸻ living in this ⸻ who admitted ⸻ authorities said ⸻ of Russell Carr

Page 13

David Eames Kammerer

STUDENT MURDERS FRIEND, SINKS BODY

Continued From Page 1

of 419 East Fifty-seventh Street, and of Mrs. Carr, who is separated from her husband and lived with her son at 421 West 118th Street. At that address, however, the superintendent denied knowing them.

Young Carr, who had just completed his freshman year and em⸻ ⸻

detectives to the spot and after a few minutes of fumbling around located the glasses and handed them to the investigators. Then he accompanied them to the scene of the killing, where he re-enacted, as far as he could, the grim events that had taken place there.

More inclined to believe him than previously, but still at a loss as how to proceed, the investigators took him back to the district attorney's office. Then, at 2:30 P. M., came the news that a Coast Guardsman had seen a body floating in the Hudson River off 108th Street.

By the time the marine police and the Coast Guard had retrieved ⸻

Kammerer's Parents Prominent

Special to THE NEW YORK TIMES.

ST. LOUIS, Aug. 16—David Kammerer was the son of socially prominent Mr. and Mrs. Alfred L. Kammerer of Clayton, Mo., a suburb of St. Louis. His father is a consulting engineer. The son was graduated from John Burroughs School here in 1929 and from Washington University in 1933.

After some teaching experience

Rimbaud believed that the poet became a true visionary by a systematic 'deranging of the senses' and by absorbing all 'poisons'. William Blake, another of Burrough's favoured writers, had coined the maxim, 'The road of excess leads to the palace of wisdom.'

Jack and Ginsberg became willing pupils in Burroughs' hands – gazing open-mouthed at his bookshelves, which groaned with European classics, and drinking in his worldly wisdom. They both adhered to the lists of suggested reading he gave them which included Kafka, Cocteau, Apollinaire, Nietzsche and Oswald Spengler. Like the character Francis Martin in *The Town and the City*, Jack no longer felt alone with his dissatisfactions about 'society and its conventions and traditions and grievous blotches', after discovering that 'a whole coherent language had sprung into being around this restless, intelligent, determined trend, this gentle, invisible revolt in America'.

By the summer of 1944, Kammerer's obsession with Lucien Carr had intensified. He made drunken threats to Carr's girlfriend, Celine, and threatened to kill himself if his affection for Carr was not reciprocated. On the night of August 13, he tracked Carr down in the West End Bar on Broadway and the two men went walking though the nearby Riverside Park. When they sat on a bench to talk, Kammerer suddenly went berserk and attempted to rape Carr, saying that if he couldn't have Carr then he would rather they both died. A fight ensued, during which Carr pulled out a pocket penknife and stabbed Kammerer twice through the heart. Panicked by what he had done, he dragged the bleeding body to the side of the Hudson, tied the legs and hands together with his shoelaces, weighted it with rocks strapped in place with strips of Kammerer's shirt and rolled it into the flowing water. Carr then contacted Burroughs and Jack and told them what he had done. Burroughs advised him to get himself a good lawyer and then hand himself in to the police. Jack thought he was being more immediately practical by agreeing to act as a lookout while Carr disposed of the murder weapon down a sewer grating on 125th Street and then buried Kammerer's glasses in Morningside Park. To ease the tension, they then went for a drink, visited the Museum of Modern Art and took in a movie.

Two days passed before Carr gave himself up to the police, by which time Kammerer's body had been found floating near 108th Street. Carr was immediately arrested and held without bail. The story of the nineteen-year-old sophomore who had murdered his friend made newspaper headlines

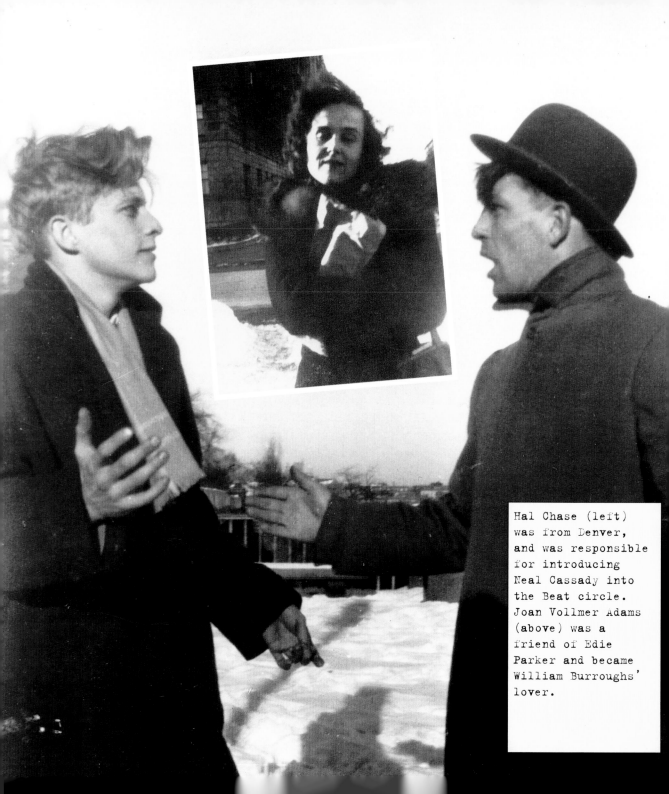

Hal Chase (left)
was from Denver,
and was responsible
for introducing
Neal Cassady into
the Beat circle.
Joan Vollmer Adams
(above) was a
friend of Edie
Parker and became
William Burroughs'
lover.

in New York. Burroughs and Jack were hauled in as material witnesses, because they had both known about the crime but had failed to report it.

Jack found himself languishing in Bronx County Jail, trying to raise money for his bail. This disgrace vindicated Leo Kerouac's view that his son had been slowly corrupted by bad company, so he refused to help out. Edie's family was willing to come through with $2,500, but on the condition that she and Jack married. Though Jack and Edie loved and respected one another, marriage had never been a serious option. Edie was still fleeing from everything that reminded her of her respectable bourgeois background, and Jack juggled affairs and one night stands to avoid having to commit to a single relationship. But the possibility of imprisonment for Jack was incentive enough for them to give it a try.

On August 22 1944, Jack was driven from jail to City Hall, where he and Frankie Edith Parker were married. Lucien Carr's girlfriend, Celine, acted as maid of honour, and a detective stood in as best man. The reception was a round of drinks in a nearby bar and there was no honeymoon because Jack had to return to his cell and await the arrival of the $2,500. Carr pleaded guilty two days later to second-degree manslaughter, and was sentenced to an indefinite period at Elmira Reformatory (he was released in 1946). Jack's bail money was produced as expected and, after a brief spell in New York, he joined Edie at her family home in Grosse Pointe. However, life in Michigan didn't suit him. He found it dull and uninspiring after the danger and stimulation of New York and he tired of Edie's mother asking him whether he would ever be a best-selling author like Pearl Buok. He also managed to catch a bad case of the mumps which affected his testicles and caused him to worry that he might become sterile. Jack worked long enough as an inspector in the Fruehoff trailer factory to pay Edie back the bail money and then he headed back to New York.

For a time it looked as though his sham marriage to Edie was over, but in due course Jack invited her to join him in a five bedroom apartment that Joan Vollmer Adams had taken over at 419 W. 115th Street. Here the old gang, minus the imprisoned Carr, gradually regrouped. To everyone's amazement, the homosexual Burroughs began a passionate affair with Joan Vollmer Adams. Ginsberg, who had been suspended from Columbia for writing obscenities on the window of his room and who was now subject to psychological testing, took a room. There were also new lodgers: red-haired Vickie Russell, girlfriend of an aspiring hoodlum named Bob Brandenberg, and Hal Chase, an anthropology student from Denver.

Herbert Huncke, photographed in 1944. Huncke was a Times
Square hustler and petty thief, who introduced Burroughs to
heroin and Jack to the word 'beat'.

Jack sensed what he would later describe as 'a low, evil decadence' developing in and around the apartment. Vickie showed them how to extract the Benzedrine-soaked blotter strips out of ninety-eight cent inhalers, roll them into balls and swallow them with a cup of coffee to produce amphetamine highs that would last as long as eight hours. Burroughs was allowing his underworld friends to hide stolen goods in his room, and was experimenting wildly with drugs. According to Ginsberg, Jack had give him his first homosexual experience by masturbating him in the open air beneath the West Side Highway.

A catalyst of this decadent period was Herbert Huncke, a thirty-year-old bisexual, drug addict and thief who hung around Times Square at night, and had been introduced to Burroughs. 'Burroughs had a submachine gun and a box of morphine syrettes which had been passed to him by some hustler,' says Huncke. 'He didn't know what to do with them, and Bob Brandenberg had suggested that I might be a good person to get in touch with.' When Burroughs met Huncke and his friend Phil White, he found himself in exactly the kind of low-life milieu that excited and interested him. Both men were morphine users who financed their habits by stealing. Their friends were hookers, drag-queens, junkies, pimps, thugs and small-time gangsters. It was in the company of Huncke and White that Burroughs took his first shot of morphine.

Impressed by their lifestyle, Burroughs moved down to the Lower East Side to be near Huncke and White, and began to join White in attacking drunks on the subway and stealing their money. One afternoon, he arranged for Jack to come down to Washington Square to meet Huncke. 'At that time, Jack still looked like a real all-American boy,' remembers Huncke. 'He looked like one of those clean-cut fellows with neat hair who used to advertise Arrow shirts. He was a little suspicious of me that day, but soon loosened up and would come with Burroughs to meet me at my apartment on Henry Street.' In turn, Huncke was taken up to Vollmer Adams' 115th Street apartment, where he met Ginsberg and Hal Chase. 'I guess I was unusual to them,' he admits. 'I was an oddball. They'd never ever met anyone quite like me, and they didn't understand a lot of things that were going on. It was a whole new ball game.'

It was from Huncke that Jack first heard the word 'beat' used to mean beaten-down or exhausted. 'I used this expression which was, "Man, I'm beat!", which meant that I was tired,' remembers Huncke. 'It was a favourite word of mine and easy to pick up on. There was no big mystery about what was being referred to but they had never heard things like

that.' But the possible meanings of the word intrigued Jack. He came to perceive it as the feeling which characterized all those people he identified with, who had been beaten down and relegated to the margins of society. It was a feeling that linked the poor blacks he'd seen in Virginia with the junkies, queers and madmen he'd met in New York. 'We heard the word from him (Huncke),' Jack confessed. 'To me, it meant being poor - like sleeping in subways, like Huncke used to do - and yet being illuminated and having illuminated ideas about apocalypse and all that.'

This identification with society's cast-offs was to become a key to Beat writing. Broadly speaking, Jack was intrigued by hobos and the racially stigmatized, while Ginsberg was intrigued by sexual outlaws, and Burroughs by criminals and drug addicts. This was partly because they saw these social groups as having rejected mainstream America, and partly because they believed that a new vision of life would only emerge once the veneer of 'civilized values' was stripped away.

The Christian doctrine of original sin, which had inspired so many of the traditional values of America, was tipped on its head. In Christian thinking, humans were tainted by 'original sin' and needed the 'common grace' of civilization to restrain them and the 'special grace' of Christ to save them. In Beat thinking, humans were essentially 'holy' beings who had been corrupted by civilization and could be saved by rediscovering their original natures.

Ginsberg was by now in love with Jack, but Jack gave himself exclusively to no one. During 1944 his childhood sweetheart Mary Carney had married an airman, Raymond Baxter, who was sent to England shortly afterwards and didn't return until 1946. Jack continued to see Mary during visits to his old home town.

On September 23 1945 Mary gave birth to a daughter, Judy, and it was rumoured in Lowell that Jack had been responsible. 'She would never tell me who the father was,' says Baxter. 'Even when we got divorced in 1948 she wouldn't reveal his identity to my lawyer or the judge in court. All I know is that it certainly wasn't me.'

Judy, who was 28 before she realized she had been conceived during an extra-marital affair, still does not know the identity of her father. Under pressure, Mary told her that the rumour about Jack was true, but there has never been any corroborative evidence. All that Mary ever said publicly about the relationship was that, 'There was something deep between Jack and me, something nobody else understood or knew about.'

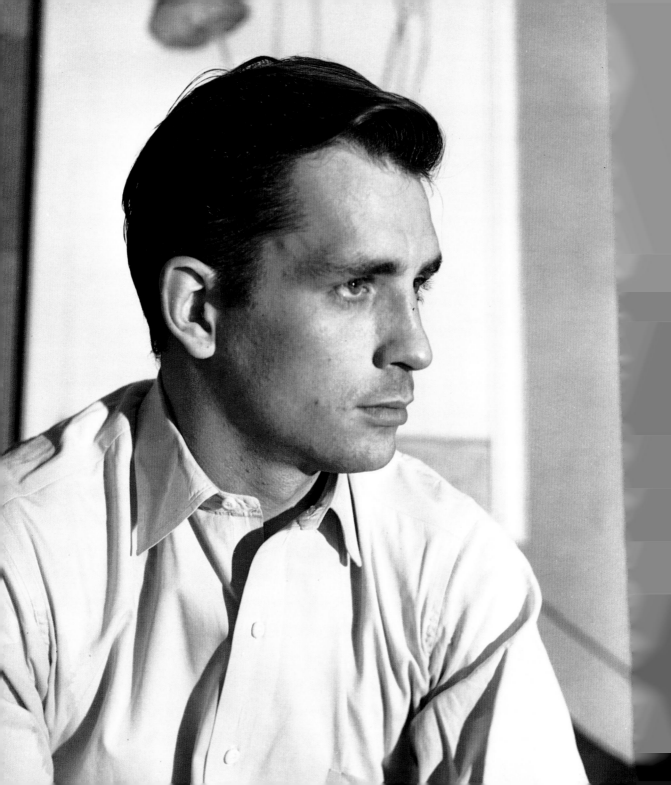

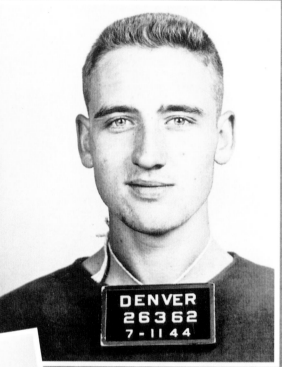
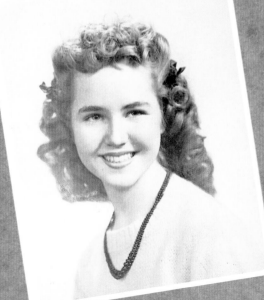

Neal Cassady (above),
photographed by the
Denver Police Department
after his third arrest
for car theft. Two years
later, after serving
time in a reformatory,
he arrived in New York
with his teenage bride
LuAnne (left) and
galvanized Jack and
Ginsberg with his lust
for life and learning.

Jack apparently never alluded to having given her a child either in his writing or in private conversation.

'It was like a love story gone wrong,' says Judy. 'I think there was always a bond between them. I never heard her say a bad word about him. She thought he was a nice, bashful kid who was very misunderstood. I think what kept them apart was the life he led - the writing and the travelling.'

Jack began to spend more time with Hal Chase who had been introduced to Columbia by Justin Brierly, a high school teacher from Denver, who was also a trained lawyer, a director of the Central City Opera House Association and a committee member for the local Ivy League Scholarship Board. A Columbia graduate, Brierly did his best to spot bright students and put them in touch with his university contacts. Chase had been one of his protégés.

Another boy that Brierly had been interested in was Neal Cassady, a poor boy from the Denver slums, whose mother had died and whose father was an alcoholic who had brought up his son in rooming houses and residential hotels. Brierly had been sexually attracted to Neal, and managed to entice him into his first homosexual experience. However, Neal remained voraciously heterosexual, sometimes finding several sexual partners in a single day.

Neal was noted for his tremendous energy and charisma. He was tough and streetwise enough to appeal to men, and charming enough to win over women. He was an exotic character who spent many of his daytime hours in Denver Public Library reading literature and philosophy, and then hustled, conned and played pool in the evenings. By the age of nineteen he claimed to have stolen over 500 cars. 'He wanted to know everything, do everything and know everyone,' says LuAnne Henderson, who married him when she was sixteen. 'You never saw him without three or four books under his arm. He'd be talking and reading and playing pool and making eyes at the women, all at the same time! He just swept everyone off their feet.'

Chase was convinced that Neal would be a good foil for Jack, because both were essentially heterosexual, sports-loving, working-class boys who loved literature and ideas. He showed Jack some letters that Neal had written him begging for a place at Columbia. In the summer of 1946, back home in Denver, he showed some of Jack's letters to Neal. The first meeting between the two should have taken place in the autumn of 1946, after Chase had persuaded three of his tutors to meet Neal.

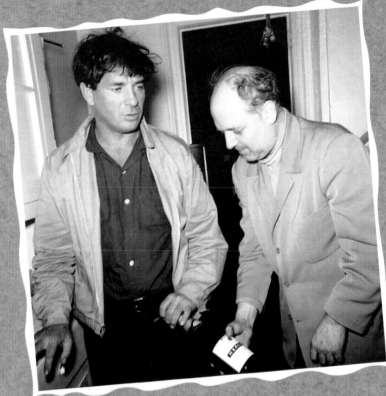

Novelist Thomas Wolfe (near right) and jazz musician Lester Young (far right) were acknowledged as influences on Jack. Record producer Jerry Newman (with Jack, above right) steered him towards good sounds in New York. Judy Baxter (above) was told by her mother , Mary Carney, that Jack was her father.

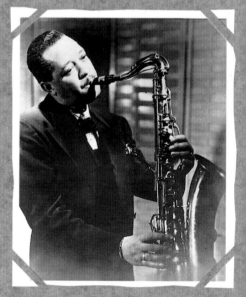

equivalent of a High School diploma, but Neal chose to let Chase down and simply did not turn up.

By the end of 1946 Jack was ready for change. The 115th Street apartment was fast degenerating. Chase had moved out, and Huncke and Phil White had moved in. Burroughs had been arrested for forging prescriptions; Joan was sent to Bellevue Hospital suffering from acute Benzedrine psychosis; and Huncke was later sent to Bronx County Jail for drug possession. Ginsberg went to live with an Irish family on W 92nd Street.

In three or four years, Jack had changed from a well-muscled athlete into a paunched and puffy drug-user. The excessive Benzedrine use had caused blood clotting in his legs, and he was hospitalized with thrombophlebitis - a problem that would stay with him thoughout his life. In Queens General Hospital he began to brood about the prospect of his own death and the apparent meaninglessness of life in the face of death. The thought made the student discussions around Columbia seem like mere 'intellectual posturing'.

These dark feelings were intensified as Jack watched his father die of cancer of the spleen. He sat with Leo in Ozone Park and was grieved that one of the few people who loved him and cared for him was enduring so much pain. When he died in his son's arms, Leo's last words were: 'Take care of your mother, whatever you do.' His body was taken to Nashua, New Hampshire, and buried beside Gerard's.

Jack was devastated. Although Leo had disapproved of the way he'd been leading his life and of the way he seemed to be squandering opportunities, Leo had remained fiercely proud, and had wanted to see Jack lifted out of the gutter he'd been forced to live in. In Jack, he must have seen a lot of himself - his love of independence, his suspicion of authority, his curiosity, his love of ordinary working-class companionship and his yearning for a vanished America. In the loneliness that followed his father's death, Jack was reminded of Christ's cry from the cross: 'Father, father, why hast thou forsaken me?'

He coped by throwing himself into the writing of a new novel, *The Town and the City*, a Wolfean epic spanning his life from Lowell to New York. Each day, as he sat down to write, he would compose a hymn or a prayer and would pin it up in front of him. In his diary he wrote, 'When this book is finished, which is going to be the sum and substance and crap of everything I've been thru throughout this whole goddam life, I shall be redeemed.'

5

On
the
Road

Jack began to pore over maps and study books about the great pioneers of American History. He had long dreamed of travelling West, and the names of the cities and states excited his imagination - just as they had done when he first heard Bobby Troup's song 'Route 66'. However, it wasn't Route 66 that Jack planned to travel, but Route 6, which cut across from Cape Cod to Los Angeles.

Neal Cassady and his wife LuAnne (below) arrived at New York's 50th Street Greyhound Terminal (left) in December 1946 and were immediately dazzled by the glamour of New York.

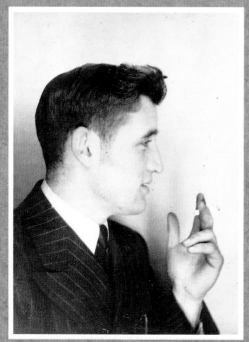

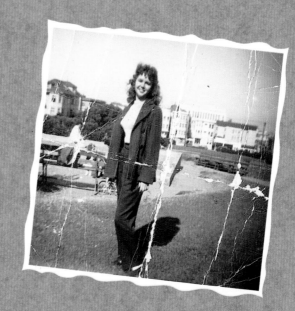

Neal Cassady finally blew into New York in December 1946
and with his arrival, as Jack would later remember, 'began the part of
my life you could call my life on the road.' After twenty-five years in
the town (Lowell) and the city (New York), Jack was ready to drink in
America, just as Jack London and Thomas Wolfe had done before him. For
the next decade he would travel restlessly from coast to coast,
propelled by equal doses of boredom and curiosity, always hopeful that
at the next destination he would be handed the pearl that would make
living worthwhile.

Cassady had decided on the spur of the moment to 'borrow' a
relative's car and drive east with his teenaged bride, LuAnne, to meet
the men whom Hal Chase had so vividly described in his letters from New
York. The couple hit a blizzard in New Platte, Nebraska, and were forced
to make the rest of the journey by bus. They finally arrived in
Manhattan at the Greyhound Terminal on W 50th Street. 'We spent at least
the first four hours in Times Square,' remembers LuAnne. 'You could see
the hay sticking out of our hair! We were just so awed by everything,
because at the time Denver was just like a big town. At first, we had
trouble getting a hotel room because I had no identification and no one
would believe we were married. In the end, Neal had to check in and then
sneak me up later.

'That night, Neal told me all the things that were going to happen.
He was going to go to Columbia and he was going to teach me everything
in the world that he knew and was going to know. It was a wonderful
night, a magical night. We talked all the time, we got no sleep and
neither of us minded a bit.'

The next day, they caught up with Chase at his Columbia hall of
residence and then the three of them went to the West End Bar to meet
Jack. For a fabled first meeting it was unmemorable, because there
were others present (Ginsberg, budding writer Alan Temko and Denverite
Ed White) and Jack and Neal were sizing each other up. White and Temko
had met Neal before and were not great admirers. They thought he was a
parasite who abused women, and they didn't think there was anything
glamorous about his life of crime.

'Neal and I were sitting in a booth with Allen Ginsberg, Alan
Temko and Ed White when Jack came walking in,' says LuAnne. 'Allen was
all excited, because Jack was the one he wanted Neal to meet, but Jack
was so shy and quiet. He watched and listened but didn't really
participate.'

Ginsberg was smitten by Neal and began to dominate the new arrival. He arranged to take Neal and LuAnne around the city, and they spent hours discussing art, literature and philosophy. Jack didn't get a look in until the Cassadys moved into an East Harlem apartment owned by Temko's cousin. Significantly, it was their meeting at this apartment which Jack chose to present as their first meeting when he wrote *On the Road*, rather than the encounter at the West End Bar.

This time, Ginsberg wasn't around. When Neal opened the door to Jack, Chase and White he was naked (he was given shorts in the book), and a similarly naked LuAnne could be seen retreating in the background. He asked his guests to wait outside for five minutes until he'd finished his business with his wife. This impressed Jack, confirming to him that Neal was every bit the sex-machine, the 'holy con man with the shining mind', that Chase had led him to believe he was. The meeting turned into an all-night rap, during which both men saw in each other the parts missing from themselves. The naturally reserved Jack could admire Neal's fierce energy, while Neal could admire Jack's dedication as a writer. Neal imagined himself as a student and author, but knew he would never have the self-discipline to do either. Jack would have liked to have been one of the 'mad ones' (as he would refer to them in *On the Road*) who never said a 'commonplace thing', but he was by nature an observer, rather than an initiator, of action.

In class, appearance, interests and sexuality, Neal was a more obvious companion for Jack than either Ginsberg or Burroughs. Growing up in Lowell, Jack had been forced to choose between his sports buddies and his discussion-group friends, and it bothered him that his life had split in this way. In Neal there was a reconciliation of the streetwise and physical with the philosophical and literary. Neal would shoot pool, steal a car and go home to read Shakespeare, all in the same day. 'They both envied each other for their opposite traits,' says LuAnne. 'Jack was everything Neal would like to have been. He had gone to college and came from a stable family – whereas Neal was practically an orphan – and he was writing a novel. Jack, on the other hand, was envious of Neal's energy, his powers with people, his charm and especially his total freedom. Whatever struck Neal – that's what Neal did. There were no limits as far as he was concerned. Jack and he just came together and they were truly brothers.'

Neal stayed in New York until March 1947, at first sending LuAnne out to work in a bakery to support them, and later taking work himself

in a parking lot. LuAnne returned early to Denver under strange circumstances. When Neal came back from work one night, she told him that the police were looking for him and that they had visited the apartment. This wasn't true, and even as the words left her mouth she had no idea why she was saying it. Neal, who had a thousand reasons for not wanting to meet the police, panicked, left the apartment and went into hiding. When he didn't return, LuAnne went back home.

'Even to this day I don't know why I did what I did,' she says now. It wasn't something that I had planned. I don't know whether it was because I was frightened. Everything was fine in my life. Neal and I were living in New Jersey, I was working, I adored Neal and I'm sure he loved me. He was with other women all the time but that was something I accepted. I knew how he was.'

After a few days of hiding, Neal came back to the city and began spending more time with Ginsberg, who was desperately in love with him. Neal was aware of this but, he reckoned that he could tolerate Ginsberg's advances in return for the free education he was getting through their long, intense conversations.

When Neal finally took the Greyhound bus back to Denver, *en route* he wrote to Jack for the first time and rekindled their friendship. On March 7, sitting in a bar on Market Street, Kansas City, he scrawled an 800-word letter describing two seductions (one successful) that he'd attempted on the journey so far. The letter came as a revelation to Jack. Not only was it frank in its subject matter, but it also perfectly captured Neal's unstructured way of rapping, and suggested to Jack a literary style that could help him break the bonds of the formalism he had inherited from the influences of London and Wolfe.

During the summer of 1947, still working on *The Town and the City*, Jack found himself left alone in New York. Chase, White and Temko had left for Colorado, while Burroughs and Joan Adams were in Texas growing marijuana and Ginsberg had found work in a Denver store so that he could be close to Neal.

Jack began to pore over maps and study books about the great pioneers of American history. He had long dreamed of travelling West, and the names of the rivers, cities and states excited his imagination – just as they had done when he first heard Bobby Troup's song *Route 66*. However, it wasn't Route 66 that Jack planned to travel, but Route 6, which cut across from Cape Cod to Los Angeles. He was going to hitchhike to Denver and meet up with Neal.

The attractive and
vivacious LuAnne (left)
was fictionalized by
Jack as Marylou in *On
the Road*. William
Burroughs (below)
became Old Bull Lee.

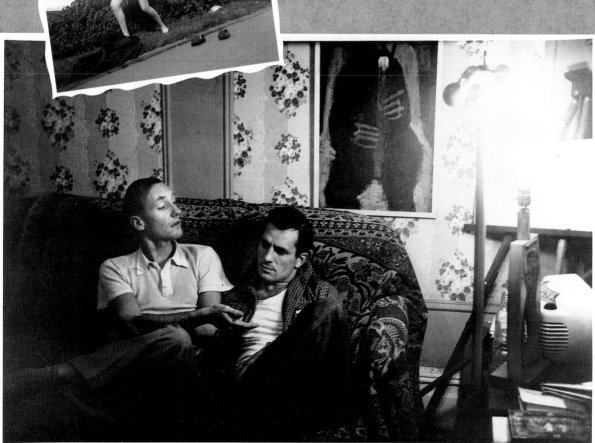

"But Jack I've told you before, if you continue your present pattern living with Mémère you'll be wound closer & closer round her apron-strings till you're an old man..." William Burroughs acting as André lidian sophisticate yapping at the all-American serious Thomas Wolfean youth Jack Kerouac thoughtfully listening, attentive to "the most intelligent man in America" for a funny second in the living room, 206 East 7th Street. On, Bill: "Undoubtedly you realize this Buddhist 'Second Religiousness of the Fellaheen' you've gotten from Spengler's *Decline of the West* may provoke high-teacup literary critics of the Future to more vicious attacks on your spontaneous prose genius than your poor French-Canadian family heart can imagine, take it from an old Queen dearie!" Manhattan September-October 1953.
Allen Ginsberg

His first attempt, on July 17, was aborted when, after five rides, he found himself stuck in a rainstorm on Bear Mountain Bridge, just a few miles up the river from New York City. He had to take a bus back and start again. This time, he decided to do the first leg of the journey by bus, and so he travelled out to Joliet, Illinois, by way of Chicago.

From Joliet onwards he hitchhiked down Route 6, flushed with the excitement of being on the open road. For the first time, he was seeing the American landscape he had loved in books and movies - the Rock Island railroad, the rolling waters of the Mississippi, the corn fields of Iowa and Illinois, the plains and valleys of Nebraska and the snow-topped mountains of Colorado. And he was meeting the real people of the land - cowboys, housewives, farmers, truck-drivers, hobos, oil men and ranchers. As he travelled, he made observations in small notebooks that he always kept in the breast pocket of his jacket. He wrote down snatches of conversations that he heard, described the landscape and reflected on his state of mind, aware that what he was experiencing would one day become the substance of his art.

Upon arriving in Denver he was disappointed to discover that the Columbia gang hadn't held together. Chase, White and Temko had not pursued Neal since his return, and didn't even know where he was. Jack stayed at first in Chase's family home, and then moved in with Temko, who was living in a luxury apartment owned by White's parents. It was only after ten days that he tracked Ginsberg down and then found Neal.

In the six months since leaving New York Neal's life had, predictably, become more complicated. He had started a serious affair with Carolyn Robinson, a fine arts and theatre student from the University of Denver, and had persuaded her that he was on the brink of a divorce from his wife. 'The day I met Neal, he told me he was married,' says Carolyn, 'but that night he came to see me at the resident hotel I was living in and said he was breaking up with LuAnne. The next morning, he was there saying that they just weren't going to make it and that I'd be much better for him. To my old-fashioned notions, if he said it was over, it was over.'

But Neal and LuAnne's relationship was far from over. After visiting Carolyn every night and convincing her that she was the only woman for him, Neal was returning to LuAnne, who knew nothing of the affair. He was also spending a lot of time with Ginsberg - swallowing doses of Benzedrine, sitting cross-legged on a bed and confessing his deepest secrets. Ginsberg was keeping a detailed journal and starting to

Jack hitchhiked down
U.S. 6. In Davenport,
Iowa (below), he had
his first glimpse of
'my beloved
Mississippi River'.
In Longmont,
Colorado, he lay
outside a gas station
(left) and
contemplated the
Rockies.

write a poem, which he was calling *Denver Doldrums*. 'This would have been Allen's idea because Neal wasn't into sitting down, let alone sitting cross-legged on a bed,' says Carolyn. 'Allen was the wimpiest-looking wimp you had ever seen at that time, but Neal desperately wanted to know men who were interested in ideas.'

So fascinated was Neal by the workings of Ginsberg's mind that he neglected Jack somewhat although he did introduce him to his friends Al Hinkle and Bill Tomson, and took him to see the Skid Row section of Denver where he had been raised. He told Jack that Carolyn was going out to California at the end of the summer, and that while she was away he was planning to drive to Texas with Ginsberg to see Burroughs and Joan Adams on their farm.

Jack realized that his time in Denver was drawing to a close. He had promised to meet up with Henri Cru in San Francisco, where they both planned to try to get work on one of two boats sailing around the world through the Far East, India, Africa and the Mediterranean. He took a bus from Denver and crossed through Utah and Nevada before setting eyes on California for the first time.

His journey ended on Market and 4th in San Francisco where he stood and marvelled that he was now 3,000 miles away from home. He already had a particular affection for San Francisco because of Jack London, who had lived and worked there before his premature death in 1916. 'San Francisco is the last great city in America,' Jack would say. 'After that (there is) no more land. It was where poets and bums could come and drink wine in the streets.'

London was an important role model for Jack because he had been self-educated and had worked as a labourer before making his fortune as a writer. He described himself as a 'rampant individualist', and had been a longshoreman, salmon fisher, patrolman, oyster pirate and a labourer in a cannery. He had even lived as a rail-riding hobo in order to experience the underside of American life. In 1916 London had written, 'I would rather be a superb meteor, every atom of me in magnificent glow, than a sleepy and permanent planet. The proper function of man is to live, not exist.' This passage must have influenced Jack's *On the Road* description of people like Neal, who burned like 'fabulous yellow roman candles exploding like spiders across the stars and in the middle you see the blue centrelight pop and everybody goes "Awww!"'

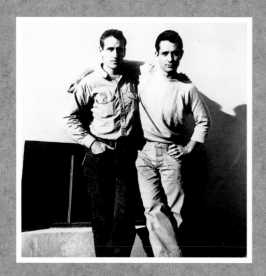

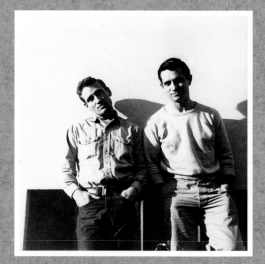

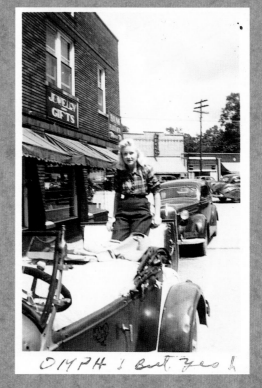

The relationship between Jack and
Neal Cassady (above and top)
provided the impetus for the *On
the Road* period. Carolyn Robinson
(right), pictured in 1940, was
to exercise a powerful attraction
over both men.

Henri Cru was living across San Francisco Bay in Mill Valley, where he had taken temporary work as a security guard. Jack joined him and his girlfriend at their hillside shack. During the first week of his time there he stayed in and typed up a 40,000 word screenplay, which he hoped to sell to a Hollywood contact of Cru's. During the next week, he joined Cru as a $50-a-week security guard, complete with badge, club and gun, patrolling a dormitory building in Sausalito for an overseas construction company.

The job on the ship never materialized. Cru took the screenplay to Los Angeles but his director-friend barely looked at it. Jack consoled himself by writing letters to Neal, Ginsberg, Burroughs and Carr, in which he discussed his writing and his plans to meet up with them in California or New York. He confessed to Neal that he felt he was poised to be the Boswell or Balzac of his time, chronicling daily life in an age of important change.

Early in October, he hitchhiked south – just missing Neal, who had come to San Francisco to be with Carolyn Robinson. Two rides took him 400 miles to Bakersfield, where he met a young Mexican girl on her way to Los Angeles by bus. They linked up and lived together for the next two weeks; first in a hotel in Hollywood and then in Selma, where they worked as cotton-pickers. There were vague plans to meet again in New York, but they both knew it was a relationship born of lust and convenience and waved farewells down a dusty track as Jack headed for the main road. He hitchhiked to Los Angeles before taking a bus to Pittsburg, where his money ran out.

He then hitchhiked back to his mother's home in Ozone Park and began work once again on *The Town and the City*, which was turning into an epic novel. By the end of 1947 he had written 280,000 words and was planning to write another 30,000. At the same time, he received a letter mailed from San Francisco in which Neal outlined a literary theory he was developing. He said that all rules, self-conscious styles, long words and 'lordly clauses', should be ditched in order to allow a pure communication of feeling. This appealed to Jack, who already had the greatest admiration for Neal's writing and was similarly unimpressed with bookishness and what he referred to as 'tedious intellectualism'. He was trying to find a way to express himself which had the scope and insight of classic literature combined with the immediacy and popular surface of a comic book or a jazz record.

Ginsberg, too, was trapped by formalism and struggling to find a poetry capable of embracing his new outlook. In May 1948, he had a mystical experience in his East Harlem apartment which was to transform his outlook and, eventually, his poetry. He was reading from a book of William Blake and felt that he could hear the actual voice of the eighteenth-century poet reciting the words, then everything both inside and outside the apartment blazed with a sudden intensity. 'I had the impression of the entire universe as poetry filled with light and intelligence and communication and signals,' he later explained. 'Kind of like the top of my head coming off, letting in the rest of the universe connected to my own brain.'

His initial reaction was to tell a rather startled woman in the next apartment that he'd just 'seen God'. He then returned to Paterson to tell his agnostic father. Many of his friends were convinced that he needed further psychiatric help, but Jack was not a sceptic. He had never lost the belief in God that had been taught to him as a child, and, although Ginsberg's experience was of something more impersonal he could relate to it.

In the same month that Ginsberg had his Blake vision, Jack completed *The Town and the City*. It now ran to a massive 380,000 words and had taken him two-and-a-half years. Ginsberg was so impressed by it that he volunteered to show it to influential literary people in New York.

Jack's evocation of the American landscape (left) has given *On the Road* an enduring appeal. In one of the book's most quoted passages he stands 'at lilac evening' on Denver's Welton Street (right) 'wishing I were a Negro, feeling that the best the white world had offered was not enough ecstasy for me ...'

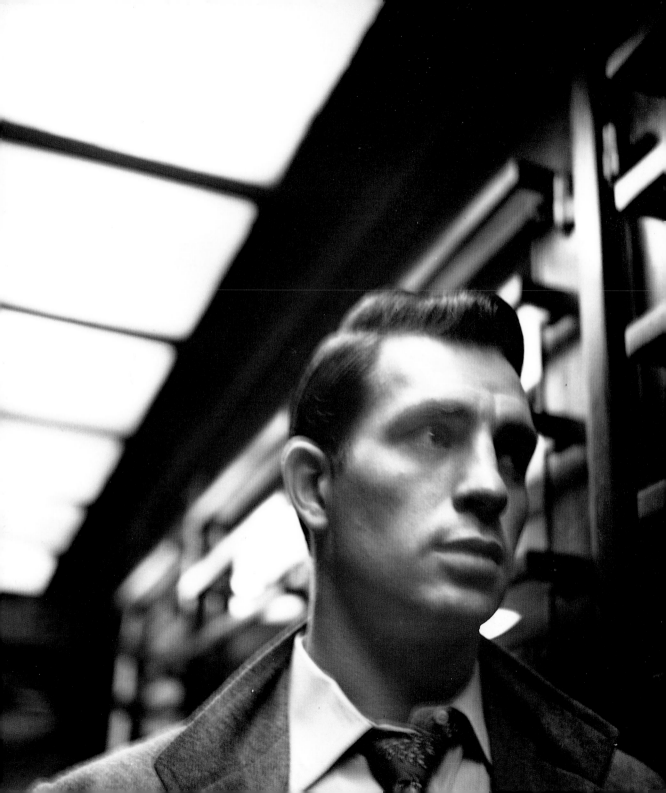

San Francisco Blues

While he dreamed of a ranch in California, the reality of Jack's life was that he was still living at home with his mother, who was having to work in a shoe factory to support him. It seemed incredible to his friends that a man of twenty-six was spending half his life as a travelling adventurer and the other half unemployed, living with his mother in the suburbs.

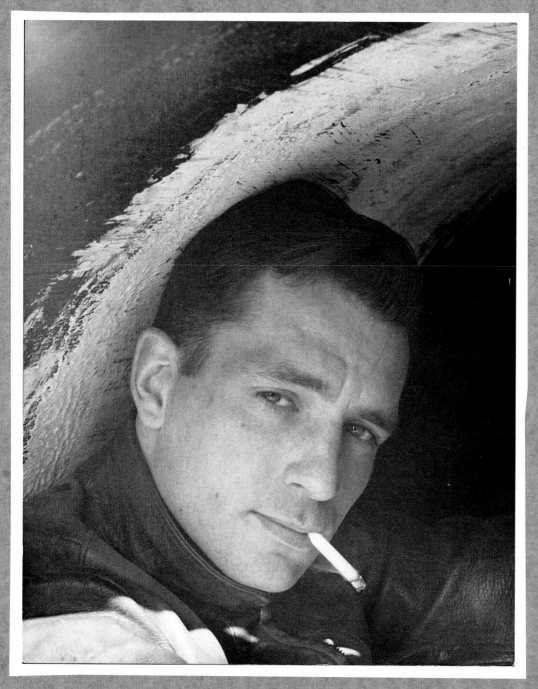
Jack photographed in 1949 by Wilbur T. Pippin.

In *On the Road*, Jack glossed over his life in 1948

with the single sentence: 'I stayed home all that time, finished my book and began going to school on the G. I. Bill of Rights.'

He didn't have the money to do much else, because all his hopes were pinned on the potential publication of *The Town and the City*. He fantasized about a large publishing advance and being asked by a Hollywood producer to write the screenplay. With his new-found wealth he intended to buy a ranch in Northern California where he could raise cattle and grow corn, surrounded by his family and friends.

The letters he wrote at this time are littered with dreams of moving on to other places and starting a new life, but nearly all of his aspirations were impractical. 'He was a perfect example of a Pisces,' says Carolyn Cassady. 'He lived in a fantasy world. His initial response to everything was always emotional. He expressed his opinions spontaneously and they often conflicted with each other. He never followed a single thread, and it's this habit of inconsistency that makes it so hard for people to determine what he actually thought.'

While he dreamed of a ranch in California, the reality of Jack's life was that he was still living at home with his mother, who was having to work in a shoe factory to support him. It seemed incredible to his friends that a man of twenty-six was spending half his life as a travelling adventurer and the other half unemployed, living with his mother in the suburbs. Burroughs once told him that Jack's main problem was that he couldn't cut the apron strings. Jack was badly stung by this remark, and Carolyn Cassady still defends the nature of his attachment to Gabrielle. 'I don't think it was a case of apron strings,' she says. 'I think it was simply that when he was with her he could be totally himself. He didn't need to be shy and embarrassed like he was so often in life. He could say anything he wanted and know that she would still understand him and love him. He could do that somewhat with Neal, but with his mother he just let it all hang out.'

Jack's life became more active again when Burroughs and Ginsberg roared back into town. Together, they visited art galleries, went to jazz clubs and found themselves on a circuit of art crowd parties where they met the poet W. H. Auden and painters Jackson Pollock and Larry Rivers. It was at one such party that Jack met John Clellon Holmes, an aspiring novelist who lived with his wife on Lexington Avenue, who was later to become an important apologist of Beat literature and a chronicler of the group's antics.

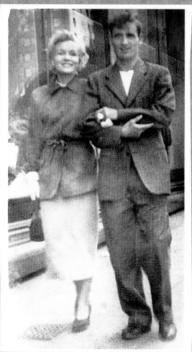

Women and automobiles (top) were two of Neal
Cassady's most powerful passions. He is
pictured (left) in San Francisco shortly
after marrying Carolyn Robinson. In 1949 he
drove Jack from North Carolina to California
in a newly purchased 1949 Hudson (above).

It was Holmes who put the term 'Beat Generation' into general ciruclation. Two or three months after meeting Jack, he was talking to him about the 'Jazz Age' of the 1920s and the 'Lost Generation' of the 1930s, and asked what term might eventually summarize the attitude of the people Jack was surrounded by. Thinking back to Huncke's term, 'beat', Jack replied, 'I guess you might say we're a beat generation', explaining 'beat' as 'a weariness with all the conventions of the world'. Four years later, Holmes wrote an article for *The New York Times* entitled 'This Is the Beat Generation', and Beat entered the public consciousness. It was Jack, though, who first put 'beat' into print, when in *The Town and the City* (1950) he referred to 'cats' and 'chicks' who wandered 'beat' around the city.

Both Jack and Holmes saw Beat as having a religious significance. As Jack saw it, to be Beat was to be in possession of secret knowledge. The Beat had stripped everything down to basics and didn't have to rely on society for self-image. He saw what was happening within his crowd as a fulfilment of Oswald Spengler's prediction that the decline of the West would produce what he called a 'Second Religiousness'.

There was, as yet, no coherent theology among the Beats, but there was a lot of talk about God. Ginsberg, the Jew, would talk about Western society being judged in a 'day of wrath' and the 'holiness' of the outcasts that peopled Times Square. Jack, the Catholic, wrote in his diary that the aim of his life's work would be 'to love God', and he would discuss 'visions' and 'angels' with Al Hinkle, who claimed to have experience of both. These words – 'holy', 'wrath', 'visions' and 'angels' – were to become used throughout Beat literature, later in combination with such Buddhist terms as 'dharma', 'satori' and 'nirvana'.

With *The Town and the City* out of the way, Jack began work on two new books – a dream-like reflection on his childhood called *Doctor Sax*, and a story that would have Neal Cassady as its central character. In October 1948 he started a course at the New School studying world literature, myth and creative writing.

Neal had managed to get his marriage to LuAnne annulled in Denver, and had married the already-pregnant Carolyn in San Francisco in April. Five months later, their daughter Cathleen was born, and with the help of Al Hinkle, who had now moved out to California, Neal got a regular job on the Southern Pacific Railroad. The family moved to a one-bedroom apartment on Alpine Terrace, and to Carolyn's delight Neal appeared to be settling down.

But Neal was far from tamed. In December, during a seasonal lay-off from the railroad, he bought himself a brand new Hudson and took off with Al Hinkle and Hinkle's new wife, Helen, to drive across America and bring Jack back to California. 'He had the whole trip covered,' says Carolyn. 'He had the car payments taken care of, he left enough money for me and my daughter, and said he was only going to be gone for two weeks. At the time, I thought he was deserting me, but later I realized that in his eyes he was being perfectly responsible, because he had no personal knowledge of normal family life. He didn't have the same frame of reference that most people had.'

The first stop on Neal's journey was Denver, where LuAnne was now living while waiting to get remarried to a sailor. 'It was three o'clock in the morning when I heard someone banging the door and shouting, "Open up,"' remembers LuAnne. 'I let him in, and he told me that we were going back to where we belonged. He was going to make me go with him. That was a wild trip.'

The group had hardly any money between them, but for most of the journey Neal managed to fuel the car for free by winding back the meters at gas stations, and they economized by sleeping in the car. Helen Hinkle, less than enchanted with being driven by the crazy Neal, decided to travel directly to Burroughs' home from Tucson, Arizona and meet up with Al there in two weeks' time.

Jack and his mother were in Rocky Mount, North Carolina, spending Christmas with his sister Caroline ('Nin') and her husband Paul Blake. When the mud-splattered Hudson arrived at the front door with LuAnne, Neal and Al Hinkle inside, Jack was completely overjoyed and invited them in to share the family turkey and all its trimmings.

Jack's sister was about to move back to New York, and in a burst of generosity Neal offered to help. After an initial trip, Al Hinkle and LuAnne were left at Gabrielle's Ozone Park apartment while Neal and Jack returned to Rocky Mount to pick up Gabrielle and the last of the furniture. After driving 2,000 miles in three days, Jack, Neal, LuAnne and Al Hinkle stayed in New York for three weeks of mad partying with Ginsberg, who was now working for Associated Press, and Lucien Carr. 'Something was happening every night, and everyone was drinking, talking and smoking pot,' says LuAnne. 'For a while, we stayed at John Clellon Holmes' place, and it was a continuous party. There would sometimes be up to a hundred people in that apartment, with music blaring, and John would be sitting there trying to type!'

(102)

Jack and LuAnne were attracted to each other, and though nothing had happened between them as yet Neal sensed that he might be about to lose his mistress. He subtly encouraged Jack to sleep with her, working on the assumption that if he appeared to be offering LuAnne to Jack, Jack would back off. It was a technique Neal was to practise all his life. 'Although I didn't know it at the time, this was one of Neal's defence mechanisms,' says LuAnne. 'Whenever he thought he was losing control over one of his women he would encourage the situation. Jack backed away because he was shy anyway and he knew that this wasn't really what Neal wanted.'

On January 19 1949 Jack, Neal, LuAnne and Al Hinkle left for California. Jack's reasons for going, as given in *On the Road*, were that he wanted to observe Neal at close quarters and that he fancied an affair with LuAnne. Both his wishes would be granted.

Despite the fact that there was snow on the ground and no heater in the car, Neal was dressed for the journey in a white T-shirt. The 1949 Hudson had already taken a severe battering. The windscreen-wipers had stopped and the fenders were dented after the car had crashed into a ditch on the journey east. The radio was always turned to its full volume and tuned into a jazz or blues station (if there was one), and Neal would beat the dashboard in time to the music until it eventually sagged. 'He acted like a racing driver,' says Al Hinkle. 'He would sit far back with his arms extended and an intent look on his face. He liked to drive as fast as he could, keeping his eye on the rear-view mirror for any sign of the police, and he loved to pass by other cars on the inside lane just to give the drivers a shock.'

They headed south to visit Burroughs and Joan Adams, who now lived across the Mississippi from New Orleans in Algiers, Louisiana. As they drew closer, Jack's love affair with the South was revived. He was overjoyed to hear disc jockeys on the local radio stations playing 'coloured' records, and as they crossed the Mississippi by car ferry he gazed at its brown waters and imagined he was seeing a 'torrent of broken souls'.

They stayed with Burroughs just long enough for Jack's G. I. cheque to catch up with him, and then left for California (leaving Hinkle behind to stay with his wife). Jack's money didn't last long, so they began picking up hitchhikers and begging for cash, and stealing food from gas stations. In Benson, Arizona, Jack even pawned his watch for a dollar's worth of gas.

Jack was still astonished by the American landscape. He loved the

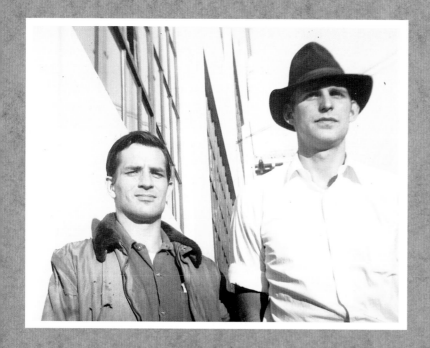

Railroad worker Al Hinkle (left, in hat) was on the celebrated *On the Road* trip from Rocky Mount to New Orleans. Jack and Neal Cassady (below) were so poor during this period that they stole food from gas stations.

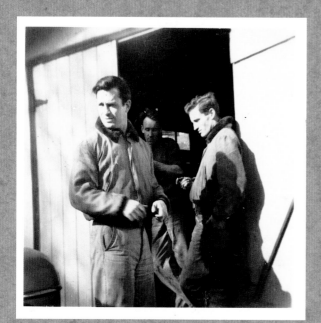

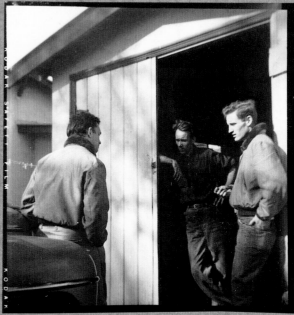

shifting scenery and the way the evening sky changed the further west they travelled. Everything he saw out of the window was soaked in myth - myths of voodoo practitioners and bluesmen, myths of cowboys and pioneers, myths of medicine-men and gold-rush prospectors.

When they arrived in San Francisco, Neal left LuAnne and Jack on O'Farrell Street and suggested that they find a hotel together. He then headed back to his wife and child. Jack was shocked, but LuAnne was more philosophical. 'You see what a bastard he is?' she said. 'He'll leave you out in the cold any time it's in his interest.'

They now had no money at all, and LuAnne persuaded the manager of the Blackstone Hotel, where she'd once lived, to let them have a room on credit. They stayed in the room for two days of sex and intense conversation, which left both of them drained. 'I truly loved him,' says LuAnne, 'but at that time and in that place both Jack and I were lost. Jack was very detached from life. He observed everything but didn't get involved in the reality of it. That applied to his relationships, too. He fell in love, but I don't think he ever wanted to hold on to anyone.

'To be honest, he wasn't very interested in sex. He looked sensual, he acted sensual and he was very loving, but he wasn't a sensual person. I think that was because he was too interested in observing and taking everything in. It was a constant preoccupation - whether he was making love or at a party. He was never really participating.

'Neal and I had a terrible fight in front of Jack while we were staying in New York. We fought all the way down the stairs and ended up making love on the floor. I think that that excited Jack more than making love himself. If he had had his choice, I think he would have said that he would rather have watched Neal and me than go to bed with me himself.'

Jack eventually called Neal and asked him to bail him out, so Neal took him back to Carolyn's place on Liberty Street, leaving LuAnne at the Blackstone Hotel. Jack was relieved to be in the company of Carolyn's basic honesty and decency. He stayed a few days, while Neal went to work demonstrating pressure cookers in the homes of potential customers. At night, the two friends went out and caught jazz gigs in the Fillmore district or across the bay in Richmond.

Jack was particularly taken with Slim Gaillard, a Cuban-born hipster musician who sang, danced, played a variety of instruments and had created his own form of hip-talk called 'vout', which largely consisted of adding 'orooni' or 'avouti' to the end of any word (anyrooni wordavouti). Jack admired Gaillard's ability to improvise with language and to combine a

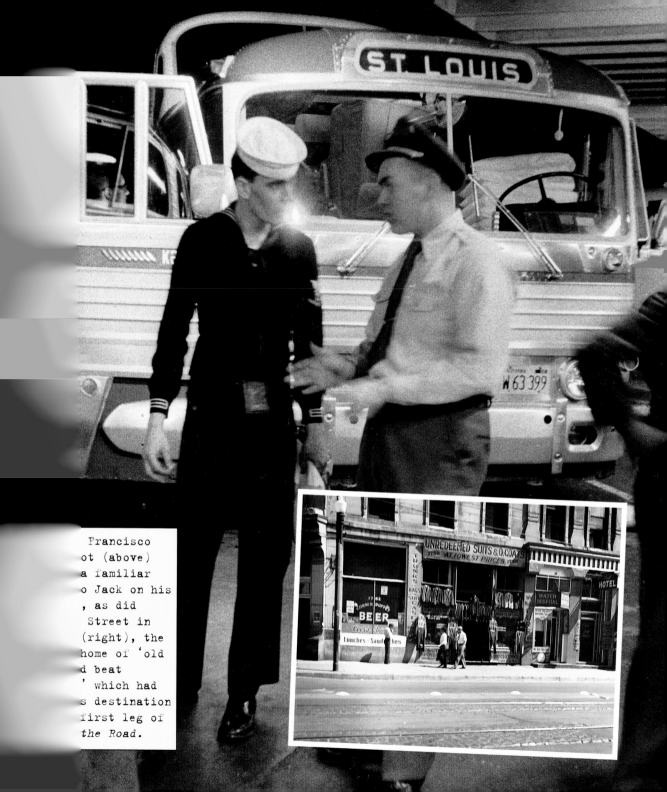

Francisco
ot (above)
a familiar
o Jack on his
, as did
Street in
(right), the
home of 'old
d beat
' which had
s destination
first leg of
the Road.

surreal form of poetry with an exuberant Afro-Caribbean jazz. 'To Slim Gaillard, the world was just one big orooni,' he would write in *On the Road*.

Jack left San Francisco by bus, his ticket routed to take him through Washington State, Idaho, Montana and Michigan so that he could see new parts of America, and also so that he could visit Edie in Grosse Pointe. On March 29 1949, six weeks after his arrival back in New York, he learned that *The Town and the City* had been accepted by Harcourt Brace, where his editor was to be Robert Giroux. His advance was to be $1,000, payable in monthly instalments.

With new material on Neal he got back to work on *On the Road*, though he was still living the experiences that would make up the final version. In the spring of 1949 he saw it as an allegorical novel which owed something to John Bunyan's *The Pilgrim's Progress*, where the hero would go through several tests before reaching a point of repentance, after which he would regain his lost purity.

In May he left for Denver, hoping to start his life over again, but all his Denver friends were by now elsewhere and things were not the same. It was with a feeling of lostness and dashed hopes that he wandered into the coloured section of the city early one evening, feeling like 'a speck on the surface of the sad red earth', and found himself wishing he was a Negro because, he told himself, the white world didn't have enough joy, ecstasy, life, kicks, darkness, music and night.

This romantic notion of blacks as happy, spiritually-liberated people who were in touch with their bodies was to become an important element of Beat philosophy, and anticipated the rock 'n' roll revolution of the next decade – where black styles of music, dress, dance-movements and language were, for the first time, taken up *en masse* by white middle-class teenagers.

Tired of being lonely, and encouraged by letters from Neal, Jack left Denver and moved on to San Francisco, arriving at the Cassadys' new home on Russian Hill at two o'clock one morning. For the next week he and Neal raced around the city scoring pot and listening to jazz, leaving Carolyn at home to look after the baby Cathleen. She didn't mind having Jack stay, because she knew it made Neal happy and she'd grown up with lodgers in her home, but she did resent being ignored. Matters came to a head one morning when, after a brief argument, Jack and Neal were kicked out of the house. 'I didn't know what else to do,' she says now. 'That's all I'd been taught to do. If your husband let you down or misbehaved you told them to get

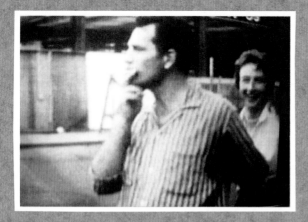

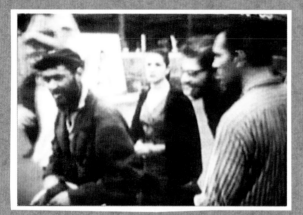

SATURDAY *August?* 1949

SEPTEMBER

S	M	T	W	T	F	S
	1	2	3	4	5	6
7	8	9	10	11	12	13
14	15	16	17	18	19	20
21	22	23	24	25	26	27
28	29	30				

6

SEPT. 1947

Carolyn,
Im leaving today - wont
ever bother you again.
I won't come back in a
month to make you start
it all over again - shudder
shudder!
Here is a few dollars that
I can give you. You won't
receive any more until Sept.
The things of mine still
at the house — do what you
want with.
I am going to Denver,
Detroit, and New York City and
won't ever come back to
Frisco. Incidentally, I'm not
going to see Lu Ann — don't
know where she is.

249. SAT., SEPT. 6. 1947 -116

Writ by Helen Hinkle - Neal

Jack admired the
independence of the
American hobo (above
left) and emulated his
rootless lifestyle.
Neal Cassady's note to
Carolyn (above) had to
be written by Helen
Hinkle because he had
damaged his right hand.
John Clellon Holmes
(left) became the first
writer to put Jack's
phrase 'the Beat
generation' into print.

out. They'd been out somewhere and when they came back in I just said, "Don't bother. Get going." We both regretted it later, and it took me a long time to realize that sending people away doesn't solve anything.'

After a few days carousing in bars and jazz clubs, Jack and Neal picked up a drive-away car and headed for Denver, where Neal made an attempt to trace his father, whom he hadn't seen for years. He had had a vision while smoking marijuana that he should get together with him again, but no one he spoke to in Denver knew where he was.

They then went to a travel bureau and picked up a black 1947 Cadillac limousine with whitewall tyres, which needed delivering to Chicago. Neal couldn't believe his luck. Dressed in his white T-shirt and washed-out Levis, he jumped into the driver's seat and barrelled out onto the highway. Within two minutes, he was pushing up to 110 m.p.h., a speed he managed to maintain on most of the straight stretches, bringing it down to 80 m.p.h. for the bends.

They went to the Loop in Chicago, where they visited some jazz clubs, saw the British pianist George Shearing play and then picked up a bus for Grosse Pointe, Michigan. There, they met up with Edie, who was still living at home. Edie arranged for a friend, Virginia Tyson, to have Jack and Neal put up in her parents' house while they were away in Nova Scotia. The Tysons' house was magnificent. It had four bedrooms, four bathrooms and a grand piano in the living-room on which Jack played during the evenings. There was a maid who cooked and did the laundry, and there was a candlelit meal each day in the dining-room. On the second day they were there, a huge party was held in the basement. There was beer on tap, and a three-piece jazz band that Jack and Neal had found were brought in to play. There was a lot of drinking and dancing, and Jack and Neal sat in on the drums and piano at different times during the night.

The two stayed for a week, mingling with Edie's rich friends at their country clubs and in their private basement bars. There were moments when Jack and Edie felt as though their relationship was starting all over again, but in reality he was as unsettled as ever. Before he left they made plans to have their marriage legally dissolved.

Jack and Neal continued their journey as passengers in a Chrysler being delivered to New York. It was almost the autumn of 1949 when they arrived. Jack's mother had moved to Richmond Hill in Queens, and she allowed Neal to stay there with them for a few days only. On the night of their arrival Neal and Jack walked the streets, rapping. They gripped each other's hands and pledged undying friendship.

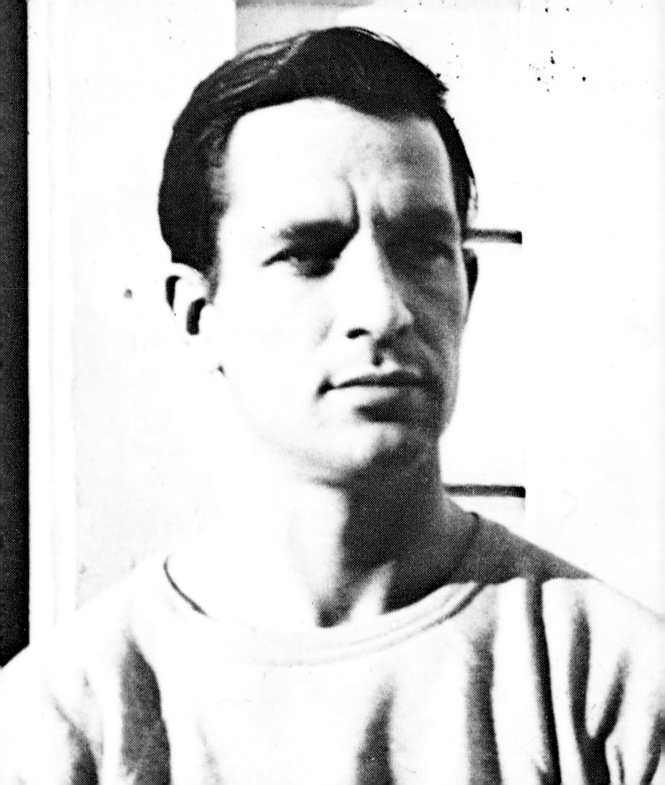

7

Crazy Dumbsaint of the Mind

Jack spent his time smoking marijuana, reading the Bible and praying for a vision which would change the course of his work. He wanted to create something midway between "the pecious and the trashy.. the esoteric and the popular", but he wanted it to come from somewhere deep inside himself.

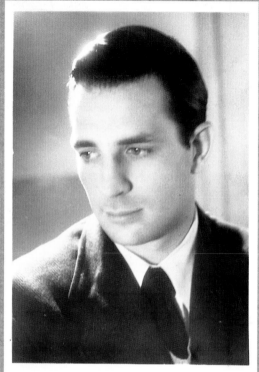

JOHN KEROUAC

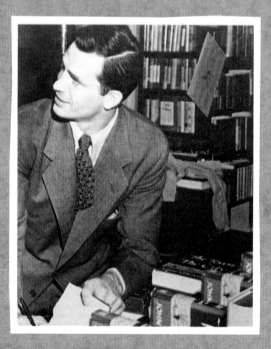

Still known as John (above left) when he published *The Town and the City*, Jack was invited to a book signing in Denver (left) by the educationalist Justin Brierly (above right), who had first put Neal Cassady in touch with Hal Chase.

***The Town and the City* was published on March 2 1950,**
and was reviewed well in prestigious newspapers such as *The New York Times*, which praised its 'depth of vision'. Only one sour note was sounded, by the *Lowell Sun*, which criticized the book for its weak characters, vulgar language and preoccupation with sex, drugs and alcohol. It was, Jack would reflect in 1959, 'A novelty-type novel, with all traditional characters and development and everything like that.'

His friends were supportive – Ginsberg going as far as to compare the book's main characters with those of Dostoevsky's *The Brothers Karamazov*. Allan Temko reviewed it for the *Rocky Mountain Herald* and Justin Brierly wrote an article for the *Denver Post*. There was an autographing party held in Lowell which was attended by Roland Salvas, Jim O'Dea, Charley Sampas, G. J. Apostolos and some of Jack's other childhood friends.

After a decade of being 'a student who writes', 'a sailor who writes' or 'an unemployed bum who writes', Jack was now a published novelist. His editor, Robert Giroux, tried to raise his profile by taking him around the fashionable cocktail parties of New York and dressing him up to attend the opera. But, despite the attention and the favourable press, the book stopped selling within weeks of publication, and Harcourt Brace responded by putting a brake on its advertising. It soon became apparent that Jack would be lucky to earn out his advance. His dreams of huge royalties and a farm in California were fading fast.

At the end of May he took a bus to Denver, where Justin Brierly had arranged a book signing at a department store. Jack stayed with Ed White, and toured the bars and jazz clubs with Al Hinkle and Frank Jeffries, a friend of Neal's. Having driven back from New York in a 1937 Ford Sedan, Neal was back in town and ready to go down to Mexico, where he imagined he could acquire a quick divorce from Carolyn which would allow him to marry Diana Hansen, a model he had met at a party in New York who was by now four months pregnant with his child.

Jack, who still had more dreams than firm plans, was easily persuaded to head south with Neal and Jeffries. As they drove down through New Mexico and over the Texas Panhandle, Neal had Jack and Jeffries recounting stories of their lives, which they took their time to tell, exploring every detail in the manner of a Proustian novel. High on marijuana and ecstatic with the new scenes of American life passing by their windows, they sustained these raps for hours on end while Neal goaded them on to tell more.

For the final journey of *On the Road*, Jack and Neal Cassady (above) drove down to Mexico City. On the way down they visited Ciudad Victoria (below) where they spent an evening in a whore-house which boasted recorded music, a bar and a dance floor.

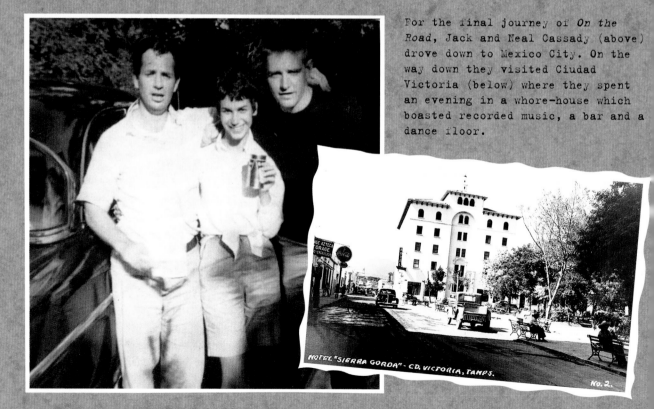

HOTEL "SIERRA GORDA" - CD. VICTORIA, TAMPS.

No. 2.

They crossed into Mexico over the Rio Grande Bridge at Laredo, then travelled down through Monterey and Linares into Ciudad, Victoria. This was Neal's first time outside America, and Jack's first visit to a non-English-speaking country. Both were captivated by the primitive dusty roads, the dirty, broken-down adobes and what they perceived as the 'coolness' of the Mexicans. This was, to them, a country where Beatness reigned; where old men wore jeans and smoked on front porches and no one passed judgement on anyone else.

Jack saw the Mexicans as the 'fellaheen', the poor of the world: the people whom Oswald Spengler had identified in *The Decline of the West* as those who would inherit the Earth when the great powers had obliterated each other. They were in touch with nature and in touch with their feelings, unlike the typical white Westerner. 'They knew who was the father and who was the son of antique life on earth, and made no comment,' Jack wrote.

In Ciudad the three tousled men were stared at by barefoot peasants who were unaccustomed to seeing American travellers looking so impoverished. At a gas station, they were approached by a young Mexican who rolled them a huge joint and offered to take them to meet girls.

After sharing his home-grown marijuana with them, their new Mexican friend took them to a local whore-house, complete with couches, mambo music, a bar and a dance floor where girls could be hired for $3.50. They left after three hours, sweating and drunk; Neal handing out money to the bored-looking policemen who were loitering on the sidewalk outside.

They drove on to Mexico City and took on an apartment next door to William Burroughs in the quiet residential neighbourhood that he and Joan had moved to in October 1949. Mexico City, then with a population of only one million, was a Beat paradise for Burroughs. Drugs were cheap and their use was generally ignored by the police (who could be bought off anyway) and the city had a spirit of the old frontier towns of the last century.

While Frank Jeffries used the opportunity to take acting courses at Mexico City College – where Burroughs was already studying Mayan and Mexican archaeology – Neal headed back to the States alone. On July 10 he married the pregnant Diana Hansen in order to give their child legitimate parentage, but promptly left her and rejoined Carolyn in San Francisco.

Jack spent his time smoking marijuana, reading the Bible and praying for a vision which would change the course of his work. He wanted to create something midway between 'the precious and the trashy . . .

(115)

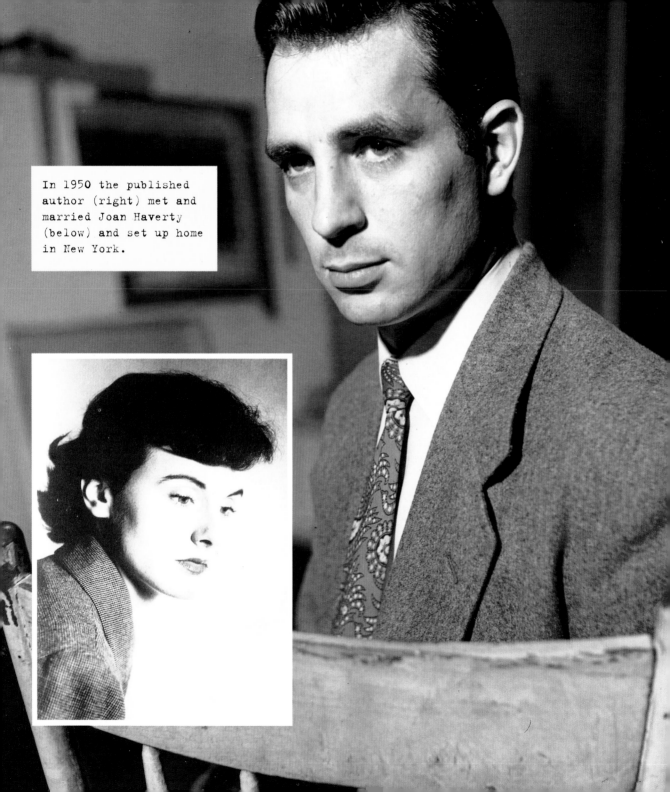

In 1950 the published author (right) met and married Joan Haverty (below) and set up home in New York.

the esoteric and the popular', but he wanted it to come from somewhere deep inside himself. The drugs he was taking were making him aware of the intricacies of his consciousness and, as he wrote about these glimpses of cognizance in his notebooks, he hoped he would discover new levels of truth.

'I want to work in revelations, not just spin silly tales for money,' he wrote to Ed White on July 5. 'I want to fish as deep as possible into my own subconscious in the belief that once that far down, everyone will understand because they are the same that far down.'

By late July he felt he was ready to return home and restart work on *On the Road*, so he hitchhiked his way back to New York. While he'd been away in Mexico America had become involved in Korea, and this worried Jack. The spectre of a showdown between Russia and America hovered over a generation which had only just finished fighting World War II and was by and large trying to settle down and raise its children.

During a three-week break from writing Jack went to Cape Cod with John Clellon Holmes and Lucien Carr, where he had a brief affair with a girl called Nancy. Back in New York by early autumn, he met Joan Haverty, the love of an old friend called Bill Cannastra who lived in a loft on 21st Street. Cannastra, a flamboyant bisexual, was a notorious party-giver whose gatherings would invariably end up as mass orgies.

Cannastra had recently been killed in a tragic accident. Fooling about with some friends on a subway train just as it left Bleecker Street station, he had pretended to climb out of the window. Because he was drunk they tried to haul him back in, but his head caught against a pillar and he was dragged out to his death.

Joan had continued living in his loft, and it was there that Jack met her on November 3. They drank hot chocolate, went to a party at Lucien Carr's and had breakfast together the next morning. Exactly two weeks later they were married, although neither of them knew quite why. On her part, it was probably to avoid having to return to her family in upstate New York. On his, it was probably an insurance policy for his lonely mother – he felt that Joan was just the sort of girl to look after her in her old age.

Although Jack was unfaithful to all his women and continually avoided domesticity, the ideal of a monogamous marriage and a happy home had remained with him. He was particularly vulnerable to these dreams of a conventional family life when he was lonely, and especially during the autumn of 1950, when Neal was in San Francisco, Burroughs was in Mexico

and Ginsberg was experimenting with women for the first time in his life.

Jack and Joan began married life in the 21st Street loft that Cannastra had left behind. Joan was working in a department store while Jack continued to work on *On the Road* at home, but in December Jack decided that he'd feel less lonely during the days if they could move in with his mother at Richmond Hill.

His search for a style of prose capable of reflecting his new life was continuing when a long letter arrived from Neal. (The legendary document was subsequently lost. Jack claimed it was 40,000 words long, but others who read it judged it to be more like 13,000.) The letter detailed his sexual encounters in great detail, but also flashed back to scenes from his past which he thought were essential to understanding the present. It read like the breathless rap of someone on speed, and while Neal begged Jack to 'have patience with my verbosity', he explained that he was simply reporting 'the incidents exactly as they occurred'.

Jack considered the letter a masterpiece, and compared it to the work of Joyce, Celine and Dostoevsky. What impressed him most was that by writing as he spoke Neal avoided any literary pretensions, thereby capturing more easily the essence of his experience. It convinced Jack of two things. Firstly, that he should write in a more natural style which was closer to his way of speaking. Secondly, that his future work would involve reporting things as they happened in his life, rather than creating fictions. He immediately set out on this path by writing a series of confessional letters back to Neal. 'I hope I will become more interesting and less literary as I go along,' he wrote, 'and proceed to the actual truth of my life.'

For the first time since his days in Lowell he discussed his feelings about the Catholic church, which he felt had failed in its duty to be a refuge for the poor, the humiliated and the suffering, and to be a source of joy. He felt comfortable confessing these feelings because Neal, despite his unstable childhood, had been raised as a Catholic and had served as an altar boy. Jack mentioned a recent visit to St Patrick's Cathedral in New York which had moved him to tears, and said that he still believed that Christ was the Son of God. Though many of these letters were not mailed, the exercise was probably worthwhile, if only because Jack was expressing his thoughts and feelings.

In mid-January 1951, when Jack's mother left for North Carolina to live with her daughter Caroline, Jack and Joan moved to an apartment at 454 W. 20th Street where, for a short time, they lived like a normal

young married couple. He took part-time work as a script synopsizer for Twentieth Century Fox and she became a waitress at Stouffers. In the evenings he would work on his manuscripts while Joan concentrated on sewing.

In March, John Clellon Holmes came by with the completed manuscript of *Go*, which was to be the first published novel to consider the lives of Jack and his friends. Originally titled *The Beat Generation*, the book named Jack 'Gene Pasternak', Ginsberg 'David Stofsky', Herbert Huncke 'Albert Ancke', Neal 'Hart Kennedy' and Holmes 'Paul Hobbes'. It was a good, solid book, which accurately detailed the literary scene that Holmes had stumbled into, but there were no stylistic breakthroughs. It was the work of an informed observer, rather than a passionate participant.

Jack was slightly annoyed that a lot of his own conversation had been recorded verbatim in the novel, but was otherwise encouraging. He must have felt reasonably unthreatened by Holmes, because he spent time discussing his problems with the characters in *On the Road* with him, and shortly afterwards began a new version of the book in the confessional style of his letters to Neal.

One problem Jack had with pouring his thoughts out unedited was that his chain of thought tended to break every time he fed a new sheet of paper into the typewriter. In order to preserve an uninterrupted flow, he began writing on continuous rolls made up from twelve-foot-long sheets of drawing paper.

For twenty days he worked solidly on the new manuscript, completing 34,000 words on April 9, and 86,000 words by April 20. Working on the single roll he became totally engrossed, detailing his road trips as if explaining them to Joan for the first time. Rather than invent characters, he used real names of people and places.

On the Road was now a travel tale that told of Jack's five major journeys out of New York since meeting Neal, ending with the most recent visit to Mexico. It was unravelled rather than plotted; drew heavily from his notebooks, in which every small detail was observed; and contained almost no invented characters or situations.

Jack would say later that it was nothing more than the tale of two young men driving across the country, but the manuscript had a much deeper resonance than that, because Jack wasn't simply travelling – he was embarking on a journey during which he hoped to discover something he could believe in, something that would make life worth living. 'Though

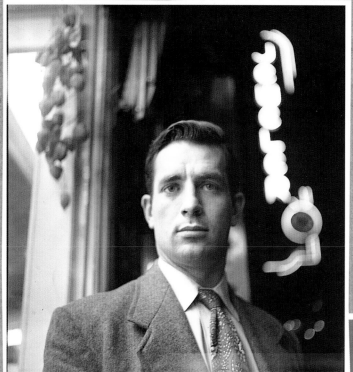

On the Road: Typed manuscript, [1951]
[...], John Sampas

[illegible caption text]

Following the
publication of *The
Town and the City*,
Jack struggled with
the manuscript of *On
the Road* (above
right), which was
rejected by many
publishers before
being taken up by
Viking Press.

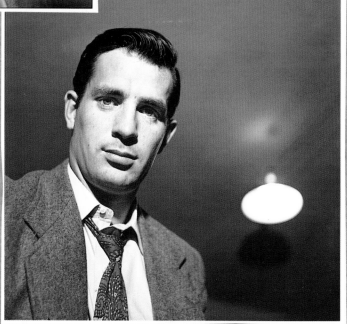

they rushed back and forth across the country on the slightest pretext, gathering kicks on the way, their real journey was inward,' wrote John Clellon Holmes.

Perhaps the book's greatest achievement was in the sheer joy and delight it expressed in the discovery of the American landscape. *On the Road* truly was the 'America as a poem' that Jack had dreamed of back in his Columbia days. His eye for detail and his careful note-taking paid off. This was the unearthing of America by someone who hadn't ventured West until the age of twenty-five.

The first version of *On the Road* was sent to editor Robert Giroux, who promptly turned it down. It was also rejected by Farrar Strauss & Young, who suggested that the manuscript was in need of revision. Jack made plans to rewrite it, but was at the same time working on *Visions of Neal*, an experimental reworking of much of the *On the Road* material which would later be published as *Visions Of Cody*.

The completion of this version of *On the Road* almost coincided with the end of his marriage to Joan. They had been unsuited from the beginning – none of Jack's friends could understand what had brought them together. Added to this was his unpredictability and his mood swings. The break-up began with Jack spending nights away at Lucien Carr's apartment, and ended when he came back unexpectedly one night to discover her embracing a fellow worker from Stouffers.

Although Jack was no stranger to infidelity, the pain of being cuckolded himself was acute. The humiliation was even greater when, in June, Joan told him that the baby they had tried so long to produce was now on the way. He tried to get her to have an abortion and when she refused he left, first of all returning to Lucien's and then later joining his mother in North Carolina. Joan went back to her own mother in Albany, and when she began proceedings to get money for pre-natal care, Jack started to deny that the child was his.

In North Carolina, Jack worked on the revisions to *On the Road* suggested to him by Ginsberg, who felt that Neal's character needed building up while the book as a whole needed editing down. In September, Jack heard that Neal and Carolyn had a son, John Allen Cassady (named after Jack and Ginsberg), and the shock news that Joan Adams had been accidentally killed in Mexico when Burroughs had tried to shoot a wine glass from off the top of her head with an automatic pistol. Joan was buried in Mexico City and Burroughs was locked up in Lecumbere Prison for thirteen days while the $2,312 bail money was raised.

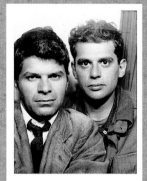

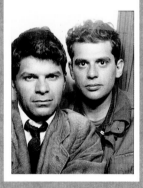

The Beat circle expanded
with the addition of New
York poet Gregory Corso
(right), who was
discovered by Allen
Ginsberg (above). He
began writing poetry
while in prison as a
teenager, and was in San
Francisco when publicity
over the Beat Generation
exploded.

Back in New York during October, Jack began to develop the technique he was to refer to as 'sketching', which involved following his thoughts wherever they led him and recording the impressions without the interference of the censoring, organizing part of his mind. The impetus came from Ed White: 'As architectural students, we often carried sketch pads around with us, and I told Jack he should do the same thing for his writing,' says White. 'He started doing it, carrying little notebooks in his pocket, and he would stop here and there in the city and take notes. I thought he could do in writing what we were doing in drawing as a way of remembering things that caught his eye.'

Ginsberg was moving in a similar direction with his poetry, initially under the influence of William Carlos Williams, whose best-known dictum was 'no ideas but in things', and, more recently, under the influence of Kerouac's prose. They were both striving to capture a similar experience, both influenced by the cadences and images of the Bible, and both trying to free themselves from self-conscious literary styles. 'I have a secret ambition to be a tremendous life-changing prophetic artist,' Jack admitted.

A new arrival on their scene was Gregory Corso, a Greenwich Village-born poet who, with his background as a homeless criminal, fulfilled their dreams of a noble savage. Corso had never known his mother and had been raised in foster homes until he took to the streets at the age of twelve. By the time he reached twenty-one, he had been imprisoned four times – most recently for a three-year stretch in Clinton Prison, where he had discovered Shelley and the Greeks and had started writing poetry. 'I don't know if Jack and Allen knew too many criminals at that time,' says Corso. 'They knew me, and I'd been in prison, and they knew Huncke, but we were more poets and writers than anything else. We just happened to end up in jail.'

Neal was by now trying to persuade Jack to return to San Francisco. He wanted Jack to teach him to write while he supplied Jack with a congenial place to live and write with plenty of books to read, jazz to listen to and a tape machine to record their raps on. 'Carolyn will be like your mother,' he assured Jack.

The
Railroad
Earth

 During this time, Jack experienced a great freedom
in his writing. In a letter he boasted that he had
reached 'peak maturity', but predicted that this
wouldn't be recognized for another fifteen to twenty
years.

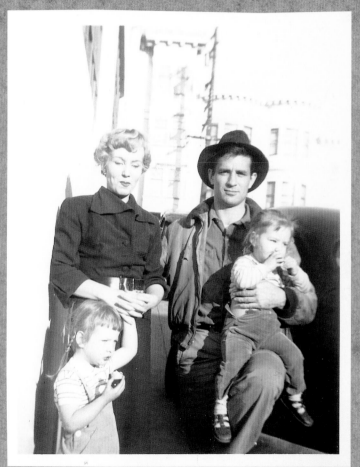

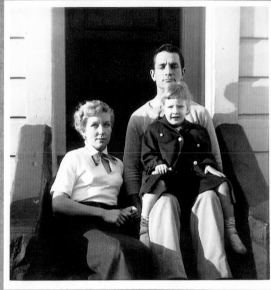

Initially, the relationship between Jack and Carolyn Cassady (above and left) was innocent, but when Neal left San Francisco on a railroad job it turned into an affair.

Jack decided to travel West again in December 1951.

Once more, he had hopes that Henri Cru might be able to get him work on a ship but, if that failed, there was the chance to live and write at the Cassady home. He took the bus to San Francisco, where he arrived on December 18. He worked for four days as a baggage handler for the Southern Pacific Railroad before taking a train down to Los Angeles where Cru was due to dock on board the *President Harding*.

While waiting for Cru, Jack took lodgings in a Skid Row hotel and spent his time developing his 'sketching' technique. When Cru arrived, the two of them went cavorting in Santa Monica and Hollywood and ate a Christmas meal on board ship. But, despite Cru's persistence, there was still no offer of work with the Merchant Marines. So Jack returned to the Cassadys, where he was given an attic room with a mattress on the floor, a radio, a collection of books and a desk made of a six-foot sheet of plywood. He also started working as a brakeman for the Southern Pacific Railroad.

It was a perfect situation for Jack. The Cassady home was in a quiet street lined with frame houses, but it was only a matter of yards from the Hyde Street cable car and a reasonably short walk from all the artistic activity of the North Beach. He liked being able to work alone and undisturbed, but also to have the option of company and conversation whenever he felt like it. He appreciated having people around to test new pieces of writing on. Most of all, he liked being around a woman who would mother him.

Up until now, his relationship with Carolyn had been one of guarded respect. They liked each other, but their relationship was through Neal and they had never opened up to each other. Now, in the more intimate surroundings of the family home and with Neal often out at work, a powerful attraction developed between them, although nothing was ever said about it.

'The attraction was there when we first met in Denver,' remembers Carolyn. 'We were dancing together, and the chemistry was there in a way that it wasn't with Neal. I had no physical feelings towards Neal. That's why I thought I was all right to marry him – because he was the first man I'd been out with that I had no physical attraction to. As Jack said on that first day: "Too bad Neal saw you first!" I felt the same way.'

In January 1952, Jack was drunk in a Skid Row club and picked up a black prostitute. Wanting Neal to be able to join in the fun, he phoned

To Carolyn —

Best wishes for you and your wonderful family including The old man there, whats-his-name there, Old Neal — Love to you all —

Jack Kerouac
Dec. 19, 1951

With The deepest apologies I can offer for the fiasco, the foolish tragic Saturday of Neal's birthday — all because I got drunk — Please forgive me Carolyn — it'll never happen again —

It was while living on Russell Street in San Francisco (below) that Jack and Neal upset Carolyn (above right) by bringing a prostitute home. A remorseful Jack penned the above footnote the next day.

him at home. In bed with Carolyn at the time, Neal took the call and then hurriedly explained to her that he had to go out because Jack had been arrested. After he left the house, Carolyn heard nothing of the two men until they arrived home early in the morning with the prostitute. When Carolyn discovered them she was shocked, and told Jack to take her somewhere else. 'I didn't feel any censure,' says Carolyn. 'But my home was not the place to bring prostitutes - there were children around. The woman poured a string of insults at me and then asked Neal to drive her home. Jack chose to go with them.'

Jack and Neal spent the whole of the next day driving aimlessly around the city and when they returned home Jack was so embarrassed about the incident that he stayed in his room. He later picked up the copy of *The Town and the City*, which he had recently given Carolyn and added the message: 'With the deepest apologies I can offer for the fiasco, the foolish tragic Saturday of Neal's birthday, all because I got drunk. Please forgive me, Carolyn. It'll never happen again.'

It was not long afterwards that the railroad asked Neal to do a two-week 'hold down' in San Luis Obispo. This meant leaving Jack alone with Carolyn and the three children - Cathleen, Jamie and John - and as he left Neal cryptically acknowledged the possibility of a romance beginning between his wife and his best friend. 'You know what they say, "My best pal and my best gal!"' he said. 'Just don't do anything that I wouldn't do!'

The throw-away comment shocked and embarrassed Carolyn who, despite being the wife of a legendary profligate, was extremely conventional in her views of sex and marriage. She believed that partners should obey the terms of the contract they entered in on. Jack, too, was always shocked when a pass was made at him by someone's wife.

So while Neal was away nothing happened between Jack and Carolyn, although they did start talking a lot about their families and their childhoods. When Neal returned, Carolyn confronted him about what he had said. Did he know how much he had hurt her? Did he think that they would have made love or was he just taking precautions? Didn't she mean more to him than the other girls he had 'shared' with Jack? Neal's only reaction was to say that it wouldn't have worried him if something had happened. 'Why not? It would have been fine.'

'It hurt me deeply when he said that he wouldn't have cared if I had slept with Jack,' she says now. 'I thought that I was going to lose out forever and that if he wasn't going to play the same game as me then

Jack pictured outside the Cassady home on Russell Street, San Francisco during the period of his affair with Carolyn. He is seen (left) with Al Hinkle and the Cassady children Jamie, Cathy and John Allen.

I might as well play his game. I thought that the alternative to faithfulness was probably going to be the best survival tactic in this situation.'

Spurred on by her anger at Neal's indifference, Carolyn set out to seduce Jack. She prepared his favourite meal of pizza, salad and wine, put on her most alluring perfume, and arranged a candlelit meal when the children were in bed. They made love for the first time that night on the leather living-room couch. 'I felt awful afterwards because I didn't believe in it,' she says. 'Neither of us were great lovers, so it wasn't anything in that department. It just made it easier to communicate.'

It was the beginning of a strange affair which changed the dynamics of the relationship between Jack, Neal and Carolyn. 'They stayed at home more,' she says of Jack and Neal. 'They were keeping an eye on each other. Instead of going out hunting women, they'd take me out with them, or I'd go out for walks with Jack at night.'

Yet, despite the legendary openness that both Neal and Jack celebrated in their letters to each other, there was never any discussion of what was going on. 'I think Neal must have known right away, but he never ever said anything,' Carolyn reflects. 'We wouldn't have dreamed about discussing it. We didn't even admit it to ourselves.

'People don't realize the times we were living in. We were still ruled by Victorian ideals. That's why Jack never wrote about the affair. It just wasn't done. You just didn't write about having sex with your best friend's wife. We never admitted it because we were ashamed of it.

'Neal never even asked me if anything was going on with Jack. Never. And if he was around he was always the head of the household. Jack and I wouldn't even look at each other or touch each other because he was the friend living with us and Neal was the man of the house. It was nothing like in the movie *Heart Beat*, where it was "Whose turn is it tonight, fellows?" That would have been horrifying.'

This period was perhaps the most intense of the relationship between Jack and Neal. The two men would spend whole evenings together with Carolyn reading to each other from Proust, Spengler or Shakespeare. They would turn on the reel-to-reel tape machine and record their stoned raps with each other. Sometimes, they would bring home characters they had met in local bars to spice up the discussions. Then Jack would transcribe the tapes and use the transcription as the starting point of the next stoned rap.

During the early evenings they would often play tennis together, and at nights they would search out the best bop in clubs like Jackson's Nook in the Fillmore District, or R & B in the poor black bars around Third Street and Townsend. In one San Francisco club they got talking to Billie Holiday, and another day Jack saw Joan Crawford near their house filming *Sudden Fear*. Carolyn pursued her drawing and painting, and was no longer ignored.

The poet Philip Lamantia, whom they had met previously in New York, introduced them to peyote – the first psychedelic drug that either of them had taken. The first time they took it Jack felt that he knew what it was like to die, and the next time, he hallucinated music. Lamantia read to them from *The Tibetan Book of the Dead*, a Buddhist 'bible' which spoke of death and rebirth. He also showed them new poems he was writing about American Indians.

Lamantia was different from most of the drug-users they had known because he regarded drugs as a sacrament and drug-taking as something akin to a religious ritual. Like Jack, he was raised in the Catholic church, but unlike Jack he had experienced a re-conversion in adulthood.

During this time, Jack experienced a great freedom in his writing. In a letter he boasted that he had reached 'peak maturity', but predicted that this wouldn't be recognized for another fifteen to twenty years. The work that he was most likely to have been referring to was *Visions of Cody*. Jack thought of this expansive paean to his friend as 'the first modern novel' because of its non-linear structure, which switched from sketch to biography to parody and contained a sizeable middle section consisting of a transcription of an actual Cassady-Kerouac rap.

It seems that Jack still felt that he hadn't yet distilled the essence of Neal in *On the Road*, and that the only way to do so was to approach his character simultaneously from four directions – to get into his thinking, his background, his conversation and his effect on others – and to use a different literary style for each approach. Today, *Visions of Cody* is reckoned by many (including Allen Ginsberg) to be Jack's best book.

With *On the Road* now accepted by Ace Books, who were also due to publish William Burroughs' account of his heroin habit, *Junkie*, Jack felt that he and his generation were on a roll. William Carlos Williams had professed admiration for Ginsberg's poetry and promised to write an introduction to his first collection, and John Clellon Holmes had

received a $20,000 advance for his first novel, *Go*. In his notebook, Jack proudly stated his ambition to write three major works each year, 'like Shakespeare'.

Jack had always planned to spend the summer of 1952 writing in Mexico, and so when Neal and Carolyn left in April to visit Carolyn's family in Nashville they took him along and drove him down to the Mexican border at Nogales, New Mexico. There, he boarded a bus bound for Mexico City which travelled down dirt tracks and had to be rafted across rivers along the way. On the bus, Jack struck up a relationship with a 'Mexican hipcat' called Enrique, who gave him mescal and later introduced him to a group of Mexican Indians living in stick huts, who handed him marijuana cigars laced with opium.

Once in Mexico City, he met up with Burroughs, who was still mourning the loss of Joan. Together they went hiking and shooting, as well as visiting the ballet and drinking at Lola's bar. Throughout May and June, Jack worked solidly on *Doctor Sax*, the novel that focused on his childhood fantasies which he'd started almost four years ago. But the enthusiasm for life and for writing that he had felt in San Francisco was ebbing. He had recently turned thirty, and hadn't even mastered a menial trade – something which Henri Cru had done at sea and Neal had done on the railroad. He had no money, he was separated from his wife, and had a daughter (born February 16), for whose maintenance he was being pursued.

He wrote to Carolyn suggesting that she and Neal come and live in Mexico, where it was possible to rent an apartment for $20 a month, and told her that he'd managed to write 45,000 words – a third of *Doctor Sax*. He shot morphine with Burroughs and picked up cheap prostitutes. He left Mexico City in late June to stay with his sister in Rocky Mount, North Carolina. Burroughs wasn't sad to see him go because he felt that he'd become a freeloader.

Jack's gloom deepened in July, when he came to New York. Ace Books weren't happy with his revised version of *On the Road*, and even Allen Ginsberg was pushing him to cut certain sections because the references were too personal. When he contacted his original publishers, Harcourt Brace, they told him that lawyers representing Joan Haverty had contacted them to try and discover his whereabouts. John Clellon Holmes, meanwhile, was following up the success of the acceptance of *Go* by beginning a novel about a jazz musician. This irked Jack, because Holmes already knew that Jack had talked about building a book around the

Al Hinkle, Neal Cassady
and Jack all worked for
the South Pacific
Railroad. Jack worked
as both a brakeman and
a baggage handler based
at the Third and
Townsend Street rail
terminal in San
Francisco (above left).

careers of Lester Young and Billie Holiday, which he was going to call *Hold Your Horn High* (Holmes' book would eventually be called *The Horn*).

Fearful that Joan's lawyers would track him down if he stayed in New York for too long, Jack split for California, hitchhiking most of the way to San Francisco from Rocky Mount, and then taking the train to San Jose where the Cassadys had just moved into an eight-room house on East Santa Clara Street.

Jack took work on the Southern Pacific Railroad again, but this time as a brakeman. It was a job that Neal was enjoying already, but Jack didn't fit in as easily. His shy and introverted personality made it hard for him to be a team member, he hated being teased and called 'Carrywack' or 'caraway seed', and didn't have the confidence and agility needed for the fast moves involved in freight-car switching. 'He was afraid of the wheels and wasn't interested in the job,' says Al Hinkle. 'The only things he liked were the money, riding in the caboose and hanging out with the hobos who slept under the bridge at Watsonville at the end of the line.'

His romance with Carolyn picked up where it had left off – she was even open to Jack's suggestion that they all take off and live together in Mexico. 'That was a serious suggestion,' says Carolyn. 'He just couldn't follow through with anything. The next thing was that he moved out from our house, in around October 1952, and went to live in the Skid Row area of San Francisco.'

He moved into the Cameo Hotel, which was not far from the railway station, and threw himself into the life of what was known as Little Harlem; drinking in the local bars; talking with the hobos, who he felt were spiritually related to the 'fellaheen'; and sketching an impressionistic piece that would later be published as *October in the Railroad Earth*. 'The Cameo was a real poor place,' remembers Carolyn. 'I drove him there. It smelled of urine and there were drunks all over the lobby.'

His notebooks of the period show that he was living on a diet of pizza, hot dogs and ice-cream, typically washed down with either Coca-Cola or wine. He would make lists of things that he planned to do, but where his plans involved either sex or drugs he would lapse into French. In one list of ten things to do (including 'haircut' and 'shoe shine'), he includes 'FILLE (LA NEGRE)', 'tubes de benny' and 'LA CLEF A JUANITA'.

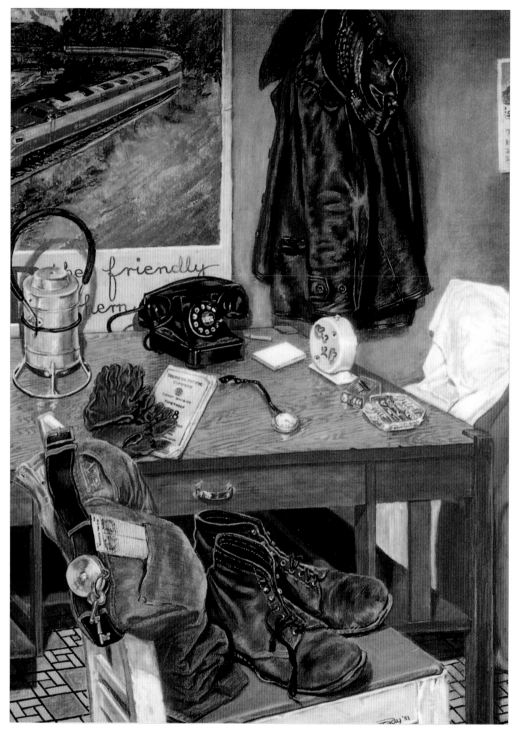

(136)

In December Jack was laid off from the railroad, and Neal drove him down to Mexico City then headed back home, having stayed only long enough himself to buy a supply of cheap marijuana. Burroughs was still out on bail for killing Joan, and had to sign in at the police station once a week. However, wishing to avoid the possibility of a jail sentence, he left suddenly for America, leaving Jack on his own.

Jack found the prospect of spending Christmas alone in Mexico City unappealing, so he hitchhiked back to New York and spent the next three months at his mother's home in Richmond Hill, watching television, drinking beer, reading Genet in French and writing a novel based on his teenage relationship with Mary Carney.

The good news was that Malcolm Cowley, an editorial advisor for Viking, liked *On the Road* and wanted to consider it for publication, as Ace Books were now almost certainly not going to be doing anything with it. Although Cowley was fifty-four, he seemed to be an ideal person to handle the book. Harvard-educated, he was a literary historian who had specialized in the works of The Lost Generation and had authored the classic account of the movement, *Exile's Return* (1934). He had been personal friends with Ernest Hemingway, Hart Crane and F. Scott Fitzgerald, and was credited with re-establishing the reputation of William Faulkner. Had he sensed another movement in the making?

In *Railroad Blues* (left) Carolyn Cassady painted Neal's railroad clothes and equipment as he left them one evening in San Francisco in 1951.

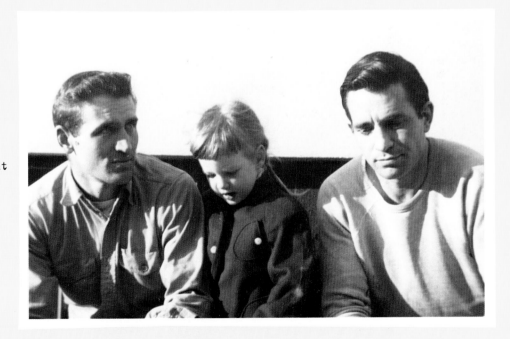

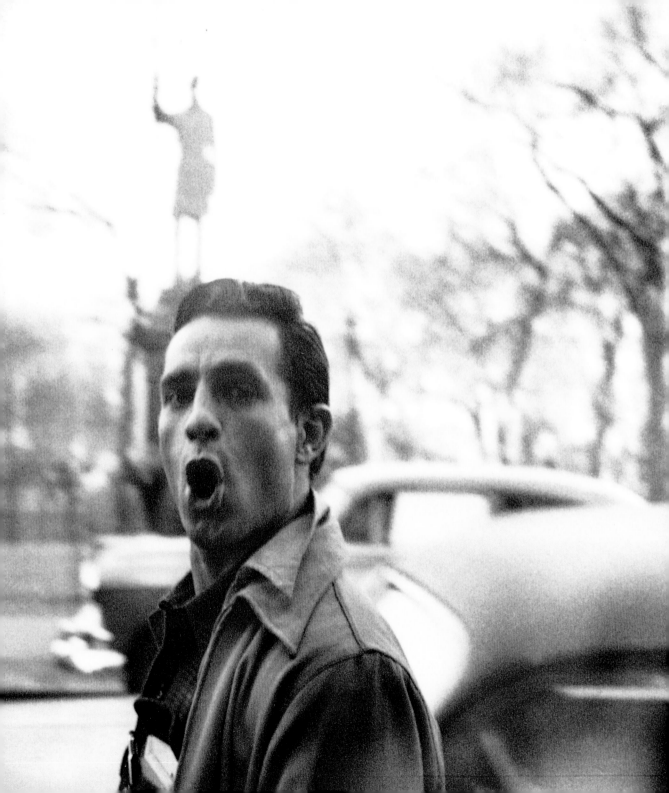

9

The Dharma Bum

He wanted his writing to embody the rush of energy rather than to describe it in the detached voice of an observer... and believed that his speed- writing technique, facilitated by benzedrine, enabled him to simultaneously grasp the conscious and unconscious aspects of experience. It was, he boasted, " the only possible literature of the future".

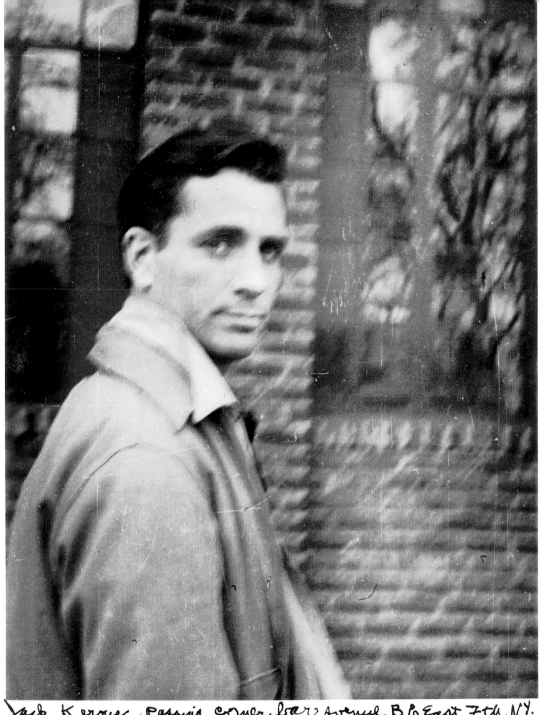

Jack Kerouac passing corner bar Avenue B & East 7th N.Y.,
we went out for a walk along Tompkins Park, September 1953.

Allen Ginsberg

The publication of John Clellon Holmes' *Go* in 1952

and William Burroughs' *Junkie* in 1953 (under the pseudonym William Lee), emphasized Jack's failure to get *On the Road* published. He had been the first to record the lifestyle of the emerging Beat Generation, and it now looked as though he was going to be the last to see his chronicles in print.

Because *Go* had apparently detected a new cultural trend, *New York Times* literary editor Gilbert Millstein commissioned Holmes to write a feature based on his knowledge of the Beats. In 'This Is the Beat Generation' (November 16 1952) Holmes argued that Beatness was a sign of a religious awakening in the face of the spiritual crisis presented by modern life. Although Jack was discouraged by publishers' response to *On the Road*, he never lost faith in himself. His confident boast following Holmes' *New York Times* article was that he would become to his generation of writers what Ezra Pound became to T. S. Eliot.

Jack spent the early part of 1953 with his mother in Richmond Hill, and then drifted back to California, taking more work as a brakeman in San Luis Obispo and San Jose before moving back into the Cameo Hotel, where he once again entertained the idea of going to sea. He was now occasionally taking heroin, although he confided to Seymour Wyse that he never injected it. His notebooks show appointments to meet 'Henry H. Horse' (fifties underworld slang for heroin), and include the comment that under the influence of the drug he felt that he understood everything and was in love with everyone. 'That's MY heaven,' he enthused.

He finally did find a job at sea. He was hired as a waiter in the officers' saloon on board the *S. S. William Carruth* bound for South Korea, but his employment didn't last long. After passing through the Panama Canal and docking in Mobile, Alabama, he was found on shore, drunk with a prostitute, when he should have been at work. The captain dismissed him from service and he was released at the next port of call, New Orleans, from where he made his way back to Richmond Hill and the manuscript of *On the Road*.

During the summer of 1953 he spent a lot of time in Greenwich Village, hanging around bars such as Fugazzi's and the San Remo which were now recognized meeting places for the new 'hipsters'. It was through this scene that he met Alene Lee, a small, coffee-skinned girl who lived on the Lower East Side and worked for a publishing company which specialized in books on alternative health. Born and raised in

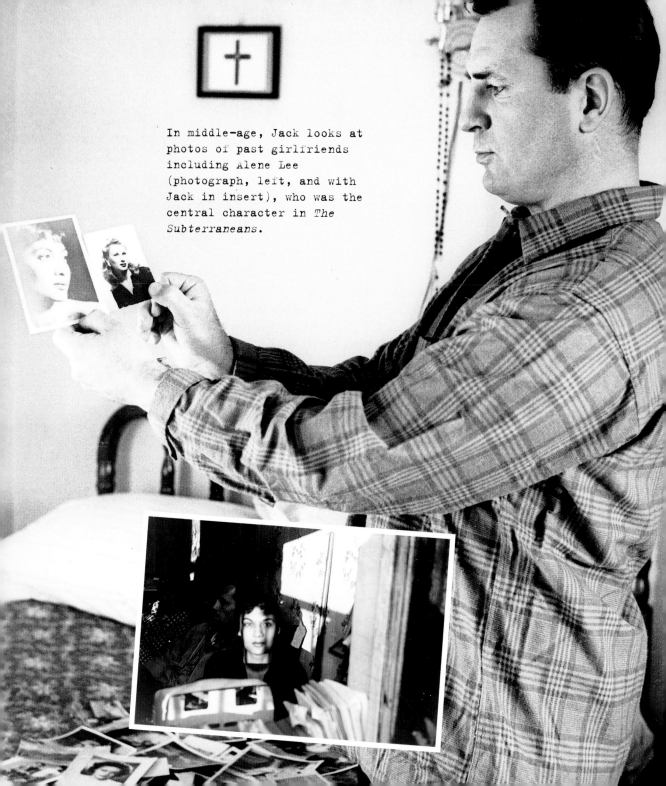

In middle-age, Jack looks at photos of past girlfriends including Alene Lee (photograph, left, and with Jack in insert), who was the central character in *The Subterraneans*.

New York, she mingled easily with a group that Ginsberg considered 'Christlike' and had labelled 'the subterraneans'.

To Jack, Alene represented an ideal combination of hip Western intellect and African body and, for the month of August, they became lovers. Two months later, during a Benzedrine-fuelled seventy-two-hour stint, he wrote an account of the affair called *The Subterraneans*, which detailed not only the letters she sent him and the private conversations they had, but also described her body and her prowess as a lover. Completely unaware of the offence the piece would cause, he sent Alene a telegram saying that he was coming over to deliver her a 'soul surprise'.

As she read the piece in her apartment, with Jack watching her, Alene was overcome with shock. She felt that her portrayal was unfair, and was horrified by the thought that these intimacies might someday be published. He initially offered to burn the manuscript then and there (although it is unlikely to have been the only copy), but eventually compromised by setting the novel in San Francisco rather than New York and giving her Indian blood to obscure her true identity. For the rest of her life she avoided being identified as Mardou, and only ever gave interviews to biographers on the understanding that her real name wouldn't be revealed.

The Subterraneans showed Jack progressing with his 'bop prose', writing ever-longer sentences, employing minimal punctuation, and indicating pauses with a dash rather than a full-stop. It was the pace and attack of the writing that was important to him. He wanted his writing to embody the rush of energy rather than to describe it in the detached voice of an observer. He was proud that 'not a word of this book was changed after I had finished writing it', and believed that his speed-writing technique, facilitated by Benzedrine, enabled him to simultaneously grasp the conscious and unconscious aspects of experience. It was, he boasted, 'the only possible literature of the future'.

To enable Ginsberg and Burroughs to understand his current development as a writer, Jack prepared for them a nine-point list, later published as *Essentials of Spontaneous Prose* – one of the rare times he committed his literary theories to print. In it, he argued that deadness in literature came from subservience to rules, selectivity, punctuation and revision, and he called for writing which followed the associations thrown up by the mind and which swam 'in a sea of English with no

San Francisco, 1955.
Peter Orlovsky, Allen
Ginsberg, Natalie
Jackson and Neal
Cassady. Jackson,
Cassady's lover at
the time, would die
later that year after
cutting her throat
and falling from a
building.

Jack photographed at
San Francisco's China
Basin with poets
William Morris (left)
and Philip Whalen
(right). Jack wrote
his first poetry
book, *San Francisco
Blues* while living in
a Skid Row flop house
(overleaf).

discipline other than rhythms of rhetorical exhalation and expostulated statement'. He considered that any preparation, other than focusing on the subject, and any editing, except to change names, defiled the purity of the prose.

His ideal was the 'undisturbed flow', during which the mind centred on an object or a memory and then began to transmit impressions to paper without any thought of finding the 'right word' and without any preconceived ideas. He likened the technique to the jazz musician who picked on a musical phrase and then just 'blew' with it, not knowing where it would go or when it would end. Spontaneous prose sought not to be 'good' writing but 'honest confession', because it should be 'the song of yourself'.

The underlying belief was that truth resided in the primal consciousness, and that the rational mind had somehow to be outwitted in order to sneak past it and grab the goodies. Drugs were a way of bringing this about. He wanted the 'uninhibited' subconscious to make itself known, and to bypass the censoring tactics of the conscious mind. 'You simply give the reader the actual workings of your mind during the writing itself,' he explained in 1967. 'You confess your thoughts about events in your own unchangeable way.'

His journey as an artist and a thinker had been moving inexorably in this direction ever since his conversion to 'real' jazz as an expression of the soul. In its affection for the untamed – whether uncivilized fellaheen or New York criminal – Beat thinking had always shown a commitment to the 'natural' and the 'spontaneous'.

Jack saw parallels between his own approach to writing and Charlie Parker's improvisatory jazz, poet W. B. Yeats's trance-writing and the action-painting of Jackson Pollock. He was also becoming influenced by Buddhism, which taught the importance of surrendering to 'the void'. As John Tytell observed of Kerouac in *Naked Angels* (1976), 'Knowing, the Buddhists taught, was exclusively spontaneous, never a function of past memory. Whatever occurred in innocent spontaneity could become meditative: he could live from moment to moment, relaxed, playful, weightless, without tension or expectation.'

It appears that Jack's interest in Buddhism developed during 1953. It could have been influenced by Ginsberg's recent immersion in Oriental art, literature and religion, but the direct impetus was the break-up with Alene Lee and his desire to retreat from the city. 'I was suffering from the grief of losing a love, even though I really wanted to lose

it,' he once said. 'I went to the library to read Thoreau. I said, "I'm going to cut out from civilization and go back to the woods like Thoreau," and I started to read Thoreau and he talked about Hindu philosophy. So I put Thoreau down and I took out, accidentally, *The Life of Buddha* by Asvaghosha.'

When Jack returned to California in February 1954 he began a serious study of Buddhist literature at the public library in San Jose, reading Dwight Godard's *A Buddhist Bible* and *The Gospel of Buddha* by Paul Carus and making extensive notes. Mahayana Buddhism (Jack was never a disciple of Zen, which he called 'a gentle but goofy form of heresy') seemed to offer solutions to his feeling of alienation and his terror of death. Buddhism teaches that such sorrow comes from our failure to let go of illusions. We suffer because of 'ignorant desire'. We feel lonely because we fail to accept that life is only a dream anyway. The moment it dawns on us that nothing is real, we loosen our grip and are rewarded with joy. Buddhist techniques, including meditation and instruction through koans, are designed to snap the mind into such an experience of 'enlightenment'.

For the best part of a decade Jack took his Buddhism very seriously – learning to meditate, abstaining from sex in an attempt to break the mind's bondage to 'illusion', and pompously informing the sophisticated Malcolm Cowley that all things were imaginary and in a state of suffering 'due to ignorance'. He argued with Neal, who had recently been converted to the messages imparted by medium Edgar Cayce, with Burroughs, who told him that Buddhism was 'psychic junk', and, over several years, worked on *Some of the Dharma*, a lengthy chronicle of his study of Bhuddism.

His next creative project appears to have been indirectly informed by his recent acquaintance with Oriental literature. Sitting in a rocking chair at the window of his room at the Cameo Hotel, he looked down on the 'bebop winos and whores and cop cars' that passed beneath him and wrote eighty short poems that sketched the scenes he saw in simple, haiku-like language. *San Francisco Blues*, as he titled this first poetry collection, was also a jazz tribute – each poem seen as a 'jazz blues chorus' which had a set number of bars but which was otherwise determined only by 'the musician's spontaneous phrasing & harmonizing with the beat of the time as it waves & waves on by in measured choruses'.

After two months in California, he went back to Gabrielle and took

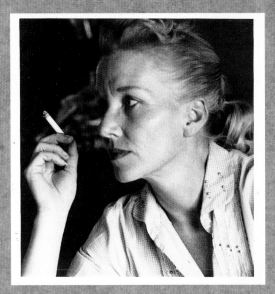

Allen Ginsberg (below left) carried on a homosexual affair with Neal Cassady for a number of years until Carolyn (left) caught the two men *in flagrante delicto*.

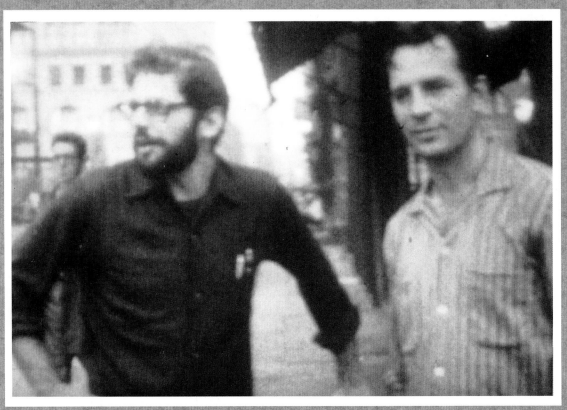

a job on the New York Dock Railway at the Brooklyn waterfront for $18.35 a day to pay for his keep. He had been keeping a diary of his dreams, which he wanted to type up, and was planning *city City CITY*, a science-fiction novel about a computer-controlled world where the oceans have been filled in with material from other planets and the earth is covered in steel plate. He also wanted free time to continue practising meditation. As he arrived in New York, Ginsberg was on his way to Central America, then San Jose, where he hoped to pursue Neal.

Relationships between the key Beat Generation figures were becoming incestuous. Burroughs was now in love with Ginsberg, who was, in turn, still infatuated with Neal who was married to Carolyn. Carolyn, for her part, expressed 'unconditional love' for both Neal and Jack. 'I was not romantically "in love" with either of them,' she says. 'I was a sexual cripple and so never cared about that part.'

Ginsberg was, by his own admission, becoming obsessed with Neal. He dreamed about him and filled his journals with his longings. They had had occasional sex since their first meeting in 1947, but Ginsberg was upset that it didn't seem to mean anything to Neal. While Ginsberg was filled with anticipation for their sessions, Neal just wanted Ginsberg to do whatever he wanted and get it over with. 'Neal's whole philosophy of life was to keep everybody else happy,' says Carolyn. 'He married Diana to make her happy. You just can't live that way, though. It doesn't work. But that was his motive. He just gave himself away. He felt sorry for Allen, who saw him as this great passion. He tried to oblige, but kept telling him he didn't like it. I don't think he ever took an active part in homosexual sex.'

One morning in August, Neal was giving himself away to the eager Ginsberg when Carolyn arrived on the scene. 'I opened the door and saw Allen blowing Neal,' she remembers. 'It was just such a shock. It wasn't that it was homosexual, but that someone was intruding on our relationship. It could have been another woman as far as I was concerned. I hadn't expected it, because Allen had specifically told me that he had given up all hope of a relationship with Neal, and no longer thought of him physically. I had trusted that what he said was true, and we'd had what I thought was a wonderful time together.'

She immediately asked Ginsberg to find another home, and made sure that he left by driving him up to Berkeley and giving him $20 to look after himself with. It was the beginning of the most creative period of Ginsberg's life. He moved from Berkeley into the Hotel Marconi on San

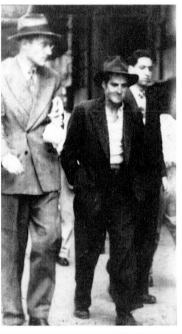

William Burroughs
(left) moved to
Mexico City where his
main drug supplier
was Dave Tercerero
(above, with
Burroughs). When
Tercerero died, Jack
had a brief affair
with his wife and
described her in his
novel *Tristessa*.

Francisco's North Beach, and hooked up with a twenty-two-year-old 'ex-hipster girl' named Sheila Boucher, who impressed him with her hipness, beauty, intellect and love of jazz.

He then contacted Kenneth Rexroth, the guru of the post-war San Francisco poetry scene, and was invited to the soirées that were held in his home every Friday night, where local poets exchanged ideas and read their work to each other. He visited the San Francisco Poetry Center, where he met local poet Michael McClure, and shopped at City Lights on Columbus Avenue, the world's first paperback book store, which had been opened the previous year by poet and painter Lawrence Ferlinghetti and magazine editor Peter Martin.

The San Francisco scene's exciting mix of poetry readings, jazz shows, Oriental thought and liberal politics was the perfect stimulus for Ginsberg. Through painter Robert LaVigne he met Peter Orlovsky, who was fresh out of the army, and began the most serious relationship of his life. Leaving the Marconi Hotel, and Sheila Boucher, he took an apartment at 100 Montgomery Street and Orlovsky moved in with him.

In April 1955, New World Writing published an extract from *On the Road*, which they titled 'Jazz of the Beat Generation'. It had been placed by Malcolm Cowley, and drew the attention of the literary élite to an important work in progress, making it easier for Cowley to get the green light from Viking. It was also Jack's first piece of published writing since 1950, when the magazine *Neurotica* had published his *Pull My Daisy* collaboration with Ginsberg as 'Song: Fie My Fum'.

Jack's agent, Sterling Lord, who had been introduced to him by Robert Giroux, was doing his best with the accumulating pile of Kerouac manuscripts, but was getting nothing but rejections. Dutton turned down *On the Road*, Criterion Press passed on *The Subterraneans*, and Noonday Press rejected *Doctor Sax*. He sent *Wake Up*, Jack's Life of Bhudda, to the Philosophical Library, but they would only publish it if Jack would guarantee a sale of 600 copies himself.

In August Jack headed back to Mexico City. Still striving to practise detachment from earthly desire, he avoided his normal contact with the local prostitutes, but didn't feel compelled to give up morphine, marijuana or whisky. His drug-taking brought him into contact with a Mexican dealer called Esperanza Villanueva, the widow of a man who had previously supplied Burroughs, and he promptly fell in love.

Esperanza was a sick woman. Addicted to heroin, she lived in a dirty shack decorated with Catholic icons and sold her body to pay for

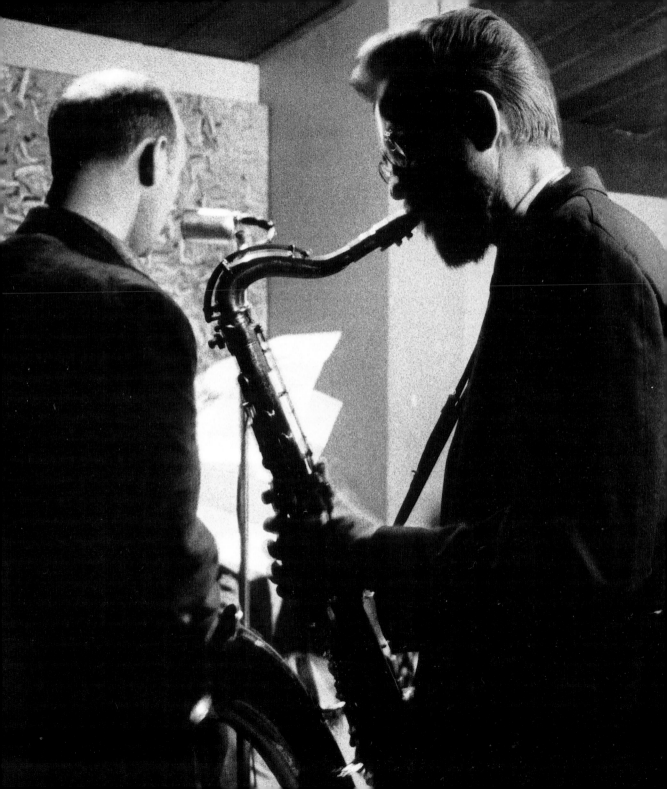

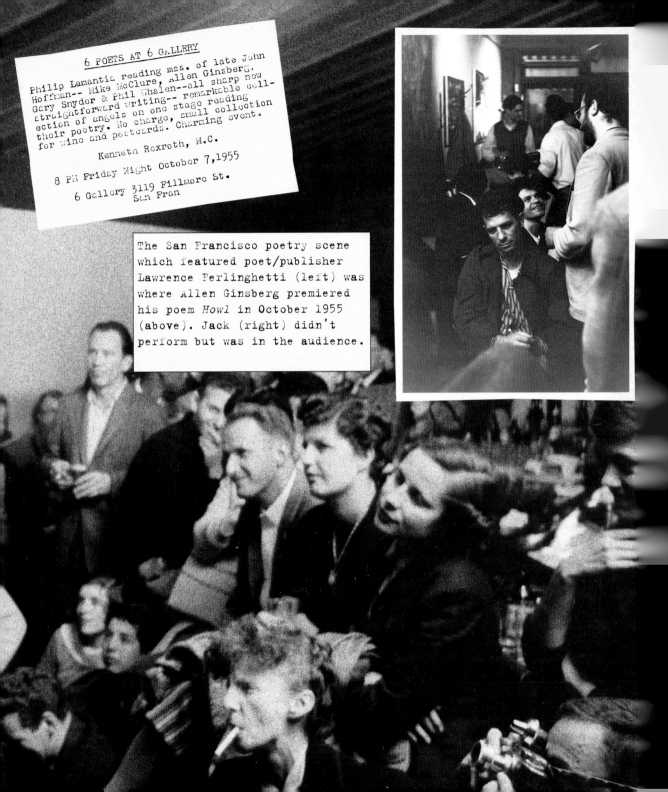

6 POETS AT 6 GALLERY

Philip Lamantia reading mss. of late John
Hoffman-- Mike McClure, Allen Ginsberg,
Gary Snyder & Phil Whalen--all sharp new
straightforward writing-- remarkable coll-
ection of angels on one stage reading
their poetry. No charge, small collection
for wine and postcards. Charming event.

Kenneth Rexroth, M.C.

8 PM Friday Night October 7,1955

6 Gallery 3119 Fillmore St.
San Fran

The San Francisco poetry scene
which featured poet/publisher
Lawrence Ferlinghetti (left) was
where Allen Ginsberg premiered
his poem *Howl* in October 1955
(above). Jack (right) didn't
perform but was in the audience.

drugs, but Jack found himself attracted to her suffering. In *Tristessa*, the novel he was later to write about her, he compared her eyes to Billie Holiday's and her look of resignation to that of the Virgin Mary.

Tristessa, which he began writing as the story unfolded, saw him caught between the old Catholic certainties and the Buddhism he was still trying to grasp. There was no way to synthesize the two without violating their essential beliefs. Catholicism taught him that there was a real world and that our actions in it were judged by God. Buddhism taught him that the only human failing was to believe that the world was real.

He continued to write short poems, limiting the length of each one to the size of the pages in his pocket notebooks, and sent 242 'choruses' of what he was calling *Mexico City Blues* to Ginsberg to illustrate the potential of spontaneous poetry.

Although Jack didn't know it, Ginsberg was just about to act upon the advice from Kenneth Rexroth that he loosen up his style. As he sat in his first-floor room overlooking Montgomery Street one afternoon in early August 1955, he began writing for his 'own soul's ear', and as the line 'I saw the best minds of my generation' was typed out, using the measure of breath as the length of each phrase, rather than classical metre, he realized that he had discovered the freedom of imagination he'd been looking for.

This was the beginning of *Howl*, the poem that would eventually take the Beat Generation from where it had been as the secret of a few readers of the literary pages into a national and then international phenomenon. As Jack sat on a rooftop in Mexico City writing *Mexico City Blues*, Ginsberg, in San Francisco, had found his authentic voice in a combination of Old Testament prophecy, American speech-rhythms, jazz-riffs and hipster-talk, which gushed out of him as if a dam had been breached.

He immediately sent a copy to Jack, who was at first less than enthusiastic – admitting its verbal power but arguing that it wasn't spontaneous because he could see that there had been revisions. On September 1, Ginsberg moved to a small cottage on Milvia Street in Berkeley, and a week later Jack left Mexico City to join him. He arrived in Berkeley high on Benzedrine and sat in Ginsberg's living room playing a record of the *St Matthew Passion* until he came home.

Ginsberg was now in a state of high excitement, organizing a poetry reading at a converted auto repair shop in the Fillmore district where

(154)

he would perform in the company of the Bay Area poets Gary Snyder, Philip Whalen, Philip Lamantia and Michael McClure. His original plan had been to put on an evening of Beat Generation readings, during which he would read with Jack and Neal, but neither of his friends had the confidence to appear in public.

Jack was introduced to these local poets, and was particularly taken with Snyder and Whalen, who were Buddhists, loved hiking in the Californian mountains and practised a simple lifestyle. Snyder had been a Buddhist since the late 1940s and was now studying Japanese at U. C. (Berkeley), and translating the poetry of Han Shan from Japanese to English. Whalen was a student of Zen who had recently spent the summer fire-watching in Washington's High Cascades.

The reading which was to transform the profile of the Beat Generation took place on October 13. Jack was in the audience of around 150 people, banging on a jug of Californian Burgundy and shouting 'Go! Go!' to give the evening the spirit of a jazz event rather than a formal literary gathering. The highpoint of the evening was Ginsberg's unveiling of his recently completed poem *Howl*, which he delivered with such passion that the audience was electrified. It wasn't simply the torrent of language, but the fact that Ginsberg was speaking on behalf of all of them, articulating their feelings of lostness in modern America.

'In all of our memories no one had been so outspoken in poetry before,' says McClure. 'We had gone beyond a point of no return - and we were ready for it, for a point of no return. None of us wanted to go back to the grey, chill, militaristic silence, to the intellective void - to the land without poetry - to the spiritual drabness. We wanted to make it new and we wanted to invent it and the process of it as we went into it. We wanted voice and we wanted vision.'

After the event, Jack told Ginsberg that this one poem was going to make him famous in San Francisco. Kenneth Rexroth corrected him by saying that it would make him famous 'from bridge to bridge'. The next day, Ferlinghetti, in his role as the publisher of City Lights' Pocket Poets Series, sent Ginsberg a telegram which read: 'I greet you at the beginning of a great career. When do I get the manuscript?'

Jack began seeing more of Snyder, who lived in a cottage furnished only with wooden crates and straw mats, and who travelled around either on foot or by bicycle. They discussed the different schools of Buddhism, and Snyder taught him the art of constructing epigrammatic seventeen-syllable poems in the style of Japanese haikus, as well as entertaining

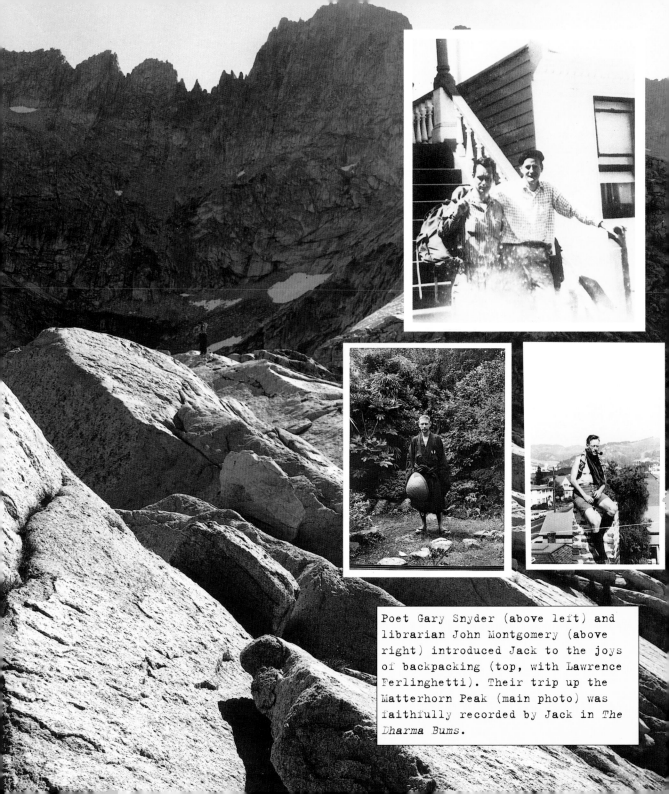

Poet Gary Snyder (above left) and librarian John Montgomery (above right) introduced Jack to the joys of backpacking (top, with Lawrence Ferlinghetti). Their trip up the Matterhorn Peak (main photo) was faithfully recorded by Jack in *The Dharma Bums*.

him with his translations of poetry.

In late October Snyder invited Jack to join him and his librarian friend John Montgomery as they climbed the 12,000-foot Matterhorn mountain in the Sierra Nevada – a trip that Jack was to immortalize in *The Dharma Bums*. For Snyder, who had spent a lot of his life outdoors, it was an unexceptional autumn ramble, but for Jack, who hadn't done anything so vigorous since breaking his leg at Columbia, it was a great achievement, made all the more pleasurable because he was drinking in Snyder's wisdom of wildlife, backpacking, survival, astronomy, Buddhism and radical politics.

Just as Neal represented the garrulous, energetic person that Jack would never be, so Snyder represented the politically active, spiritually consistent person that he would never be. In *The Dharma Bums* Snyder is idealized as a rugged individualist – a prototypical back-to-nature hippie who scorns the complacency of American affluence and calls for a generation of 'Zen lunatics' to practise 'eternal freedom to everybody and all living creatures' while praying in the mountains, hiking down the roads and composing spontaneous poetry.

This was the most intensely religious period of Jack's life. *The Dharma Bums* showed him still juggling the merits of Buddhism and Catholicism – towards the end of the book he portrays himself sitting on the grass meditating under the moon, 'wishing there were a personal god in all this impersonal matter'. Sensing Jack's reluctance to abandon his belief in some of the key tenets of Christianity, Snyder prophetically commented: 'I can see you on your deathbed kissing the cross.'

After coming down from the mountain, Jack went to stay with Neal in Los Gatos before going to his sister's home in Rocky Mount for Christmas. It was during his stay with Caroline that he began writing *Visions of Gerard*, a tender but highly romanticized portrait of his brother's death, in which he tries again to comprehend the meaning of suffering. His best attempt to unite Buddha and Christ is to reduce the essential teachings of both to: 'All is Well, practise Kindness, Heaven is nigh'.

Early in the New Year, Jack wrote four letters to District Rangers in Washington State, applying for a job as a fire-spotter in one of the national forests. He imagined that while alone in a lookout tower he would be able to study, write and meditate in perfect peace. Perhaps he would even receive the enlightenment he had been searching for.

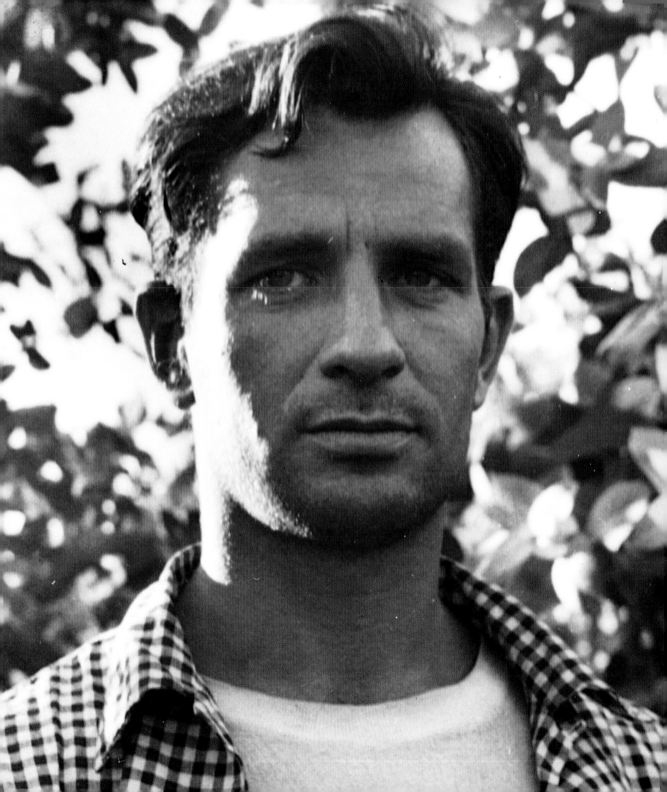

10

Flaming Cool Youth

At the age of thirty-four, although just on the verge of success, Jack had begun his personal and literary decline. He had been almost everywhere he was ever going to go, had said almost all he was ever going to say, and life had lost its capacity to thrill him.

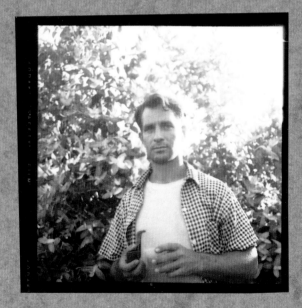

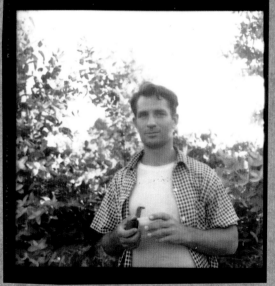

Jack photographed at Gary Snyder's farewell party held at Locke McCorkle's home in Mill Valley during May 1956. He is seen (top left) talking to Philip Whalen.

A letter of acceptance came from the National Forest Service
offering Jack work as a lookout on Desolation Peak in the Mount Baker
National Forest, starting in June 1956. Gary Snyder was due to leave
California on May 5 for two years of study in Japan, and Jack made plans
to stay with him for a month in his Mill Valley cabin before travelling
to the job in Washington State.

He left Rocky Mount on March 17, arriving at Snyder's early in
April. He settled in and began typing up *Mexico City Blues* and worked on
one of his most experimental projects, *Old Angel Midnight*, which he
described in a letter to John Clellon Holmes as 'an endless automatic
writing piece', the routine in Mill Valley was ideal. During the day
both he and Snyder would be reading or writing and then, in the evening,
they would go walking and talk.

During one of these talks Snyder encouraged Jack to write a sutra
(a Buddhist discourse). Jack responded with *The Scripture of the Golden
Eternity*, sixty-six brief meditations based on the paradox that: 'All
things are different forms of the same thing. I call it the golden
eternity . . ., and yet, 'There is no golden eternity because everything
is nothing.'

When the time came for Snyder to take the boat to Japan a three-day
party was thrown, after which Jack went to the dockside to wave goodbye
to his mentor. Six weeks later he hitchhiked north to the Ranger Station
in Marblemount to receive a week's training before leaving for his
remote tower on Desolation Peak, twelve miles from the Canadian border.
In doing this lonely job he was consciously emulating Snyder and Whalen,
who had both worked as fire-watchers in the High Cascades. He planned to
use the time as a period of cleansing. There would be no alcohol, drugs
or sex, and so he could write and meditate and perhaps come face-to-face
with God (or the void), 'and find out once and for all what is the
meaning of all this existence and suffering and going to and fro in
vain'.

But instead of visions and revelations he faced boredom and an
aching loneliness in the face of the emptiness around him. His thoughts
began to return to Lowell, to Mary Carney and the life he might have had
if he had never hit the road. Instead of facing God he faced himself,
and he didn't like what he saw. 'What did I learn?' he later asked
himself in *Desolation Angels*. 'I learned that I hate myself because by
myself I am only myself and not even that . . .'

After sixty-three days on Desolation Peak he came down, desperate

The haunting Hozomeen Mountain ('Hozomeen is the Void') as seen from Desolation Peak, Jack's home for 63 days in 1956. When he came back down the mountain the Beat movement had gained the attention of the media and he posed (below, with Allen Ginsberg) for the classic photograph which was to grace the covers of his books.

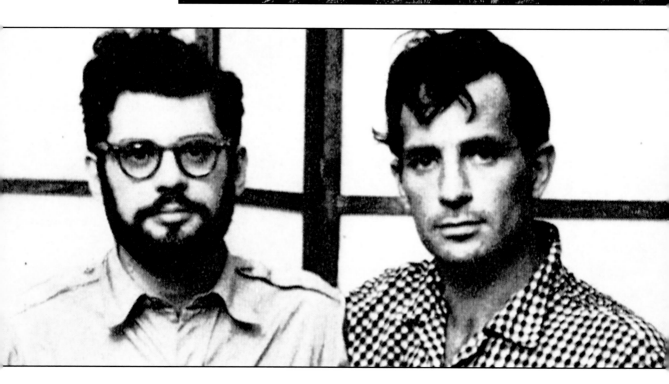

for company and kicks. After a night on the town in Seattle he took the bus down to San Francisco, where he discovered that the media was hungry for Beat Generation stories. *Howl* was to be published by City Lights; the *New York Times* was about to print a big story on the new San Francisco poetry scene, and both *Life* and *Mademoiselle* were planning features which would include Jack, Ginsberg and Gregory Corso.

This attention ruffled the feathers of some of the long-established Bay Area poets who had been performing for years. 'The Beats were just carpetbaggers,' says Ferlinghetti. 'They were passing through. Kerouac, Ginsberg and Corso were East Coast people. There was already a movement in San Francisco made up of indigenous poets.'

It was for the *Mademoiselle* feature, provisionally titled 'Flaming Cool Youth of San Francisco Poetry' but actually published as 'The Lively Arts in San Francisco', that Jack posed for the photograph which later graced the paperback editions of his books throughout his life, and forever fixed the image of Jack Kerouac in the minds of a generation. Gregory Corso ruffled his hair for the shot, to make him look more Bohemian, and gave him a silver cross to wear outside his shirt. The cross was later cropped out, due to fear that the image of a Beat wearing a Christian symbol might offend the American public.

At the same time, Jack heard that Malcolm Cowley had been given the go ahead by Viking to publish *On the Road* in the new year. The disenchantment with modern American life that had characterized the Beat Generation for so long was now no longer the grievance of a small minority of misfits. Suddenly Beat literature had real commercial potential, and found resonance in the concerns of the culture as a whole. On the streets there was an increase in juvenile delinquency and inner-city gang warfare, which had sociologists wringing their hands and asking how such anti-social behaviour could exist in the wealthiest and most powerful nation on Earth. In the universities there was a sense of unease about the subordination of individualism to the faceless organization.

The most articulate criticism of this latter trend came from William H. Whyte, the assistant managing editor of *Fortune* magazine. In his book *The Organization Man*, Whyte argued that modern American organizations created a bland uniformity where all traces of individual expression were carefully ironed out. 'The quest for normalcy,' said Whyte, 'as we have seen in suburbia, is one of the great breeders of neuroses, and the Social Ethic only serves to exacerbate them. What is

Mexico, November 1956. Jack, Ginsberg and Peter Orlovsky (standing). Gregory Corso and Lafcadio Orlovsky (kneeling).

normalcy? We practise a great mutual deception.'

In a similar spirit, academic Paul Goodman examined the restlessness of the young in *Growing Up Absurd*, also published in 1956, and concluded that America would be wise to listen to its youthful critics, including the Beat Generation. 'Let me say that we of the previous generation who have been enraged to see earnest and honest effort and humane culture swamped by [the organized system] are heartened by the crazy young allies, and we think that perhaps the future may make more sense than we dared hope.'

Rock 'n' roll was yet another expression of the desire to break the bonds of conformity. The film *The Blackboard Jungle* had introduced Bill Haley's *Rock Around the Clock* the year before, but it was in 1956 that Elvis Presley became a national and international phenomenon. It was on January 11 that he cut his first single for RCA (*Heartbreak Hotel*), and September 9 that he made his début on the *Ed Sullivan Show*. Jack watched the show with poet Gregory Corso, and both of them sensed that with a white boy borrowing rhythm and blues something significant was taking place. 'We liked Elvis, that's for sure,' says Corso. 'He wasn't political, but we identified with the sexual wiggling of his body. We thought that was great.'

Later in that month, Jack returned to Mexico to complete *Tristessa* and to start *Desolation Angels*, and in November he was joined by Ginsberg, Orlovsky, Orlovsky's brother Lafcadio and Gregory Corso. He was no longer the abstemious Buddhist, but was now the Catholic caught up on a treadmill of sin and repentance. He sought out teenaged prostitutes, and even took part in homosexual orgies organized by Ginsberg and Orlovsky.

Corso was the first to leave Mexico, and the others followed, driving back to New York. Jack and Ginsberg found that they were mini-celebrities in Greenwich Village, due to the buzz about their forthcoming books. Jack's most urgent task was to revise *On the Road*. Malcolm Cowley still wanted some scenes deleted or condensed. 'I had no power to stand by my style for better or worse,' he told *Paris Review* in 1968. 'Malcolm Cowley made endless revisions and inserted thousands of needless commas.'

At the age of thirty-four, although just on the verge of success, Jack had begun his personal and literary decline. He had been almost everywhere he was ever going to go, had said almost all he was ever going to say, and life had lost its capacity to thrill him. He was

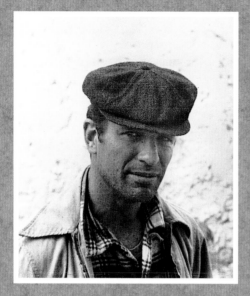

It was while Jack was in Tangiers (left and below) during March 1957 that news came through that the first copies of *Howl* (right) had been impounded by US Customs on grounds of obscenity.

THE POCKET POETS SERIES

HOWL

AND OTHER POEMS

ALLEN GINSBERG

Introduction by

William Carlos Williams

NUMBER FOUR

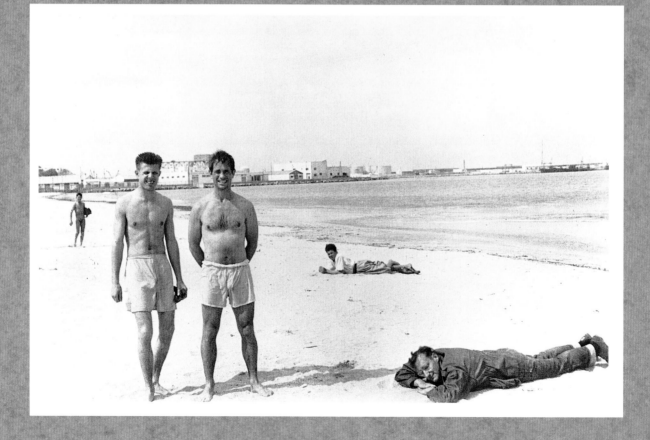

drinking heavily, missing appointments and causing embarrassing scenes with his new girlfriend, Helen Weaver, and Cowley. He would provoke fights and throw insults simply to test people.

Those who had known him over a long period of time were astonished by the changes in his character. John Clellon Holmes noticed a physical deterioration and a lack of sparkle in his eyes. LuAnne Henderson, who had met him in San Francisco in July, noted his switch from beer to whisky, and that he'd become a much harder person over the past decade. 'I always thought of him as the sweetest man I had ever met,' she says, 'but he changed overnight through drink.'

In February 1957, after finally signing his Viking contract, Jack took off on a Yugoslavian tanker to Tangiers, Morocco, where Burroughs was now living in a hotel in the old French quarter. Known to its guests as Villa Delirium, the hotel, which was run by the former owner of a Saigon brothel, was a haven for Western decadents who wanted cheap sex and drugs without fear of arrest.

Jack's plan was to spend the spring in North Africa and then travel through Europe in the summer. However, he was soon complaining about the bad food, the poor opium and the high price of the whores. Burroughs was working on *The Naked Lunch*, the first of his novels to bear his real name, and Jack, who had suggested the title and had been responsible for convincing him that he should become a writer in the first place, helped type the manuscript.

Ginsberg and Orlovsky arrived in Tangiers in March, with the news that 500 copies of *Howl* which were being shipped to City Lights from printers in London, England had been seized by the US Customs for being obscene. There was to be a court case in July and, as Ginsberg well knew, a huge amount of publicity which would help cement his reputation as a spokesman for the Beat Generation.

More than any of the other Beat Generation writers, Ginsberg knew the value of promotion and visibility, and his willingness to be a forthright public poet and activist meant that the media continued to pay attention to him. He had fought hard to bring Jack and Burroughs to the attention of New York publishers and critics, and when *Howl* was published he made sure that copies were sent to people like Charlie Chaplin, W. H. Auden and T. S. Eliot.

It is often forgotten that at the time *Howl* was published, Ginsberg had spent over six years in advertising and journalism. He had worked on a campaign to sell toothpaste, had been a copy-boy at the *New York World*

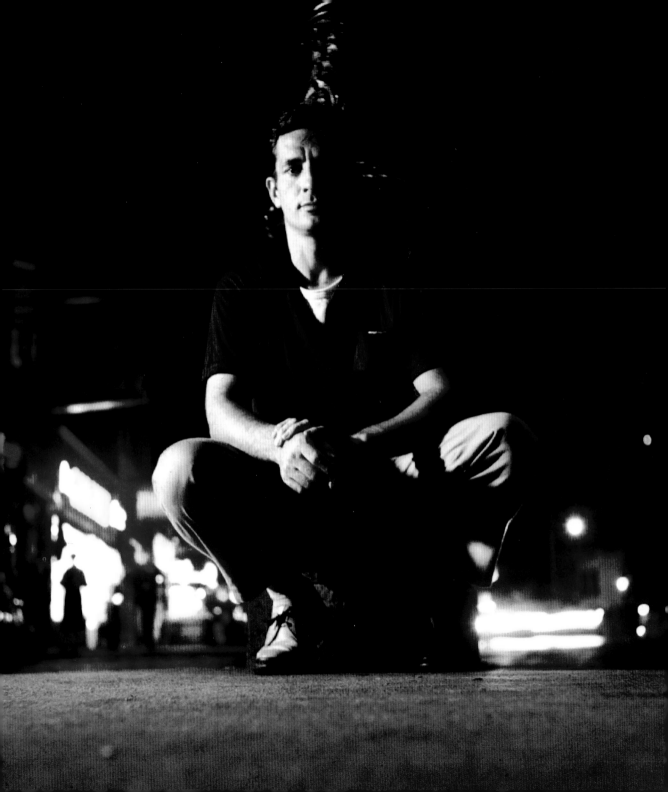

Telegram, and had spent two years in New York as a freelance market researcher. He knew how to promote a product and knew how to create a good story that the press would pick up on.

Ginsberg had sent invites to a Venice Beach reading, emceed by Lawrence Lipton, to Anaïs Nin, Aldous Huxley, Marlon Brando and James Dean (only Nin attended). At the reading he responded to the taunts of a heckler by striding out into the audience and removing his clothes before the man. 'Stand naked before the people,' Ginsberg said, doing just that. 'The poet always stands naked before the world.' It was undoubtedly an act performed in sincerity; but was typically dramatic, provocative and outrageous – and made for good copy.

Ginsberg sensed that he was participating in literary and cultural history. He was the one member of the Beat Generation who always kept a camera at the ready, who kept clippings files and who wrote journals of amazing detail. 'He was the really smart one', admits Gregory Corso. 'He was the one who had the knack of seeing things happening.'

Jack had no real sense of publicity. He claimed he was 'too bashful' to do public readings, avoided television as much as he could, and did nothing to sell himself in interviews. Like Ginsberg, he realized he was taking part in significant events, but he was more concerned with completing a series of books that would one day tell the story of his life than with promoting a group identity.

On April 5 1957, Jack took a boat to Marseille, and then travelled through Aix-en-Provence, Arles and Avignon until he reached Paris. There he met up with Gregory Corso, who was writing pornography for Olympia Press. Paris was a magnet for American writers and artists, who enjoyed its tolerant lifestyle and the existential philosophies of Sartre and Camus. But instead of looking up ex-patriot writers, Jack chose to become a normal American tourist, taking in the splendours of Sacré Coeur and Notre Dame and walking round the Louvre.

He took a train from Paris to London where he saw *Anthony and Cleopatra* at the Old Vic, heard Bach's *St Matthew Passion* performed at St Paul's Cathedral, and looked around the National Gallery. Rock 'n' roll had just hit Britain, and he was interested to walk around Soho which was now a haven for 'Teddy Boys', who wore thick-soled shoes called 'brothel creepers', tight 'drainpipe' trousers and long jackets with velvet collars.

He arrived back in America at the end of April and decided to take his mother out to California, where he set her up in a hotel while he

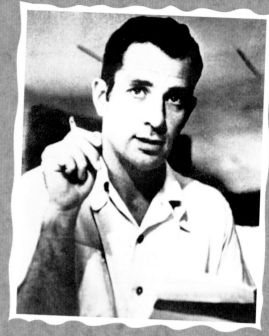

Books of The Times

By GILBERT MILLSTEIN

"ON THE ROAD" is the second novel by Jack Kerouac, and its publication is a historic occasion in so far as the exposure of an authentic work of art is of any great moment in an age in which the attention is fragmented and the sensibilities are blunted by the superlatives of fashion (multiplied a millionfold by the speed and pound of communications).

This book requires exegesis and a detailing of background. It is possible that it will be condescended to by, or make uneasy, the neo-academicians and the "official" avant-garde critics, and that it will be dealt with superficially elsewhere as merely "absorbing" or "intriguing" or "picaresque" or any of a dozen convenient banalities, not excluding "off-beat." But the fact is that "On the Road" is the most beautifully executed, the clearest and the most important utterance yet made by the generation Kerouac himself named years ago as "beat," and whose principal avatar he is.

Just as, more than any other novel of the Twenties, "The Sun Also Rises" came to be regarded as the testament of the "Lost Generation," so it seems certain that "On the Road" will come to be known as that of the "Beat Generation." There is, otherwise, no similarity between the two; technically and philosophically, Hemingway and Kerouac are, at the very least, a depression and a world war apart.

The 'Beat' Bear Stigmata

Much has been made of the phenomenon that a good deal of the writing, the poetry and the painting of this generation (to say nothing of its deep interest in modern jazz) has emerged in the so-called "San Francisco Renaissance," which, while true, is irrelevant. It cannot be localized. (Many of the San Francisco group, a highly mobile lot in any case, are no longer resident in that benign city, or only intermittently.) The "Beat Generation" and its artists display readily recognizable stigmata.

Outwardly, these may be summed up as the frenzied pursuit of every possible sensory impression, an extreme exacerbation of the nerves, a constant outraging of the body. (One gets "kicks"; one "digs" everything, whether it be drink, drugs, sexu'l promiscuity, driving at high speeds or absorbing Zen Buddhism.)

Inwardly, these excesses are made to serve a spiritual purpose, the purpose of an affirmation still unfocused, still to be defined, unsystematic. It is markedly distinct from the protest of the "Lost Generation" or the political protest of the "Depression Generation."

The "Beat Generation" was born disillusioned; it takes for granted the imminence of war, the barrenness of politics and the hostility of the rest of society. It is not even impressed by (although it never pretends to scorn) material well-being as distinguished from materialism. It does not know what refuge it is seeking, but it is seeking.

As John Aldridge has put it in his critical work, "After the Lost Generation," there were four choices open to the post-war writer: novelistic journalism or journalistic novel-writing; what little subject-matter that had not been fully exploited already (homosexuality, racial conflict), pure technique (for lack of something to say), or the course I feel Kerouac has taken—assertion "of the need for belief even though it is upon a background in which belief is impossible and in which the symbols are lacking for a genuine affirmation in genuine terms."

Five years ago, in the *Sun* magazine

fine the generation Kerouac had labeled. In doing so, he carried Aldridge's premise further. He said, among many other pertinent things, that to his kind "the absence of personal and social values * * * is not a revelation shaking the ground beneath them, but a problem demanding a day-to-day solution. *How to live* seems to them much more crucial than *why*." He added that the difference between the "Lost" and the "Beat" may lie in the latter's "will to believe even in the face of an inability to do so in conventional terms"; that they exhibited "on every side and in a bewildering number of facets a perfect craving to believe."

Those Who Burn, Burn, Burn

That is the meaning of "On the Road." What does its narrator, Sal Paradise, say? "* * * The only people for me are the mad ones, the ones who are mad to live, mad to talk, mad to be saved, desirous of everything at the same time, the ones who never yawn or say a commonplace thing, but burn, burn, burn like fabulous yellow roman candles. * * *"

And what does Dean Moriarty, Sal's American hero-saint say? "And of course no one can tell us that there is no God.

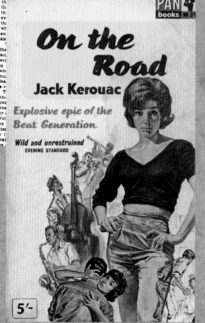

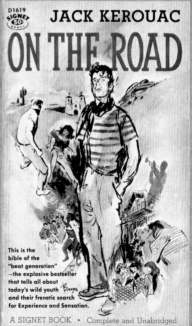

The rave review of *On the Road* in the *New York Times* (above) hailed Jack as a voice of his generation, and helped turn him into a celebrity.

wrote at Ginsberg's Berkeley cottage. He had thought that they might both settle there, but after two months he returned with her to Florida, installed her in a new home that they bought, and took off for a month of writing in Mexico City.

He was back in New York for the publication of *On the Road*, and was living with twenty-one-year-old Joyce Glassman. Jack had been advised that a review of *On the Road* was to appear, in *The New York Times* on September 5, so in the very early hours of that morning he and Joyce walked from their apartment on 68th Street to a news vendor on 66th Street who they knew had just been given the early edition of the paper.

Together, they went to Donnelly's bar and spread the copy out on a table. Gilbert Millstein, the literary editor who had commissioned John Clellon Holmes' feature on the Beat Generation, five years before, had written the review, which praised *On the Road* in no uncertain terms, calling its publication 'an historic occasion', concluding that Jack had done for the Beat Generation what Hemingway had done for the Lost Generation.

Joyce was thrilled with the review, but she noticed that Jack didn't look happy. Instead, he looked puzzled, as if, having reached the top of the mountain he'd been climbing for almost twenty years, he'd discovered that the view was really not all that good. Maybe he was assessing his responsibilities. Maybe he didn't want the anonymity and struggling to end so abruptly. 'We returned to the apartment to go back to sleep,' Joyce wrote in *Minor Characters*, her memoir and portrait of the era. 'Jack lay down, obscure for the last time in his life. The ringing phone woke him the next morning and he was famous.'

Not all the reviewers were as ecstatic as Millstein. Those who didn't like the book criticized it either for its lack of plot or for its apparent celebration of anti-social behaviour. Paul Goodman, who made his review part of the appendices of later editions of *Growing Up Absurd*, condemned it as bad writing and criticized it for celebrating inconsequential occurrences. 'There are hundreds of incidents but, throughout the book, nothing is told, nothing is presented, everything is just "written about."' The *Chicago Tribune* thought Jack's writing 'uncontrolled', whereas *The Nation* saw the book as a 'naive paean to madness' which dignified law-breaking. *Time* thought that Dean Moriarty sounded like a 'criminal psychotic', and quoted a psychiatrist's description of such a person as 'highly emotional, uncooperative, disobedient, disjointed talk, stubborn'.

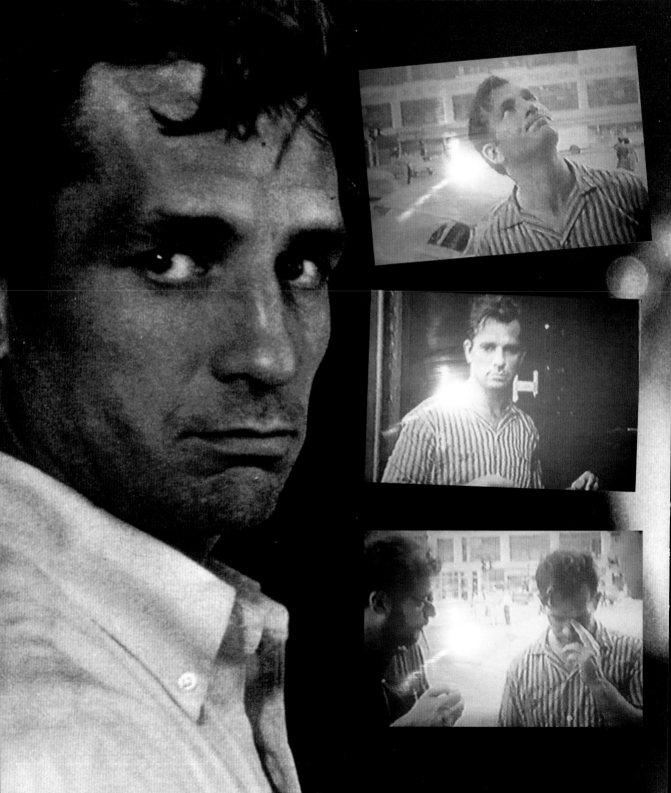

Neal had his own problems with the book. 'Neal certainly wouldn't have wanted to hurt Jack by telling him,' says Carolyn, 'but the thing that really depressed him was the fact that *On the Road* celebrated all the things which he hated about himself and all the things which he was struggling so hard to overcome. He had this terrible lust, and no one really understands what he suffered over that. I think part of it came from the fact that he had no mother-love, ever. This meant that Neal learned to con to survive, and always had to be in control. He hated women, he said, because they were his weakness.'

For the next five weeks, Jack threw himself into the lifestyle of a celebrity – drinking hard to boost his confidence, trailing from party to party, and taking his pick of women. Broadway wanted him to write a play on the Beat Generation, men's magazines begged him for features on the new hip lifestyle, and Grove Press offered to publish an unabridged version of *The Subterraneans*.

In San Francisco, there was even more Beat Generation publicity over the *Howl* trial in October, when the court finally ruled that City Lights had not been guilty of publishing and selling an obscene book. Jack made his first television appearance in New York, being interviewed by John Wingate on *Nightbeat* for WOR-TV. The Beat writers were a social oddity but also, for Middle America – who knew that they used obscene language, took drugs and had casual sex – they had the glamour of striptease artists or gangsters. While disapproving of what they got up to, it was still possible to get a cheap thrill while contemplating their actions.

Jack was aware that to many people his publicity value was as an unregenerate American male, but he didn't want to play that role. He saw himself as a suffering artist in search of sainthood, not a peddler of sleaze. 'Tell me, Jack, exactly what are you looking for?' asked Wingate. 'I'm waiting,' said Jack, 'for God to show His face.'

Jack drank to cope
with fame. By nature
he was an introvert
and yet his readers
expected him to burn
with the intensity of
Dean Moriarty.

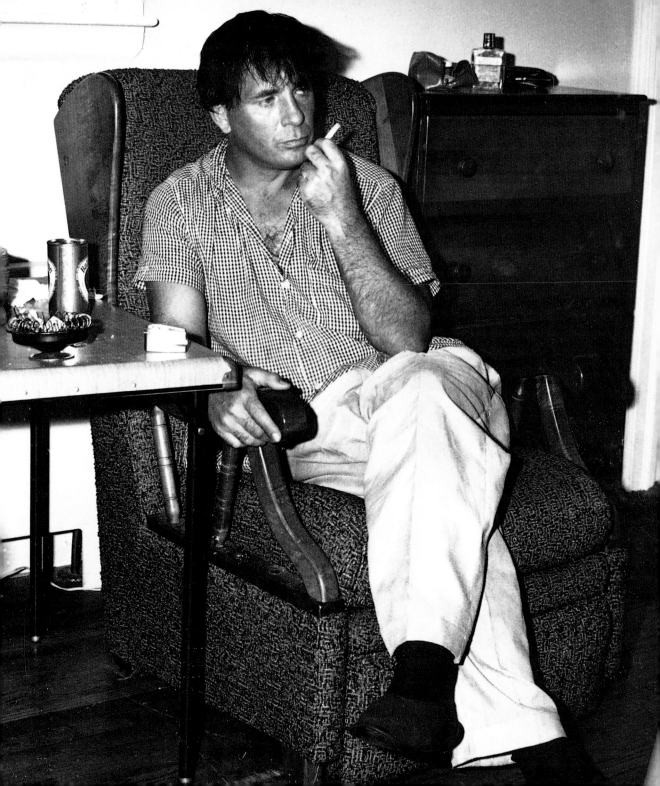

11

the final Horrors

During the trip Jack was shouting to Leary: 'Can your drugs absolve the mortal and venial sins which our beloved Saviour Jesus Christ, the only Son of God, came down and sacrificed his life upon the cross to wash away?' Leary, who was also raised as a Roman Catholic, experienced his first bad trip that day.

Jack,
uncharacteristically
dressed in a beret,
gives a reading of
his poetry at the
Seven Arts Gallery in
New York (right) and
then mingles with the
audience (below).

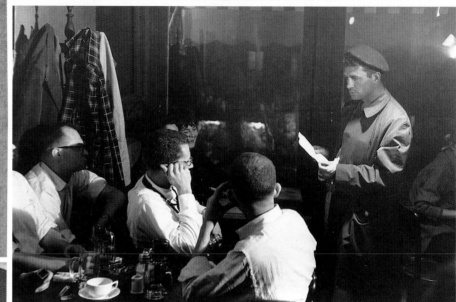

Throughout the rest of 1957 Jack worked and played in New York, writing *The Dharma Bums* in a two-week burst, giving readings of poetry and prose at the Village Vanguard in December, and hanging out with Philip Lamantia and his fellow-Catholic poet Howard Hart. He attended mass with Hart and Lamantia at Our Lady of Guadalupe, and read with them at New York's first poetry and jazz show at the Brata Gallery, where David Amram played French horn.

Jack was a natural candidate for poetry and jazz experimentation because of the powerful influence jazz had exerted over his writing and the kinship he felt with musicians. He had for years practised scat singing – perhaps his earliest form of spontaneous verbal composition – and at Neal's house he would often tape-record himself reading to music from the radio.

It was, though, Kenneth Rexroth who had pioneered the fusion of poetry and jazz – initially as a teenager in the 1920s, when he ran a club called The Green Mask in Chicago where he and Langston Hughes read poems to the music of the Austin High Gang, and then in the spring of 1957 at a San Francisco club called The Cellar, where he featured poets such as Lawrence Ferlinghetti and Kenneth Patchen.

Rexroth saw poetry readings – and especially readings with jazz – as a means of bringing literature to a wider audience. 'We think that good poetry gives jazz words that match its own importance,' he once said. 'Then, too, the combination of poetry and jazz, with the poet reciting, gives the poet a new kind of audience. Not necessarily a bigger one, but a more normal one – ordinary people out for the evening, looking for civilized entertainment. It takes the poet out of the bookish, academic world and forces him to compete with "acrobats, trained dogs and singer's midgets", as they used to say in the days of Vaudeville.'

The idea of rediscovering poetry as a performing art appealed to Jack, who had attended Rexroth's poetry soirées in San Francisco, but he lacked the courage to stand up in front of an audience. He coped with his week-long stint at the Village Vanguard only by fuelling up on whisky and fiddling with a rosary. Unsure of how his own material would connect, he played it safe by mixing poems from *Mexico City Blues* with work written by Ginsberg and Corso.

For one show, he was accompanied on piano by Steve Allen, a musician and television host. Bob Thiele, East Coast A & R director of Dot Records, approached Jack with the idea that he and Allen repeat the

performance for a record. Jack was happy to do it, and went into the studio in March 1958 to record *Poetry for the Beat Generation*, which included *October in the Railroad Earth*, choruses from *Mexico City Blues*, and a handful of unpublished poems. The album was released a year later, and was followed by *Blues and Haikus*, recorded with seasoned jazz musicians Al Cohn and Zoot Sims.

The Subterraneans, finally published in February 1958, was fiercely criticized. It was as if those who resented the success of *On the Road* were now lining up, cudgels at the ready. The *New Republic* said that Jack was simply 'ignorant', *Time* called him 'the latrine laureate of Hobohemia', and Kenneth Rexroth, reviewing the book for the *San Francisco Chronicle*, said that although it wasn't a bad book it had 'all the essential ingredients of a bad book'.

But the most carefully argued criticism, and the one which most affected Jack, came from critic Norman Podhoretz, who wrote an essay on the Beats for the *Partisan Review* entitled 'The Know-Nothing Bohemians', based largely on his reading of *On the Road* and *The Subterraneans*. He said that Jack displayed little imagination, a limited vocabulary and an inability to develop characters. Worst of all, by elevating instinct and denigrating rational thought, he considered Jack guilty of promoting a dangerous anti-intellectualism. The Beats, in Podhoretz's view, believed that 'incoherence is superior to precision . . . ignorance is superior to knowledge . . . the exercise of the mind and discrimination is a form of death'.

Jack's faith in passion and primitivism (both primal instincts and primal cultures) were, to Podhoretz, little different from the attitudes guiding the new wave of juvenile delinquency that was hitting America's cities. 'The spirit of hipsterism and the Beat Generation,' he wrote, 'strikes me as the same spirit which animates the young savages in leather jackets who have been running amok in the last few years with their switch-blades and zip guns.'

This last comment upset Jack, who saw his work in religious terms and disliked even the mild violence of films like *The Wild Ones* and *Rebel Without a Cause*. Not only did he feel nothing in common with 'young savages in leather jackets', but also disassociated himself from the bongo drum-and-sandals craze that was now in full swing as commercial interests exploited the Beat phenomenon.

In June 1958, *San Francisco Chronicle* columnist Herb Caen had coined the word 'beatnik', a play on the recently launched Russian

satellite known as Sputnik-1. To Jack, beatniks were nothing more than the 'cool hipsters' of 1948, who were characterized by low, unfriendly speech, black clothes and a laconic, sage-like image. He had always identified with the 'hot hipsters', who were 'crazy, talkative, shining-eyed . . . [running] from bar to bar, pad to pad . . .' Significantly, neither he nor Neal Cassady ever wore long hair or affected a laid-back demeanor or wore black clothes.

The beatnik craze brought Jack much unwanted attention, and he found fame impossible to deal with. The criticisms undermined his confidence; he had to drink heavily to cope with meeting so many new people and he was blocked as a writer. In March, he and Gabrielle moved to a white-frame house he bought in Northport, Long Island, where he could tend the garden, watch television and escape to the comfortable world of mother and child.

For the first time in his life he had money. Grove Press was to publish *Doctor Sax*; MGM had bought the film rights to *The Subterraneans* for $15,000; and Tri-way, an independent production company, had paid $25,000 for the film rights to *On the Road* – planning to cast Cliff Robertson and Mort Sahl as Paradise and Moriarty. Marlon Brando had earlier passed on the project because he felt the story was too loose.

Jack's peaceful summer at Northport was disturbed only by the news that Neal had been arrested in San Francisco for selling two joints to undercover narcotics officers and had been sentenced to serve five years to life in San Quentin prison. Soon, there were letters from Neal which showed him trying to reform himself by studying comparative religion and learning the names of every pope. 'Religion,' he wrote in a letter, 'is the only kick left.'

Jack didn't break cover until October, when he began hanging around in New York again, dating a young, widowed artist called Dody Müller, who introduced him to painters such as Wilhelm de Kooning. In November, he took part in a rare debate at the Hunter College Playhouse with the British novelist Kingsley Amis, anthropologist Ashley Montagu, and *New York Post* editor James Wechsler. The title of the debate was 'Is there a Beat Generation?'

Drunk, as he so often was these days, he succeeded in insulting his co-panelists ('a bunch of Communist shits'), and then delivered a prepared speech which was later published as 'Beatific: The origins of the Beat Generation' in which he explained the development of the phrase. The explanation included the story that he was standing in a

(179)

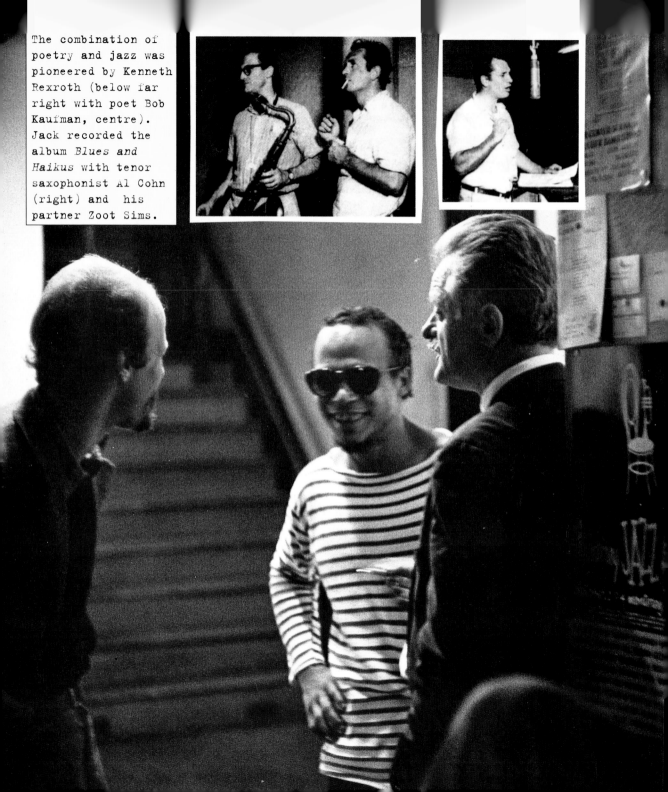

The combination of poetry and jazz was pioneered by Kenneth Rexroth (below far right with poet Bob Kaufman, centre). Jack recorded the album *Blues and Haikus* with tenor saxophonist Al Cohn (right) and his partner Zoot Sims.

church in Lowell in 1954 when he realized that Beat shared a common linguistic root with beatific or beatitude. He also expressed disgust that some commentators in 1958 were associating Beat with violence and teenage crime.

During the next year, Jack spent a lot of time at home in Northport, and fostered friendships with liberal Catholic academics and writers who seemed to find his approach to religious experience refreshing. With poet Howard Hart he could discuss the virtues of European Catholicism and the finer points of Jacques Maritain's art criticism. He even contributed poems to the Catholic journal *Jubilee*.

His trips away from home were mostly to New York; to readings with Ginsberg and Corso, or to the set of *Pull My Daisy*, an experimental film shot by Robert Frank, which used Jack's script and overdubbed voice and featured painter Larry Rivers as Neal, Gregory Corso as Jack and Ginsberg as himself. The title song was the old Ginsberg-Kerouac poem *Pull My Daisy*, with music written by David Amram.

The longest trip from home that year came when he was invited to appear on the *Steve Allen Show*, which was filmed in Los Angeles. He wasn't enthusiastic about taking part, but it meant a plane ticket to California, thirty million viewers, $2,000 and a chance to go on and hang out with his friends in San Francisco. Dressed in a new grey tweed jacket and grey slacks, Jack appeared nervous as he was interviewed by Allen, but loosened up as he read from *Visions of Cody* and *On the Road* while Allen played piano.

In San Francisco he visited Philip Whalen, and met the poets Lew Welch and Albert Saijo. Jack enjoyed a round of parties, including one hosted by actor David Niven to celebrate the launch of *Pull My Daisy*. Eventually, Welch and Saijo, who were riding to New York in a station wagon, offered Jack a lift back home.

En route, the three poets composed haikus, and shortly after arriving in New York they dropped in on photographer Fred McDarrah who was compiling a book of poems and photos called *The Beat Scene*. McDarrah sat them down and took photos as the three men dictated a spontaneous poem which was used in the book. Welch and Saijo later stayed with Jack in Northport.

By 1960, Jack's life seemed to be spiralling out of control, due mostly to his excessive drinking. In April he smashed his elbow after falling in Penn Station. The next month he injured his head badly in the Bowery. Aware of Jack's problems, Lawrence Ferlinghetti suggested that

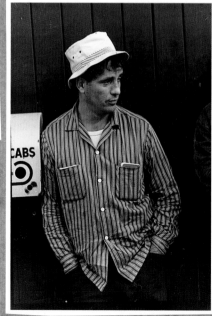

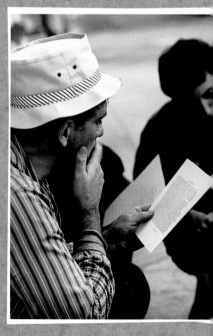

Jack (above) during the filming of the Robert Frank film *Pull My Daisy.*

Jack (above) with painter Larry Rivers and (right) on Columbus Avenue, San Francisco, with notepads in his pockets and manuscripts in his hands.

he came out to California to complete his *Book of Dreams*, which City Lights was interested in publishing. Ferlinghetti had a remote cabin close to the ocean down by Big Sur where Jack could write and retain his privacy. Jack accepted the offer on the condition that no one was told that he was coming to town – he didn't want to be bothered by fans, reporters or college students researching papers.

He left by train for San Francisco in mid-July, arrived in the city on a Saturday evening, and, abandoning his wish for privacy, almost immediately got drunk in the Vesuvio Café, one of the most prominent Beat hangouts on the North Beach, went in to City Lights and embarked on a forty-eight-hour drinking binge. Soon, everyone who mattered knew that Jack Kerouac was back in town.

On the following Monday, he took a bus down to Monterey and then a cab to Bixby Canyon, reaching Ferlinghetti's cabin. The first two weeks of isolation suited him. He cut wood, hiked, cooked his own meals and read Robert Louis Stevenson's *Dr Jekyll and Mr Hyde*. Fascinated by the sound of the ocean outside, he would sit on the beach in the evenings trying to transcribe the rise and fall of the waves into phonetic sounds.

But, as with his experience on Desolation Peak, loneliness soon set in, and the dark emptiness outside the cabin at night seemed to echo an emptiness he felt inside. It was the beginning of a minor mental breakdown. 'I felt completely nude of all protective devices like thoughts about life or meditations under trees and the "ultimate" and all that shit . . .' he wrote in *Big Sur*. 'I see myself as just doomed, pitiful – an awful realization that I have been fooling myself all my life thinking that there was a next thing to do.'

Hankering after city life and the consolations of sex and alcohol, he set out to hitchhike into San Francisco, but found that America's attitude towards hitchhikers had changed since he last stood on a roadside with his thumb out. The celebrated author of *On the Road*, with his heavy pack on his back, had to walk seven miles in the hot sun before a small truck stopped to pick him up. Even then, he was only taken as far as Monterey and had to pick up a bus from there. It was the last time he would ever hitchhike anywhere.

When he returned to the cabin in the company of Lawrence Ferlinghetti, Philip Whalen and Lew Welch, they called in on Neal, who had just been released from San Quentin and was living in Los Gatos, a leafy village ten miles south of San Jose. They persuaded him to join

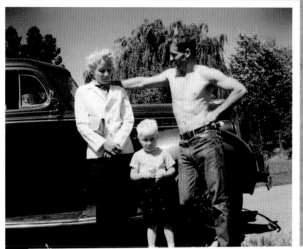

The Cassady family (top left) moved to 18231 Bancroft Avenue, Los Gatos (above) where Jack again stayed with them (left).

them for the weekend and shortly afterwards he returned with Carolyn and the children. Also there were Michael McClure and his wife, Joanna, and a young poet called Paul Smith who, much to Jack's annoyance, was a huge fan of the Beat Generation.

A bonfire was built on the beach, Smith sang folk songs and McClure passed around an erotic poem he'd written about Joanna. Jack thought it 'the most fantastic poem in America', but Carolyn was embarrassed that someone could make public with 'obscene language' what she thought should be 'cherished as personal and private'.

The next day, after a wood chopping contest and a sumptuous lunch, Jack was again struck with an attack of what he called 'the final horrors'. This was partly the effect of heavy drinking, but more significantly a deep spiritual anxiety, 'a guilt so deep you identify yourself with the devil and God seems far away'. As he lay moaning on his bed, praying in French that God would cure him of his sick heart, he noticed that his idolater, Smith, was sitting there listening.

Neal and Carolyn took Jack back with them to Los Gatos. Neal was in a problematic relationship with a woman called Jacky who wanted him to divorce Carolyn and live with her. Neal thought he might be able to resolve the situation by introducing her to Jack – if the two of them got on well, the pressure on Neal might be eased.

The two did get on well. On the night of their first meeting they made love, and within days Jack had moved into her apartment. By the end of their first week together she was talking about marriage, and Jack felt obliged to show her how unsuited to marriage he was. He made unreasonable demands, killed her goldfish by pouring wine into their bowl, and even suggested that she might allow him to keep a mistress. But none of this deterred her.

The relationship was fast becoming a farce. One night, in the company of Lew Welch and his girlfriend, they unexpectedly dropped in on the Cassadys – a visit designed to create stress. Neal pretended to be jealous that Jacky was with another man, while Jack focused his attention on Carolyn, to show Neal that Jacky was all his if he wanted her.

The men had assumed that the women – both of whom had been torn between Jack and Neal – would fight like cats. 'Bring on the saucer of cream,' Welch had joked when they first set eyes on each other, but, instead of scratching, Carolyn and Jacky sat down and talked about children and motherhood (Jacky had a four-year-old son by the poet Gerd

Stern), while the men played their games. Although Jack would write to and telephone Carolyn for the rest of his life, this was to be their last meeting.

From Los Gatos, Jack, Jacky, Lew and his girlfriend drove to Bixby Canyon, and Jack spent his last night in Ferlinghetti's cabin. Despite the company, it was to be another bad time. He developed a paranoia that everyone was out to poison him, heard voices in his head, and could sense an encroaching evil. He thought he could see a bat flying around him and could hear the sound of devils laughing. He thought of his dead cat and his mother in Northport waiting for him. He yearned for the days in Lowell when he could yawn and be bored.

Then, in the midst of the horror, he had a vision of the Virgin Mary, angels and the cross of Christ. As the image of the cross grew more distant he heard himself saying, 'I'm with you, Jesus, for always. Thank you.' The four departed the next day, and Jack asked Welch to drive them all back to San Francisco. He went to stay with Ferlinghetti, whom he told about his vision of the cross. He told him that he felt he was being punished for not having recognized Jesus as the Messiah.

This concern with suffering had preoccupied Jack since childhood, when he learned that followers of Jesus must partake in his suffering. In a chillingly prophetic passage in *The Town and the City* the character Micky Martin realizes that: 'He, too, must suffer and be crucified like the Child Jesus there, who was crucified for his sake.' He, too, was, 'a child of a holy mother, therefore he, too, would be drawn to Calvary and the wind would begin to screech and everything would get dark'.

From San Francisco Jack returned to Northport. He started hanging out with Stanley Twardowicz, a local painter whom he'd met previously in Greenwich Village, who was happy to let Jack sit in the corner of his studio while he worked. Jack began to imagine that he might make it as a painter, a musician or an actor, and enrolled for classes at Lee Strasberg's Actors' Studio. He failed to finish the first acting class, but managed to meet Marlon Brando, who refused to drink with him, and Marilyn Monroe.

Most people who knew him at this time remember his drunkenness and the way in which he let his appearance go. David Markson was a young novelist who knew Kerouac through their agent, Sterling Lord. He and his wife, Elaine, remember that Jack would often show up at their apartment door when he had nowhere to stay. He would invariably arrive in the early hours of the morning, barely able to stand up.

'One night I remember I had a call from Jimmy Hamilton, who was the bartender at the White Horse Tavern,' says Markson. 'He said, "David. I hate to wake you, but there's a guy over here who says that he's Jack Kerouac and that he's staying at your apartment. He's so drunk that normally I would just have thrown him out because we're closing up, but if he really is Jack Kerouac I don't want to throw him in the street."

'I don't think Jimmy Hamilton had ever read a book in his life, but Jack Kerouac was famous by that time. So I pulled on some clothes and went down, and it *was* Kerouac and he was stoned out of his mind. I had to drag him back half over my shoulder, and he was pissing under every tree. By then, he'd taken it for granted that if he hadn't got a place to sleep, we'd be there. He would just crash out, stay the night and go the next morning.'

In January 1961, Jack was given psilocybin by Dr Timothy Leary, who was at that time a Harvard professor and was carrying out research into psychedelic drugs. He was particularly interested in the effect the drugs had on artists. He had already enlisted the help of painters Wihelm de Kooning and Franz Kline, and the jazz musicians Dizzy Gillespie and Thelonius Monk.

The experiment took place at Ginsberg's apartment. During the trip Jack was shouting to Leary: 'Can your drugs absolve the mortal and venial sins which our beloved Saviour Jesus Christ, the only Son of God, came down and sacrificed his life upon the cross to wash away?' Leary, who was also raised as a Roman Catholic, experienced his first bad trip that day.

In the same month, twenty-year-old Bob Dylan blew into New York from the Mid-West, heading for the folk clubs of Greenwich Village. He had been turned on to poetry two years before by reading Jack's *Mexico City Blues*, was enamoured by the *On the Road* lifestyle – and was about to translate the ethos of the Beat Generation into rock 'n' roll.

The two men never met. Three months later, Jack moved from Northport to a ranch-house in Orlando, Florida, and began the final stage of his decline.

12.

Mellow Hopes of Paradise

He kept returning to Lowell, hoping to find things unchanged, but his old friends were now family men and respected pillars of the community who did not relish the discovery of a drunken writer on their doorsteps.

Ann Charters' 1966 photo of Jack with his mother (left) shocked many of his fans. A year later he moved to a house in Lowell (below), where he appeared to temporarily regain his health and spirits (bottom).

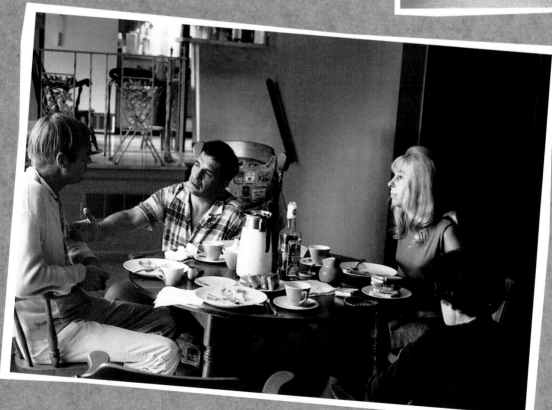

Jack became a victim of the rootlessness he had formerly celebrated.
He had obeyed only the tug of passion and the hunger for fresh
experience but, as he grew older, these were inadequate guides for
living. He had emulated Neal's desire to have 'everything at the same
time', but such a quest leads to diminishing returns. After a while, the
kicks stop coming. The body and spirit grow weary.

Although he believed in compassion, tenderness and the holiness of
life, these ideals had never been translated into a plan of action which
could occupy Jack's attention in maturity. Ginsberg went on to become a
well-informed political activist; Gary Snyder was a pioneer
environmentalist, as was Michael McClure; but Jack never involved
himself in public debate or politics. He expressed an interest in John
F. Kennedy during the 1960 presidential elections, but only because he
was a New England Catholic like himself, not for his policies. In any
case, Jack didn't vote. 'The only meaning the world has for me,' he once
observed in his notebook, 'is how it unfolds to me.'

Growing up frightened him, too. His love of Lowell, his
idealization of Mary Carney and the fact that he was still living at
home with his mother were all symptoms of his refusal to let go of an
adolescent state of mind. Although he was almost forty, he had postponed
the normal rites of passage associated with adulthood. He had so far
been married twice, but the marriages were both brief and uncommitted.
He was a father, but he had no experience of parenting. He had taken on
jobs, but had never been a breadwinner.

It was during the 1960s, when he should have consolidated his
position as an elder statesman, that he underwent a period of physical,
spiritual and artistic decline which resulted in him no longer being a
significant player in the very scene his work had helped bring into
being. He made his last trip to Mexico in June 1961, this time making an
abrupt exit after being humiliated and robbed by his drug connections.
One of the few things he returned with was enough Benzedrine to keep him
high for the ten days it took him to write *Big Sur*. When he had finished
writing he celebrated by consuming so much Cognac that he had to be
taken to the hospital.

Joan was still pursuing him to pay maintenance for their ten-year-
old daughter, Jan, and tried to embarrass him by writing about his
profligacy for *Confidential* magazine. She finally managed to get him to
court, where he agreed to pay $52-a-month child support and Joan's
$2,500 legal fees. It was the first time Jack had met Jan.

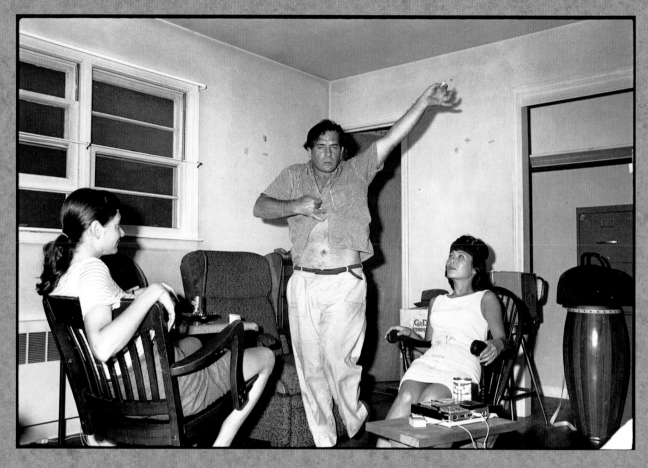

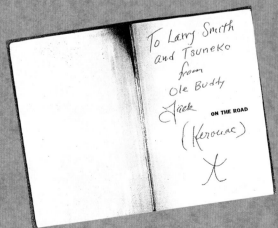

On his last day in Northport during August 1964 Jack's friend Larry Smith photographed him in a party mood. Watching him were Ann Twardowicz (left), and Smith's wife, Tsuneko. Jack signed a copy of *On the Road* for the Smiths (right).

To Larry Smith
and Tsuneko
from
Ole Buddy
Jack
(Kerouac)
X

ON THE ROAD

His drinking steadily increased – it wasn't unusual for him to consume as much as a quart of whisky a day, and many of his friends were becoming embarrassed to see him. One night, he caused so much trouble in a jazz club in Cape Cod that bouncers had to knock him out. He came to in a wet field with no recollection of what had happened. On another such occasion he came back late at night with a fellow drunk who then tried to rape Jack's girlfriend. Jack was so close to losing consciousness that he couldn't protect her.

He kept returning to Lowell, hoping to find things unchanged, but his old friends were now family men and respected pillars of the community who did not relish the discovery of a drunken writer on their doorsteps. G. J. Apostolos, an insurance agent by this time, had to throw Jack out of his home late one night because of his unreasonable behaviour. 'I don't think he drew a sober breath during the last years of his life,' says Duke Chiungos.

Most of his time in Lowell was spent talking to anyone who would listen, but there wasn't a lot of respect in his home town for an athlete who set off for Columbia with so much promise and returned with nothing to show for himself but some books that people said bad things about. In their eyes, he'd done the worst thing a working-class boy of his generation could do: he'd been handed a golden opportunity and he'd failed to take advantage of it.

He turned up drunk for a local radio show in September 1962. The interviewers, Charles Jarvis and James Curtis, fought bravely to keep the live broadcast on track while Jack raved, giggled, slurred, cried, played with words and cracked private jokes. 'What do you actually see in Lowell that has given sources for your famous books?' Jarvis asked as the show closed. 'It's a vast collection of Christians,' Jack answered. 'Do you see any visions here, any visions of God . . . in a pantheistic way?' Curtis chipped in. 'No, in a deistic way,' said Jack in a conspiratorial tone. 'In a gnostic way and in a Jesuitical way. I'm a Jesuit.'

At the end of 1962 he bought another ranch-house in Northport, Long Island, and moved in with his mother. He picked up his relationship with Stanley Twardowicz, and spent hours at the painter's studio, listening, watching and talking. Sometimes, other friends of Twardowicz's would turn up and wide-ranging conversations about art, literature and history would develop.

Neal Cassady (right) enjoyed
a second run as a celebrity
during the notorious acid
tests which featured West
Coast bands such as the
Grateful Dead. By this time
Jack (below) was dismissive
of the counter-culture.

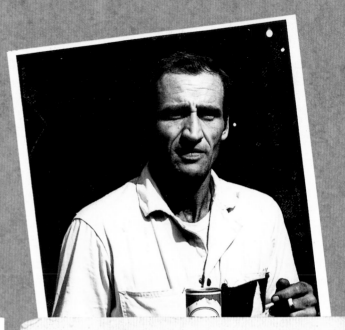

CAN **YOU** PASS THE ACID TEST ?

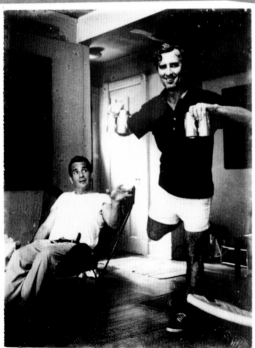

J. KEROUAC + S. TWARDOWICZ
NORTHPORT, N.Y. - 1964
PHOTO BY LARRY SMITH.

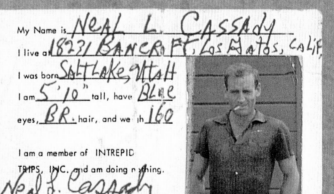

My Name is NEAL L. CASSADY

I live at 18231 BANCROFT, Los Gatos, CALIF.

I was born SALT LAKE, UTAH

I am 5' 10" tall, have BLUE

eyes, BR. hair, and weigh 160

I am a member of INTREPID

TRIPS, INC. and am doing nothing.

Neal L. Cassady
Signature

A local librarian, Miklos Zsedely, realizing the historical value of these talks, sat in on some of them with a reel-to-reel tape recorder, but Jack's conversation was now spasmodic and often mundane. If talk centred on something he had studied (Shakespeare, Proust, jazz, his own family history), he would briefly become animated, but if Twardowicz and his friends were discussing politics or painting – subjects Jack knew nothing about – he would either remain silent or offer inconsequential comments.

'Jack was an alcoholic by then,' says Twardowicz. 'If I called for him in the morning and he was still in bed, the first thing he would want to do was have a beer. He wouldn't even eat breakfast before he'd started drinking. Sometimes, he would walk through the woods to my house and he'd be so drunk that he'd fall asleep. If this was during the evening, he would sleep there all night. His mother would call up to find out where he was and I'd have to go out and look down the trail. There he would be in the woods, asleep.'

In the summer of 1964 Jack met up with Neal in New York, but the old bonds of friendship were no longer there. Although the two were similar in age, Jack was living the life of an old man who tended his garden, worried about his health and despaired about the younger generation and the future, while Neal had taken his craziness to a new level and was now at the wheel of *Furthur*, the psychedelically-painted bus which had taken novelist Ken Kesey and his group of proto-hippies, the Merry Pranksters, on their acid-fuelled cross-country trek.

On the Road had turned Neal into a legend, and after a short period of renouncing Dean Moriarty he had succumbed to the attention, and began acting in an even more extreme fashion, creating a fresh flood of Cassady stories. 'I think that he began living up to what was expected of him, and consequently lost himself,' says LuAnne. 'With me, he would be himself, but when everyone else was looking at him he became the Neal that had been celebrated in literature. He went from being a joyous, charismatic man to being an actor. He told me that he didn't know how to break the cycle.'

It would be reasonable to assume that Jack would have welcomed the Merry Pranksters as a realization of his 1950s' vision of the mobile 'rucksack generation' in search of visions, peace and beauty, but he saw only 'disrespectful' and 'illiterate' young people who desecrated the American flag. Many people had taken considerable inspiration from Sal

Paradise, Dean Moriarty and Japhy Ryder, but Jack was not able or willing to see his connection to the new generation of Bohemians.

In September 1964 he moved again, this time to St Petersburg, Florida. On September 19 his sister Caroline died of a sudden heart attack. She had recently separated from her husband, Paul Blake, after he was found to be having an affair. She collapsed after taking a phone call from him, during which he had asked for a divorce in order for him to remarry.

Predictably, her death plunged Jack into another deep depression, which he tried to alleviate with whisky. The little family from Lowell was by now reduced to two living members, and Jack and his mother clung together like survivors on a raft, consoling each other with alcohol, shared memories and Catholicism. Gerard had told his mother that he was going to build her a little white cottage in heaven, and she liked to remind Jack of this. She also told him that she had started having visions of 'Nin' safe in the arms of Jesus.

Jack was now almost totally cut off from his Beat Generation friends and contemporaries. Neal was out of his life for ever, and he would never see Carolyn again, though they continued to speak on the phone. Gabrielle forbade visits from Orlovsky and Ginsberg. Burroughs scorned him by saying that he hid behind his mother, never helped his friends and yet had made his livelihood out of recording their speeches and actions.

In June 1965 he flew to Paris to research his ancestry, but librarians at the Bibliothèque nationale, realizing that he wasn't sober, refused him access to the older records. He sought solace in more drink, prostitutes and music, and abandoned plans to travel on to Cornwall as part of his search. Instead, he visited Brittany, home of the original Kerouac family, and then flew back to Tampa.

This was his first adventure since the terrors of Bixby Canyon, and the last big solo adventure of his life. It wouldn't have merited a page in his earlier novels, but as a writer who had vowed only to report what had happened to him and not to 'make up stories', he was compelled to fashion his French trip into a novel, creating the slender *Satori in Paris* in a week.

Satori suggests a Buddhist moment of revelation, but in fact *Satori in Paris* strongly suggested a return to his Catholicism, as though he now realized that this had always been his true religion. 'I'm not a Buddhist,' he says at one point, 'I'm a Catholic revisiting the

(196)

ancestral land that fought for Catholicism against impossible odds yet won in the end . . .' Was that his satori in Paris?

Back in Florida, there was little evidence of any profound spiritual change. Increasingly often, he got his kicks by provoking people and creating minor crises. He didn't seem to mind whether the result was positive or negative, just as long as there was a result. He'd lived so long on a diet of sensations that it was difficult now to find things powerful enough to excite him.

At the Wild Boar in Tampa, a bar frequented by students and staff from the University of Southern Florida, he gained a reputation as a trouble-maker by ridiculing professors and challenging men to fights. He would take part in contests where the participants would slam each other with their beer guts. This might have been harmless fun for students and athletic young men, but it wasn't the right sort of pastime for an overweight forty-three-year-old alcoholic. Within months of the 'belly busting' contests Jack developed a hernia.

In March 1966, Jack and Gabrielle moved yet again, this time to Hyannis on Cape Cod. It was here that Jack was visited by Ann Charters, who was to compile his bibliography and later wrote his first biography. Her photographs of the sad and bloated writer shocked those who had retained their image of Jack Kerouac the square-jawed figure with the open-necked shirt who graced the back covers of *On the Road*. 'Nothing any interviewer had ever described prepared me for the sad figure in the doorway,' she later wrote in *Kerouac*. 'He was only forty-four years old, but if anything he looked like the battered, lost father of the young Jack in all the dustwrapper photographs.'

In November 1966, he surprised everyone by marrying Stella Sampas of Lowell – the sister of his long-time friend Sebastian. Older than Jack by four years, she was an unusual choice for a man who had spent his adult life making love to sophisticated young women with liberal attitudes towards sex and drugs – Stella had never left Lowell and was still a virgin. They had been friends for a long time, and corresponded at various points throughout their lives.

Just before his marriage to Stella, Jack had visited Mary Carney, who was now married for a second time. Her daughter Judy, then twenty-one, remembers the morning clearly. 'My mother was hanging clothes out on the line in the back, and he asked her to marry him and she said, "No. You've never stopped drinking." He said, "You'll never see me again. I'm gonna leave here and I'm gonna drink myself to death." And he

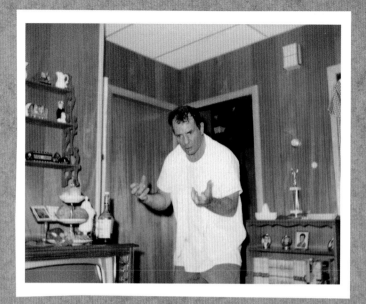

Jack was happiest in the
company of old friends and
children. These pictures
were taken in the Lowell
home of Bill Koumantzelis
in 1968. Jack was amusing
Bill's children with his
impressions of Dr Jekyll
and Mr Hyde.

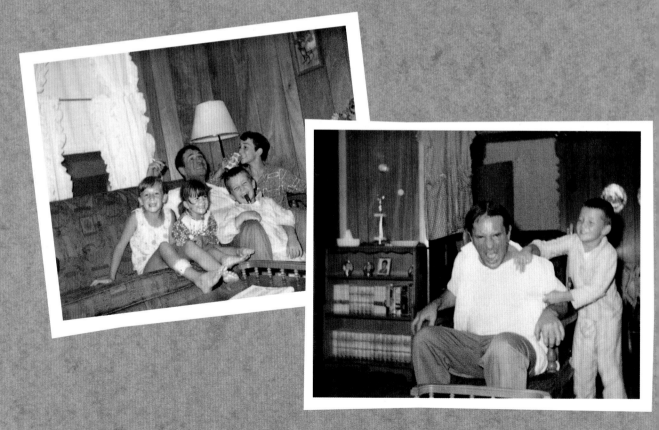

During the 1960s, Jack became a
familiar sight at Nicky's Bar in
Lowell, which was run by Nick Sampas,
brother of his old childhood friend
Sebastian. Here he is flanked by Bill
Koumantzelis and an unidentified
female friend, and another Sampas
brother, Tony (far right).

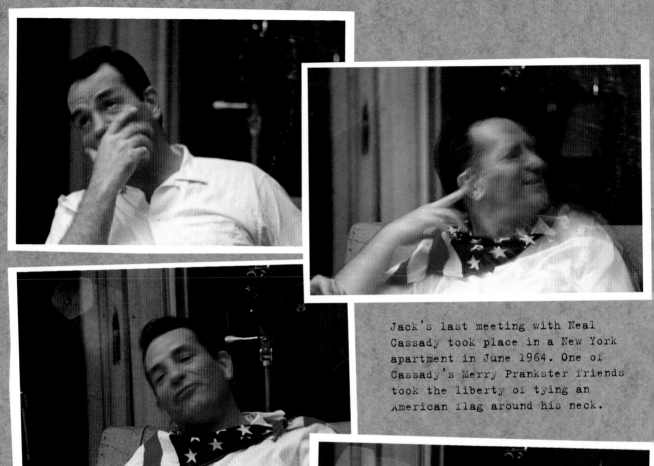

Jack's last meeting with Neal
Cassady took place in a New York
apartment in June 1964. One of
Cassady's Merry Prankster friends
took the liberty of tying an
American flag around his neck.

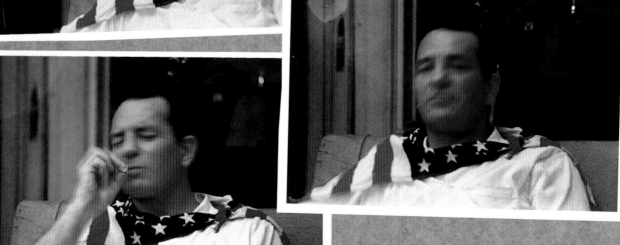

did. She always felt guilty about that.' According to Gregory Corso, 'Because he was a Catholic, he didn't want to commit suicide, but he wanted out.'

Shortly after marrying Stella, Jack looked for a home in Lowell which Gabrielle could share with them. He had his heart set on buying the Beaulieu Avenue house where Gerard had died, but it wasn't for sale. He bought a larger house on Sanders Avenue in the Highlands area and in March 1967 he set about completing *The Vanity of Duluoz*, the tale of his life from Lowell to Columbia, presenting it as if an explanation to Stella of what had happened in those early years.

But even a return to Lowell couldn't bring back Jack's lost innocence. He spent his nights in Nicky's, a bar run by Stella's brother Nick, where Jack would get roaring drunk and start complaining about his wife. On occasions, he even brought hookers with him, and Sampas would have to remove him from the bar.

In November 1967, Jan Kerouac paid her father a brief visit. She was now fifteen years old, pregnant, and on her way to Mexico with a long-haired boyfriend. Uncontrollable at home, she had dropped acid at twelve and was on heroin by thirteen. To support her habit, she had turned to prostitution.

Jack seemed pleased enough to see her, although he didn't turn the television off during their conversation. If he saw any connection between his past behaviour and her present problems he didn't mention it. According to Jan, the one scrap of consolation he offered her was the freedom to use his name. 'Go to Mexico,' he said. 'Write a book.'

Vanity of Duluoz was published in February 1968, the same month that Jack heard that Neal had dropped dead on a railroad in Mexico. He died in the style that he had lived: in a T-shirt on his way home from a party where he'd taken alcohol and barbiturates. The Roman candle had finally gone cold. Jack found the death hard to accept, and for some time following the incident harboured the hope that it was all a hoax, and that Neal would turn up one day, smiling.

The immediate cause of Neal's death was 'congestion', but the truth was that, like Jack, he had exhausted himself. There was nowhere left to go. 'The day he left for Mexico for his last trip, he came to see me and he was in a very strange mood,' remembers LuAnne. 'It was the first time in years that he had been so quiet and sensitive. He held my hand and told me that he'd just been down to Texas to see his older daughter, and that he had seen his grandson.

(201)

In his final years Jack's
condition fluctuated between
the bloated and miserable in
1966 (top) to the lean and
cheerful in 1967 (right).
His consistent props were a
cigarette, a beer and a
check shirt.

'The way he said it was as if he had now accomplished everything and there wasn't anything else. He asked me, "Where the hell am I going, LuAnne?" He never usually questioned where he was going or what was happening, and that's what made it so strange. It was as if everything was sucking him dry.'

Jack's final trip abroad came in March, when Stella's brothers Nick and Tony took him with them to Spain, Portugal, Switzerland and Germany. It was a brave undertaking by the brothers, because Jack was totally irresponsible – taking prostitutes back to his room, running out of money, getting drunk and breaking down in tears.

Home in America, it bothered him to see the rise of the counter-culture, and especially the radical politics of the New Left, which he naively saw as a Communist plot to destroy America. He went on William Buckley's *Firing Line*, with Ed Sanders and sociologist Lewis Yablansky, to discuss what was happening, but he was drunk and offered no cogent analysis. He appeared as bewildered and angry as any out-of-touch member of his generation and, watching him, it was hard to see how he had been a major inspiration to Allen Ginsberg and Bob Dylan. A point he did communicate well was that the Beat Generation had been largely misunderstood. 'The Beat Generation was a generation of beautitude, pleasure in life and tenderness,' he argued. 'In the papers they called it "Beat Mutiny" and "Beat Insurrection", words I never used, being a Catholic. I believe in order, tenderness and piety.'

In September 1968, Jack reluctantly moved out of Lowell because the damp weather was affecting his mother's health. They moved back to St Petersburg, and he resumed work on *Pic*, a novel about a black boy who'd been named after *Pictorial Review* magazine, which he'd started in 1951 and subsequently abandoned.

The last journalist to meet him was Jack McClintock, who was sent by the *Miami Herald* to get an interview which would be run alongside a piece Jack himself had written called 'After Me, The Deluge' – an anti-hippie, anti-Communist diatribe. McClintock found him sitting in front of a silent flickering television, smoking Camels and drinking Johnny Walker Red. On the wall was an oil painting of the Pope which Jack had done, and although it was daytime the living-room curtains were drawn. He seemed shut off from the outside world. He didn't even have a telephone installed because, 'I don't have anyone to call and nobody ever calls me.'

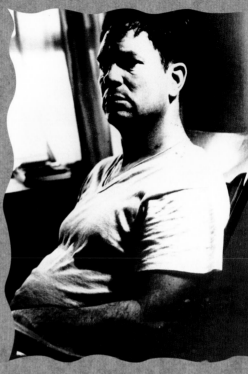

Jack's casket was taken from St Jean Baptiste
Church, Lowell (top) to Edson Catholic Cemetery
(above). Allen Ginsberg was a pallbearer. Among
the messages of sympathy sent to his mother
Gabrielle was the note (right) from Larry and
Tsuneko Smith, his friends from Northport.

MEMO from Lawrence L. Smith

To **MRS. G. KEROUAC** _____ Time _____

Dear Mrs Kerouac.
we share your grief
over Jack's sudden
death and wish you and
Stella strength to endure
this tragedy.
The memories we cherish
are of moments that were
rich and gay and
stimulating.

☐ Reply ☐ Initial and return ☐ See me

Larry & Tsuneko.

Form PP-66 The Drawing Board, Inc., Box 505, Dallas, Texas

Between slugs of whisky and beer he berated Communists, the Jewish 'literary mafia', hippies and the young kids of the day, who he reckoned no longer played basketball like he and his friends had done back in the 1930s. The only subjects which brought about a semblance of joy were his own idyllic childhood days in Lowell, football and music. He was also happy to talk about Neal, who he believed had been 'ruined' by Ken Kesey.

'I'm not a beatnik,' he told McClintock, 'I'm a Catholic.' – a restatement of the claim made in the introduction to *Lonesome Traveler* (1961) that he was 'actually not "beat", but a strange solitary crazy Catholic mystic', whose final plans were, 'hermitage in the woods, quiet writing of old-age, mellow hopes of Paradise (which comes to everybody anyway) . . .'

Jack's hopes of a hermitage in the woods and an old-age spent writing were never to be realized. On October 20, while watching television, he suddenly felt ill. He went to the bathroom and began to vomit blood. He was rushed to St Anthony's Hospital where the next day, after twenty-six blood transfusions, he died of 'haemorrhaging oesophageal varices'.

His funeral was held in Lowell on October 24 at St Jean Baptiste Roman Catholic Church. The night before, his open casket was on display at the Archambault Funeral Home on Pawtucket Street, within sight of the grotto where he had walked so often with Gerard, gazing up at the stations of the Cross. After the church service, the coffin was taken to Edson Catholic Cemetery where Stella Sampas Kerouac, family members, Allen Ginsberg, Gregory Corso, John Clellon Holmes and Shirley Holmes, Sterling Lord, Jimmy Breslin, Robert Creeley and others watched in silence as Jack's remains were lowered into the grave.

LA CONFERENZA DELL'ADDORMENTATO

Milano. Ecco un momento della conferenza stampa che ha capeweula del "beats". Jack Kerouac, ha tenuto alla Libreria Cavour. Kerouac è il signore che dorme profondamente sul divano: lo guardano perplessi, da sinistra: il direttore della libreria Bruno Uertina, il regista della televisione svizzera Grieria Mascioni e il nostro critico letterario Enzo Fabiani. Kerouac (di cui si vede una espressione "normale" nella fotografia piccola) era partito ubriaco fradicio dall'America – e in aeroplano aveva continuato a bere: arrivato a Milano, ha farfugliato qualche frase sconnessa, poi è piombato in un sonno che è durato diverse ore. Kerouac era venuto in Italia per presentare il suo ultimo romanzo, "Big Sur". Nato a Lowell (Massachusetts) 44 anni fa, ha pubblicato: "Sulla strada", "I sotterranei", "I vagabondi del Dharma" e "Dottor Sax".

'The Press Conference of the Sleeper':
During a visit to Milan in 1966 to promote the Italian translation of *Big Sur*, Jack hadn't lost his thirst for alcohol. He fell asleep during a press conference (right), passed out at a party thrown in his honour, and disgraced himself on two television interviews. This report is from *Gente* magazine, October 12 1966.

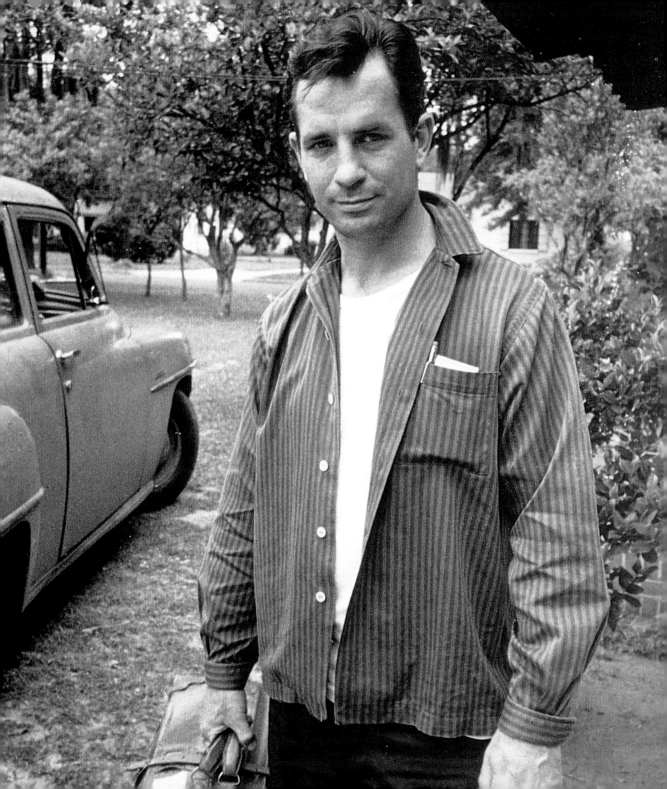

13

The Beat Goes On

His novels all resound with the question, 'How can you make sense of life in the face of suffering and death?' It is the brutal honesty of the recurring question which makes his work so vital. He is not interested in mere entertainment or even literary success. His writing is the means by which he untangles the mysteries.

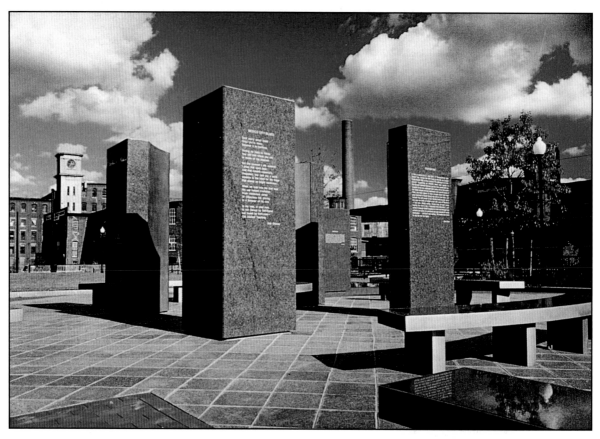

The dedication
ceremony for the
Kerouac
Commemorative at
Eastern Canal
Park, Lowell was
attended by
Jack's first
wife, Edie Parker
Kerouac (right),
and his daughter
Jan Kerouac (far
right).

On June 25 1988, a group of Kerouac fans gathered in Lowell
for the dedication of Kerouac Park, the centrepiece of which was the
Jack Kerouac memorial – a collection of eight granite columns inscribed
with fourteen texts from Jack's books.

Jack's relations and childhood buddies mingled with his Beat
Generation friends and Kerouac scholars and biographers on the downtown
site. The survivors of the Beat era now all looked like any other group
of senior citizens: grey-bearded Lawrence Ferlinghetti in his sailing
cap; a plump and white-haired Edie Parker carrying a wide-brimmed straw
hat; and Henri Cru confined to a wheelchair.

Jack had once joked that Lowell should erect a 'Zeusian statue of
Ti Jean, Jack Kerouac, native son' in front of City Hall, but for years
there was strong resistance towards honouring him in any way. His
literary reputation was never in doubt. It was a question of moral
character. Did Lowell wish to celebrate someone who seemed like such a
poor role model?

'He didn't lead a life to be imitated,' says Reginald Ouellette.
'People in Lowell never recommended that kids read his books because
they were always afraid that youth would try to emulate him. I've
enjoyed most of his books, but I believe that he wasted his talents.'

When he died, Jack left $91. Most of his books were out of print,
and whereas Ginsberg, Corso, Ferlinghetti, Snyder, McClure and Burroughs
were all active and prolific, Jack's output had been reduced to a
dribble. In the eyes of the counter-culture he was a pathetic has-been –
an angry young man who'd soured into a grumpy old reactionary.

Almost thirty years later, his stock is the highest it has ever
been. All his books are back in print, new material is being released,
and his estate is modestly valued at around $10 million. There's serious
talk of *On the Road*, the film rights to which have long been held by
Francis Coppola, finally making it to the big screen.

Current interest in Kerouac can be traced back to the scholarship
that blossomed after his death. For many fans, Ann Charters' 1973
biography, *Kerouac*, provided the first opportunity to glean the details
of his life and to match real names to fictional characters. Ten years
later, Gerald Nicosia's massive 767-page *Memory Babe* went even further,
seemingly leaving no stone unturned. There have since been books by
former girlfriends and associates including Michael McClure's *Scratching
the Beat Surface* (1982); Joyce Johnson's *Minor Characters* (1983);
Carolyn Cassady's *Off the Road* (1990); and Herbert Huncke's *Guilty of*

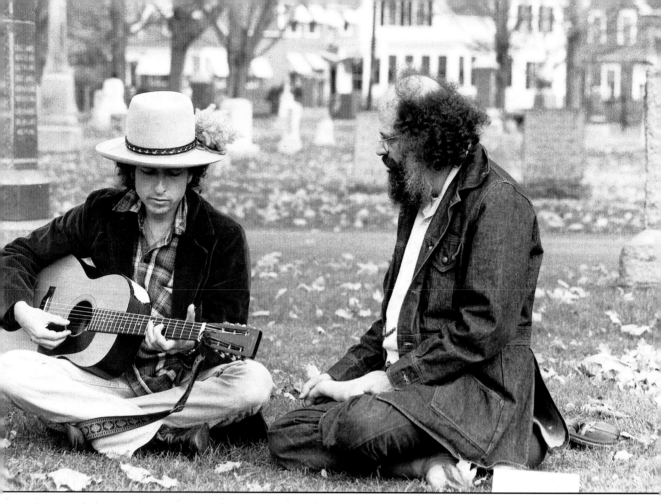

In October 1975, during
the Rolling Thunder
Tour, Bob Dylan and
Allen Ginsberg came to
Jack's grave in Lowell
to pay homage. The visit
was filmed and used in
Dylan's movie *Renaldo
and Clara*.

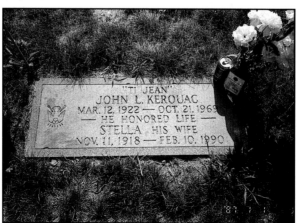

Everything (1990); all of which have helped clarify the tremendous influence of Kerouac and other Beat writers.

The last fifteen years have seen the spread of Kerouac gatherings, starting with a ten-day conference at the Naropa Institute in Colorado to celebrate the twenty-fifth anniversary of the publication of *On the Road*. Since then, there has been the International Jack Kerouac Gathering in Quebec (1987); The Writings of Jack Kerouac conference in New York (1995); and the Lowell Celebrates Kerouac Festival, held each October.

Most exciting for those who care about Kerouac's work has been the steady flow of fresh material since 1990, when Stella Kerouac died and the estate was taken over by her brothers and sisters, administered by her brother John Sampas on their behalf. Whereas Stella did her best to sever Jack's connections with Beat culture, Sampas has tried to satisfy demand for both archive documents and unpublished poems and stories.

Pomes All Sizes, which Stella had forbidden City Lights to publish, finally came out in 1992, and the following year *Old Angel Midnight* and a collection of articles, *Good Blonde and Others*. In 1995, the first volume of his letters, edited by Ann Charters, was released along with *The Portable Jack Kerouac*, and then *Book of Blues*, a collection of blues poems.

Having five new books in such a short space of time almost took one back to 1957–1959, the golden age of Kerouac, when six novels and a book of poems were published in quick succession. To add even more spice, there was a major Beat exhibit at the New York's Whitney Museum, which included manuscripts and paintings by Jack, and a Jack Kerouac CD-ROM (*A Jack Kerouac ROMnibus*), which contained a dazzling mix of previously unseen documents, photographs and memorabilia made available by the estate.

Why is it that Kerouac has not only endured but has also become an icon to succeeding generations? It has certainly not been because of critical appraisal. In studies of post-war American literature he is often reduced to an interesting curiosity, a sign of the times. In Harold Bloom's *The Western Canon* (1994), Kerouac doesn't merit a single mention – not even among the 161 American authors selected as part of a 'canonical prophecy' in the book's appendices (Snyder is the only writer associated with the Beats that Bloom feels will have lasting value). Kerouac is, however, one of the most influential authors of his period, whose imprint can still be detected not only in fiction but also in

Almost twenty
years after his
death, Jack was
honoured by having
a San Francisco
street named after
him.
Appropriately,
Jack Kerouac
Street runs
between City
Lights Books and
the Vesuvio Café,
both of them
renowned Beat
hang-outs in the
1950s.

film, commercials, travel writing, new consciousness movements, youth culture, journalism and rock music.

Unfortunately, his status as a pop icon has made it difficult for critics to look clearly at his body of work. In that sense his role as 'King of the Beats', and the image of him as an on-the-road thrill-seeker has worked against him. Jack realized early on that *On the Road* had typecast him, with the result that his poetry and his experimental prose was generally overlooked. Fame burdened him because he felt he was famous for all the wrong reasons, and he didn't have it in him to live up to the image of Dean Moriarty, who many supposed to be him.

Ultimately, the reason for his endurance is his work, which touches people with its honesty and compassion. He continues to inspire people to make art out of the substance of their daily lives, rather than to seek out special 'artistic' subjects. He continues to inspire ordinary people to break out of the narrow confinements of lives they have been handed down. He inspires the seekers, the peace-makers and the poor in spirit.

Because Jack was ahead of his time in the 1940s and 1950s, it is tempting to regard him as a modernizer with no respect for the old ways. But he was, at heart, a traditionalist who bemoaned the passing of an America where individualism and adventure had been valued more than group conformity and personal security. In *The Town and the City* he quotes the father as saying that things began going wrong 'thirty years ago', which would have been around the turn of the twentieth century. It is clear that Jack shared this view.

During the height of the Beat revolution, his dreams were always of a rural paradise where he would work on a farm and be surrounded by friends. Mexico appealed to him because the Mexican peasants still lived as the Americans had done in the nineteenth century, and Gary Snyder was a hero because of his lack of possessions and his connection with the land.

Jack's wanderings across America, which became an essential part of his reputation, were a way of asserting his freedom at a time when most Americans were tied to corporations which in turn tied them to specific living areas. He identified with the early American pioneers and particularly with hobos, who he saw as preserving the true spirit of freedom.

'He called the hobos the lost pioneers,' remembers Al Hinkle. 'He thought that in the old days they would have been pioneers, but that

time had caught up with them and society had no place for them because they were uneducated and unskilled. He thought they would have been cowboys and frontiersmen, except there was no longer any frontier.'

Kerouac resisted compromise, believing it was more important to be true to one's vision than to fit in and become noticeably successful. That stubbornness has made him a role model for unconventional artists and doyens of youth culture. When the publishers wanted stilted prose he gave them a Beat novel. When the publishers wanted more Beat novels he gave them dream-diaries, poems, sutras, stream-of-consciousness experimentation and a life of Buddha.

His Catholic upbringing, with its stories of saints and martyrs, prepared him for a life of suffering and rejection. The importance of faithfulness, of not conforming to the world, had always been stressed – as had Christ's identification for the poor, lonely and weak. He came to see his work as a religious vocation, the imparting of a vision, and increasingly his novels and poems became infused with thoughts of God, Jesus, Buddha, angels, prayer, death and heaven. One of his major contributions as a writer was in combining hip-talk, surrealism, street visions and playfulness with the language of religion. It is hard to imagine John Lennon singing *Instant Karma* or Bob Dylan singing *The Gates of Eden* without the influence of Kerouac and Ginsberg.

Most of the Beats ended up following a spiritual path, confirming John Clellon Holmes's 1958 insight that, 'The Beat Generation is basically a religious generation'. But few were attracted to any form of Christianity, which they saw as inextricably tied up with the American military-industrial complex. Both Catholicism and Protestantism appeared to bolster the system and encourage a lifeless conformity.

The Beats anticipated the trend away from formal religious observance and towards 'inner development'; away from the search for truth and towards feelings. Their mysticism was bound up with a fascination with the workings of their minds, particularly with alterations in consciousness. For Kerouac, the sensation-seeking of *On the Road* segued naturally into Buddhist meditation, which in his poem *How to Meditate* he described as being 'instantaneous ecstasy like a shot of heroin or morphine'.

Buddhism became the natural religion of the Beats because it most closely approximated their experience. There was no need to believe in God, the Ten Commandments, heaven, hell or even the existence of an afterlife. Rational thinking, which they'd come to distrust anyway after

their drug experiences, was an impediment to satori.

Buddhism had a clean image because it couldn't be blamed for creating the dark side of modern America. It preached peacefulness, harmony with nature and non-attachment to material goods. Its leaders were not men in suits and ties who fronted multi-million-dollar religious organizations, but were monks in saffron robes who practised a simple lifestyle and condemned no one.

Other historical factors made Buddhism an attractive and available option for the Beats. San Francisco was the last stop in America before Asia, and Buddhist temples had proliferated since the mid-nineteenth century. Many of the Bay Area poets spoke at least one Asian language and, in one of the defining acts of recent times, 'Christian' America had dropped atom bombs on Hiroshima and Nagasaki.

Yet, despite his long involvement with Buddhist teaching and practice, Kerouac consistently claimed that he was a Roman Catholic, and there are as many references to Christian belief and quotes from the Bible in his work as there are to Buddhism and Buddhist scriptures. He once told an interviewer that his Catholicism informed *The Town and the City*, *Maggie Cassidy*, *Tristessa*, *Big Sur*, and *Lonesome Traveler*, and would have been apparent in *The Dharma Bums* if his publisher hadn't elected to edit it out.

Although he once noted that 'The "beat" theme in the hep-cat books like *On the Road* and *The Subterraneans* is not opposed to Catholicism,' Kerouac never successfully reconciled the two. But he did try to during the revisionist period late in his life. Spontaneous prose, which had initially found support in the Surangama Sutra's counsel that 'you must learn to answer questions spontaneously with no recourse to spontaneous thinking', was now justified by Jesus, who instructed his disciples to: 'Take no thought beforehand what ye shall speak, neither do ye premeditate; but whatsoever shall be given you in that hour, that speak ye: for it is not ye that speak, but the Holy Ghost' (Mark 13:11).

The link remained weak because his Catholicism was undeveloped. There were references to it in his novels, but he didn't possess the certainty of faith that results in a burning vision that demands to be communicated. By contrast, the friends of his who were Buddhists had the zeal and commitment of converts, partly because they had first encountered the religion with adult minds and made adult applications, and partly because they believed they had found what they were looking for. Jack was a cradle Catholic and his understanding of Catholicism

remained child-like and unsuited to the volatile world of ideas into which he entered as a writer. His preoccupation was with the suffering of Christ, rather than the forgiveness and new life offered by God, and because of this he never had the assurance of salvation that would have brought relief to his sensitive soul.

Yet it was this very lack of assurance which became the fuel for his novels, which all resound with the question, 'How can you make sense of life in the face of suffering and death?' It is the brutal honesty of the recurring question which makes his work so vital. He is not interested in mere entertainment or even literary success. His writing is the means by which he untangles the mysteries. In 1950 he wrote to Ed White that he wanted, 'A pen that spurts golden fire and winds shrouds around the man. I guess I want to be an angel of some kind. That is a fact. Not for immunity, but for the right to be near God.'

The existential solution suggested in *On the Road* was superseded by the Buddhist solution, where he attempted to eliminate the questions and act as though 'nothing matters and we all know it' (*Desolation Angels*). The fact was that things did matter to Jack and he later dismissed Buddhism as 'just words'. Even the legendary bad behaviour of the 1960s was directly related to the questions that bothered him. The heavy drinking that effectively took the place of meditation in his life was, he admitted, a means of preventing him 'thinking too much' just as sex helped him 'forget about death'.

What he had always prayed for was a moment of illumination after which everything would make perfect sense. 'Something is bound to happen,' he wrote to Ed White. 'Some revelation is bound to appear to me soon, like light; like a scientific discovery, but not in a formula; so that in my work I will be able to reflect those mysteries in a glass – a glass not warped and dull like the glass of formulas – but a fiery glass.'

His life was a quest for that revelation. Even in his final years, when the world forgot about him and his body gave up, he still hoped. While writing *Vanity of Duluoz*, the last novel about his own life, he claimed he could see the cross of Christ before him when he closed his eyes. 'I can't escape its mysterious penetration into all this brutality. I just simply SEE it all the time, even the Greek cross sometimes. I hope it will all turn out to be true.'

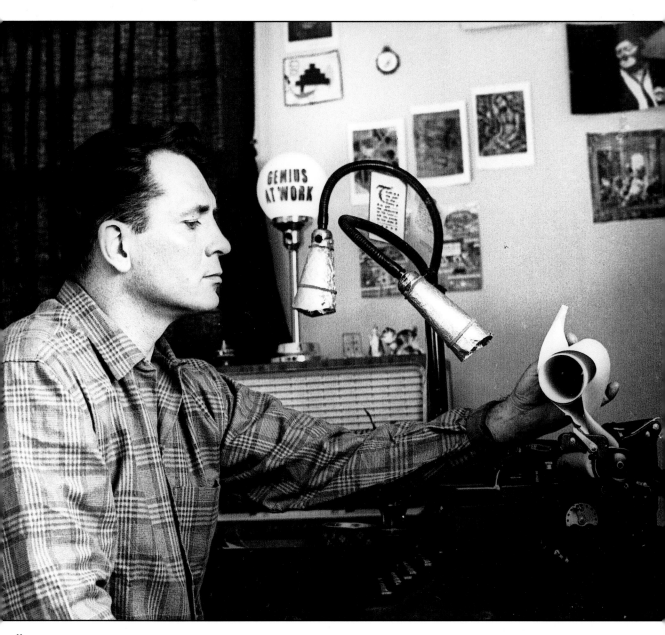

"I hope it is true that a man can die and yet not only live in others but
give them life, and not only life but that great consciousness of life..."

Jack Kerouac November 1951

(217)

Where Are They Now?

Joan Vollmer Adams
[Jane in *On the Road*] gave birth to William Burroughs' only son, William Burroughs III, in July 1947. She was 27 when she died in Mexico City in 1951. William Burroughs III died in March 1981 after a life of drug abuse and alcoholism.

David Amram
is a composer, conductor and multi-instrumentalist. He composed original music for a Broadway production of *On the Waterfront* and is guest conducting 17 symphony orchestras each year. He lives in Connecticut.

Al Avakian
graduated from Yale, studied at the Sorbonne and then became a film editor working on *Jammin' the Blues* and *Jazz on a Summer's Day*. He is credited with inventing the freeze frame. He died in 1995 at the age of 71.

George Avakian,
76 [Chuck Derounian in *Vanity of Duluoz*], became a producer for Columbia records after graduating from Yale, helped found Warner Brothers Records and became the pop director at RCA Records. The acts he signed during his career include Miles Davis, Dave Brubeck, Errol Garner, Mahalia Jackson, Duke Ellington and Louis Armstrong. He lives in Riverdale, New York, and is currently writing his autobiography.

Justin Brierly
remained in Denver working as both a lawyer and a teacher. He died there in 1984 at the age of 79.

William Burroughs,
82 [Old Bull Lee in *On the Road*], is the author of numerous books including *The Naked Lunch* (1959), *The Soft Machine* (1961) *Dead Fingers Talk* (1963), *Nova Express* (1965), *The Third Mind* (1979) and *Cities of the Red Night* (1981). His most recent publications are *Ghost of a Chance* (1995) and *My Education; A Book of Dreams* (1995). His paintings have been exhibited in the US, Europe and Japan, and his artwork is the subject of a 1996 Los Angeles County Museum of Art exhibit. He lives and works in Lawrence, Kansas.

Mary Carney
[Maggie Cassidy in *Maggie Cassidy*] spent her life in Lowell. She first married in 1944, divorced in 1948 and then remarried in 1961. She died in 1992 at the age of 72.

Lucien Carr
[Kenny Wood in *The Town and the City*] became an assistant managing editor of United Press International (UPI) in New York. He is now retired and lives in Washington, DC.

Carolyn Cassady,
73 [Camille in *On the Road*], has lived in North London since 1984 where she paints, writes and answers a growing amount of correspondence. She is the author of *Off the Road: My Years with Cassady, Kerouac and Ginsberg* (1990). Her son John Allen Cassady lives in San Jose where he works for a computer company that manufactures optical scanners. Her oldest daughter, Cathy, is a fitness instructor and her youngest daughter, Jamie, is a dental assistant.

Neal Cassady
[Dean Moriarty in *On the Road*] was 42 when he died. He was cremated and his ashes have been kept in San Jose by his son John Allen.

Ann Charters,
59, compiled Jack Kerouac's bibliography with him in 1966 and authored his first biography in 1973. She is a professor of American Literature at the University of Connecticut. Her next project is completing the second volume of *The Selected Letters of Jack Kerouac: 1957-69*.

Hal Chase,
73 [Chad King in *On the Road*], trained as an anthropologist and worked at the University of Southern California. He is now retired and lives with his family in the countryside near Paso Robles, California. He has a reputation for being a recluse who avoids Beat Generation publicity.

Duke Chiungos,
73 [Telemachus Gringas in *Vanity Of Duluoz*], ran his own milk business in Lowell. He is now retired and lives in Chelmsford, Massachusetts.

George Constantinides,
73, worked for the CIA and served in Greece, Jordan and Iran. He is the author of *Intelligence and Espionage: An Analytical Bibliography* (West View Press). After two heart attacks he took early retirement and worked for a company in Washington, DC where he still lives today.

Gregory Corso,
66 [Yuri Gligoric in *The Subterraneans*], continues to write and perform poetry. He is the author of several collections of poetry including *Gasoline* (1958), *The Happy Birthday of Death* (1960), *Long Live Man* (1962), *Herald of the Autochthonic Spirit* (1981) and *Mindfield* (1989). After years of living in Europe and San Francisco he is back in Greenwich Village.

Henri Cru
[Remi Bonceur in *On the Road*] spent his life in the Merchant Marine and kept an apartment in Greenwich Village. He never married or had any children. He died in 1993 at the age of 70.

Lawrence Ferlinghetti,
77 [Lorenzo Monsanto in *Big Sur*], is the author of 35 books of prose and poetry including the best-selling *A Coney Island of the Mind* and *Pictures of the Gone World*. He still operates the City Lights Bookstore and City Lights Publishing, and continues to write and paint. He lives in San Francisco.

Allen Ginsberg,
70 [Carlo Marx in *On the Road*], writes and performs his poetry around the world. His poems are collected in *Collected Poems 1947-1980*, *White Shroud Poems 1980-1985* and *Cosmopolitan Greetings; Poems 1985-1992*. His sound recordings are available on a four CD box-set *Holy Soul Jelly Roll* (Rhino 1994). He is the co-founder of the Jack Kerouac School of Disembodied Poetics at the Naropa Institute and Distinguished Professor at Brooklyn College. He lives in New York City.

Diana Hansen
[Inez in *On the Road*] got remarried to a Swiss banker in 1956, had a daughter two years later and continued to live in Greenwich Village and work in the PR industry. She died of cancer in 1974 at the age of 50. Her son by Neal Cassady, Curtis Hansen, 46, is now a programming director for a radio station in Connecticut.

Joan Haverty
[Laura in *On the Road*] died of cancer in 1990.

LuAnne Henderson,
66 [Marylou in *On the Road*], remarried in 1949 after her divorce from Neal Cassady. In 1951 she had a daughter and following the break-up of her second marriage in 1956 she ran three bars. Her third marriage, which began in 1966, lasted until her husband died in 1995. She lives in a mobile home in the California Wine Country.

Al Hinkle,
70 [Ed Dunkel in *On the Road*], worked for the Southern Pacific Railroad until his retirement in 1987. His wife, Helen, died in 1994. He lives in San Jose.

John Clellon Holmes
[Tom Saybrook in *On the Road*] published three novels and several books of essays and poems as well as teaching creative writing at the University of Arkansas. He lived in Old Saybrook, Connecticut, where he died of cancer in 1988 at the age of 61.

Herbert Huncke,
81 [Elmo Hassel in *On the Road*], is on methadone treatment and lives alone in a residential hotel in New York. He makes a modest living as an author and raconteur. His books include *Huncke's Journal*, *The Evening Sun Turned Crimson* and *Guilty of Everything* (1990). In 1994 he released the recording *From Dream to Dream* on the Dutch label Dig it!.

Joyce Johnson,
61, is the author of the novels *What Lisa Knew* and *In the Night Cafe*. Her memoir of the Beat Generation, *Minor Characters*, received the National Book Critics Circle Award in 1983. She is an associate professor in the Graduate Writing Program at Columbia University and lives in New York City.

Joe Kennedy,
73 [Mike Hennessey in *Vanity of Duluoz*], attended Columbia University. His studies were interrupted by the war, but he graduated in 1948 and went into sales and marketing.

Gabrielle Kerouac
[Margaret Courbet Martin in *The Town and the City*] died in St Petersburg, Florida in 1973, at the age of 78. She is buried in Nashua, New Hampshire, alongside her husband Leo (1889-1946) and their son Gerard (1916-26).

Jan Kerouac,
44, published two autobiographical novels, *Baby Driver* and *Trainsong*. She died of heart failure in 1966 after several years of kidney dialysis and a rare blood disease. At the time of her death she was involved in litigation with the Estate of Jack and Stella Kerouac, claiming that Garielle Kerouac's will was forged.

Philip Lamantia,
69 [Francis de Pavia in *The Dharma Bums*], spent the 1960s in Europe and then returned to San Francisco where he still lives. He has published seven books of poetry including *Selected Poems 1943-1966* (City Lights).

Alene Lee
[Mardou Fox in *The Subterraneans*] married coffee house entrepreneur John Mithcell and had a daughter Christina in 1958. She then had a tempestuous 10-year relationship with Lucien Carr. She worked for a New York magazine publishing company and died of cancer in 1994.

Morton Maxwell,
73 [Marty Churchill in *Vanity of Duluoz*], is a practising physician who lives and works in Los Angeles.

Michael McClure,
64 [Ike O'Shea in *The Dharma Bums*], poet and playwright, is the author of 39 books. In recent years he has permormed in collaboration with Ray Manzarek of The Doors.

John Montgomery,
[Henry Morley in *The Dharma Bums*] became a postal worker. He died of a heart attack while mountaineering in 1992.

Connie Murphy,
74, trained as a nuclear physicist and worked at the Brookhaven Laboratories. He then switched careers and became a doctor. He lives in Washington, DC.

Reginald Ouellette,
68, worked for the Planning Department of Lowell until his retirement in May 1993.

Ronald Ouellette,
76 [Boy Ouellette in *Visions of Gerard*], worked as a machinist and now works part-time in the clubhouse of a Lowell golf course.

Edith Parker
[Edna Palmer in *Vanity of Duluoz*] lived most of her life in Grosse Pointe, Michigan. She married twice. She died in 1993.

Sebastian Sampas
[Alex Panos in *The Town and the City*] died in a North African hospital in 1944 after being wounded on the Anzio beachhead.

Gary Snyder,
66 [Japhy Ryder in *The Dharma Bums*], won the Pulitzer Prize for his poetry book *Turtle Island*. An influential environmentalist and poet, he is the author of numerous books of poetry and essays. He lives in Nevada City, California, and doesn't have a telephone.

Burt Stollmack,
73 [Gene Mackstoll in *Vanity of Duluoz*], went to Cornell University after graduating from Horace Mann, served in the army during World War II and then entered the shoe business. He initially owned retail stores and later represented manufacturers in both sales and management capacities. He lives in New Jersey.

Allan Temko,
[Roland Major in *On the Road*] is an architectural critic and university professor. He lives in San Francisco.

Stanley Twardowicz,
79 [Stanley Twardowicz in *Satori in Paris*], continues to paint and take photographs. He lives in Huntington, New York.

Philip Whalen,
73 [*Warren Coughlin in The Dharma Bums*], spent many years living in Japan before returning to San Francisco in 1971. A year later he was ordained as a Buddhist monk and in 1975 became head monk at the Zen Mountain Center in Tassajara Springs, California. He has published a number of poetry books and is now abbot of the Hartford Street Zen Center in San Francisco.

Lew Welch
[Dave Wain in *Big Sur*] published eleven volumes of poetry and prose and became a poet-in-residence at Colorado State University. He committed suicide in May 1971.

Ed White,
71 [Tim Grey in *On the Road*], is a practising architect in Denver, Colorado. Fifteen letters sent to him by Jack Kerouac between 1947 and 1968 were published in the Missouri Review during 1995.

Donald Wolf,
72, became a top songwriter. His songs have been recorded by the likes of Frank Sinatra, Nat 'King' Cole and Louis Jordan. He is still working and lives with his wife in Los Angeles.

Seymour Wyse,
73 [Lionel Smart in *Vanity of Duluoz*], served in the Canadian Air Force before entering the record business with a company called Esoteric where his partner was Jerry Newman. He returned to England in the 1950s where he continued in the retail side of the audio and video business. He lives with his wife near Richmond in Surrey.

List of Sources

This is a list of the main sources I used while writing this book. I also drew on Jack Kerouac's own books (listed in the bibliography) and some major works of Kerouac biography and criticism. The biographies I frequently referred to were *Kerouac* by Ann Charters (1973), *Jack's Book* by Barry Gifford and Lawrence Lee (1978) *Memory Babe* by Gerald Nicosia (1983) and *Jack Kerouac: A Biography* by Tom Clark (1984). For analysis I drew on *The Beat Generation* by Bruce Cook (1971), *Naked Angels* by John Tytell (1976) and *The Spontaneous Poetics of Jack Kerouac* by Regina Weinreich (1990). The CD-Rom *A Jack Kerouac ROMnibus* (1995) arrived on my desk just as I was finishing and I found it completely absorbing.

Chapter 1
'The James Dean of the Typewriter'

BOOKS: *Studies in Classic American Literature* by D. H. Lawrence; introduction to Jack Kerouac's *Pomes All Sizes* by Allen Ginsberg; *Beat Culture and the New America* (Witney Museum of American Art catalogue) by Lisa Phillips.
ARTICLES: 'Dharma Mail' by Matthew Fleischer, Village Voice 28 November 1995; 'The Philosophy of the Beat Generation' by Jack Kerouac, *Esquire*, March 1958; 'After Me, The Deluge' by Jack Kerouac, *Chicago Tribune Magazine*, September 28 1969; 'My Last Good Read' by David Bowie, *You* magazine, September 17 1995; 'The Beat Regeneration' by Adrian Dannatt, *Independent on Sunday Magazine*, December 17 1995.
INTERVIEWS: Royston Ellis (July 3 1989); Allen Ginsberg (April 19 1984).

Chapter 2
'Ghosts of the Pawtucketville Night'

BOOKS: *All You Need Is Love* by Tony Palmer, *The Pulps* (ed.) by Tony Goodstone; *Kerouac at the Wild Boar* (compiled) by John Montgomery; *Visions of Kerouac* by Charles E. Jarvis; *Safe in Heaven Dead* (ed.) by Michael White.
ARTICLES: 'When Mary Carney Died' by Edward Manzi, *Lowell Sun* 1992; 'Book News from Publicity Department', Farrar, Straus & Cudahy Inc. New York 1963.
INTERVIEWS: Judy Machado (December 21 and November 28 1995); George Constantinides (September 27 1995); Roger Ouellette (November 29 1995); Reginald Ouellette (November 28 1995); Roger Brunelle (November 28 1995); Duke Chiungos (November 28 1995); Connie Murphy (July 3 1995).

Chapter 3
'Waking Up to America'

BOOKS: *Horace Mannikin 1940* (yearbook); *Portals of Possibility: Kerouac at Horace Mann* (unpublished research presentation) by Charles Shuttleworth.
ARTICLES: 'Horace Mann Eleven Downs Tome 6-0', *Horace Mann Record*, November 22 1939; 'Swing Authority George Avakian' by Jack Kerouac, *Horace Mann Record*, December 8 1939; 'The Brothers' by Jack Kerouac, *Horace Mann Quarterly*, Fall 1939 (Vol. 22); 'Count Basie's Band Best In Land' by Jack Kerouac, *The Horace Mann Record*, February 16 1940; 'Glenn Miller Skipped School to Play Trombone' by Jack Kerouac and Morton Maxwell, *Horace Mann Record*, March 15 1940; 'Real Solid Drop-Beat Riffs' by Jack Kerouac and Albert Avakian, *Horace Mann Record*, May 23 1940; 'Une Veille de Noel' *Horace Mann Quarterly*, Summer 1940 (Vol. 22); 'Lowell Stages Second Half Rally' by Jack Kerouac, *Lowell Sun*, February 19 1942.
INTERVIEWS: George Avakian (September 24 1995); Morton Maxwell (November 27 1995); Joe Kennedy (September 24 1995); Seymour Wyse (September 27 1995 and December 21 1995); Donald Wolf (September 24 1995); Burt Stollmack (September 27 1995); Dick Sheresky (September 24 1995).

Chapter 4
'A Beat Generation'

BOOKS: *Allen Ginsberg: A Biography* by Barry Miles; *Guilty of Everything* by Herbert Huncke; *Literary Outlaw: The Life and Times of William S. Burroughs* by Ted Morgan; *The First Third* by Neal Cassady; *Junkie* by William Burroughs.
ARTICLES: 'Remembering Mrs William Seward Burroughs: Joan Vollmer Adams by Edith Kerouac Parker (extract from unpublished autobiography); 'The Beat Generation Part II' by Al Aronowitz, *New York Post*, March 10 1959.
INTERVIEWS: Herbert Huncke (June 26 1995); LuAnne Henderson (November 22 1995); Judy Machado (November 28 and December 21 1995); Seymour Wyse (December 21 1995).

Chapter 5
'On the Road'

BOOKS: *The Literary World of San Francisco* by Don Herron; *Off the Road* by Carolyn Cassady; *The Visionary Poetics of Allen Ginsberg* by Paul Portuges.
ARTICLES: 'On the Road Back' by Luther Nichols: *San Francisco Examiner*, October 5 1958; 'Interview with Allen Ginsberg' by Thomas Clark, *Paris Review* 37 (Spring 1966).
INTERVIEWS: LuAnne Henderson (November 22 1995); Carolyn Cassady (June 20 1995 and November 22 1995); Al Hinkle (December 19 1995); Allen Ginsberg (April 19 1984); Ed White (January 10 1996).

Chapter 6
'San Francisco Blues'

BOOKS: *What Did I Do?* by Larry Rivers; *Kerouac at the Wild Boar* (ed.) by John Montgomery; *Protest* (ed.) by Gene Feldman and Max Gartenberg; *Kerouac*

and *The Beats: A Primary Sourcebook* (ed.) by Arthur and Kit Knight.
ARTICLES: 'This Is the Beat Generation' by John Clellon Holmes, *New York Times*, November 16 1952; 'The White Negro' by Norman Mailer, *Dissent*, Summer 1957; 'Jack and Neal at Grosse Pointe' by Edith Kerouac Parker (unpublished autobiography).
INTERVIEWS: Carolyn Cassady (June 20 1995 and November 22 1995); LuAnne Henderson (November 22 1995); Al Hinkle (December 19 1995).

Chapter 7
'Crazy Dumbsaint of the Mind'

BOOKS: *Literary Outlaw: The Life and Times of William S. Burroughs* by Ted Morgan; *Off the Road* by Carolyn Cassady; *The First Third* by Neal Cassady; *Go* by John Clellon Holmes.
ARTICLES: 'The Art of Fiction XLI: Jack Kerouac' by Ted Berrigan, *Paris Review* 43, Summer 1968.
INTERVIEWS: Al Hinkle (December 19 1995); Carolyn Cassady (November 22 1995); Gregory Corso (December 19 1995); Ed White (January 10 1996).

Chapter 8
'The Railroad Earth'

BOOKS: *Off the Road* by Carolyn Cassady.
ARTICLES: 'Jack Kerouac at Northport', (bootlegged tapes of Jack Kerouac).
INTERVIEWS: Carolyn Cassady (June 20 1995 and November 22 1995); Al Hinkle (December 19 1995).

Chapter 9
'The Dharma Bum'

BOOKS: *Go* by John Clellon Holmes; *Junkie* by William Burroughs; *Scratching the Beat Surface* by Michael McClure; *Ferlinghetti: A Biography* by Neeli Cherkovski; *Howl and Other Poems* by Allen Ginsberg; *The San Francisco Poets* (ed) by David Meltzer.
ARTICLES: 'The Yen for Zen' by Al Aronowitz, *Escapade*, October 1960.
INTERVIEWS: Gregory Corso (December 19 1995); Seymour Wyse (September 27 1995).

Chapter 10
'Flaming Cool Youth'

BOOKS: *The Organization Man* by William H. Whyte; *Growing Up Absurd* by Paul Goodman; *Protest* (ed.) by Gene Feldman and Max Gartenberg; *Lawrence Ferlighetti: The Riverside Interview* (conducted) by Gavin Selerie.
ARTICLES: 'Hip, Cool, Beat – and Frantic' by Herbert Gold, *The Nation*, November 16 1957; 'Books of The Times' by Gilbert Millstein, *New York Times*, September 5 1957; 'The Ganser Syndrome', *Time*, September 16 1957; 'Voice of the Beat Generation' by Kenneth Rexroth, *San Francisco Chronicle*, February 16 1958.
INTERVIEWS: Gregory Corso (December 19 1995); Lawrence Ferlinghetti (December 11 1995); Carolyn Cassady (June 20 1995 and November 22 1995).

Chapter 11
'The Final Horrors'

BOOKS: *The Beat Scene* by Fred McDarrah; *The Beats* (ed.) by Seymour Krim; *Flashbacks* by Timothy Leary, *A Life of Kenneth Rexroth* by Linda Hamalian; *San Francisco Poets* (ed.) by David Metzer; *The First Third* by Neal Cassady.
ARTICLES: 'The Know-Nothing Bohemians' by Norman Podhoretz, *Partisan Review* 1958; 'David Amram on Jack Kerouac' by Uri Hertz; *Third Rail* 6 (1984); 'Poetry Readings in The Cellar' (album sleeve notes by Ralph J. Gleason to Fantasy album of readings by Lawrence Ferlighetti and Kenneth Rexroth with the Cellar Jazz Quintet); 'The Last Time I Saw Jack' by Bob Thiele, *The Jack Kerouac Collection* (CD box set booklet); 'The Blazing and The Beat', *Time*, February 24 1958; 'The Voice of the Beat Generation Has Some Square Delusions' by Kenneth Rexroth, *San Francisco Chronicle*, February 16 1958.
INTERVIEWS: David Markson (June 25 1995); Lawrence Ferlinghetti (December 11 1995); Carolyn Cassady (June 20 1995 and November 22 1995).

Chapter 12
'Mellow Hopes of Paradise'

BOOKS: *Kerouac at the Wild Boar* (compiled) by John Montgomery; *The Electric Kool Aid Acid Test* by Tom Wolfe.
ARTICLES: 'This Is How the Ride Ends' by Jack McClintock, *Esquire* March 1970; 'Dialogues in Great Books: Jack Kerouac' radio interview by Charles Jarvis and James Curtis, WCAP Lowell October 8 1962; 'The Northport Tapes' by Miklos Zsedely; 'Firing Line' (transcript) TV programme with William Buckley Jr.
INTERVIEWS: Gregory Corso (December 19 1995); Stanley Twardowicz (December 19 1995); Judy Machado (November 22 1995); LuAnne Henderson (December 21 1995).

Chapter 13
'The Beat Goes On'

BOOKS: *Big Sky Mind: Buddhism and the Beat Generation* (ed.) by Carole Tonkinson; *Scratching the Beat Surface* by Michael McClure; *The Universe Next Door* by James W. Sire; *God In the Wasteland* by David F. Wells; *Naked Heart* by William Everson.
ARTICLES: 'On the Road: The Beat Movement as Spiritual Protest' by Stephen Prothero, *Harvard Theological Review* 84: 2 (1991); 'The First Word' by Jack Kerouac, *Escapade*, January 1967; 'The Yen for Zen' by Alfred G. Aronowitz, *Escapade*, October 1960; 'The Philosophy of the Beat Generation' by John Clellon Holmes, *Esquire* 1958; *Bad Dharma* by Mick Brown, *Sunday Telegraph*, April 30 1995.
INTERVIEWS: Al Hinkle (December 19 1995).

Jack Kerouac Bibliography

Written	Title	Published
1940–56	*Selected Letters*	1995
1943	*The Sea Is My Brother*	unpublished
1945–68	*Scattered Poems*	1971
1946–49	*The Town and the City*	1950
1951–56	*On the Road*	1957
1951–52	*Visions of Cody*	1960, 1972
1951 & 1969	*Pic*	1971
1952	*Doctor Sax*	1959
1952–60	*Book of Dreams*	1960
1953	*The Subterraneans*	1958
1953	*Maggie Cassidy*	1959
1954–55	*Some of the Dharma*	unpublished
1954	*San Francisco Blues*	1983
1954–65	*Pomes All Sizes*	1992
1954–61	*Book of Blues*	1995
1955	*Wake Up*	unpublished
1955–56	*Tristessa*	1960
1956	*Visions of Gerard*	1963
1956–61	*Desolation Angels*	1965
1955	*Mexico City Blues*	1959
1956	*Old Angel Midnight*	1993
1956	*The Scripture of the Golden Eternity*	1960
1957–62	*Heaven and Other Poems*	1977
1953–56	*The Dharma Bums*	1958
1957–69	*Good Blonde & Others*	1993
1959	*Pull My Daisy*	1961
1959	*Trip Trap*	1973
1960	*Lonesome Traveler*	1960
1961	*Big Sur*	1962
1965	*Satori in Paris*	1966
1968	*Vanity of Duluoz*	1968

Photo Credits

The author and publisher gratefully acknowledge the following who kindly supplied photographs and images for publication.

Jerry Bauer:
16, 46, 142, 217
Ron Bevirt: 200
Justin Brierly:
112 bottom left
British Film Institute:
16, 18
British Museum Map Library: 90 bottom right
Roger Brunelle: 56, 208 bottom left and right
John Burroughs School St Louis: 70 insert
California State Railroad Museum: 134 top left and bottom left
Carolyn Cassady: 78, 84 bottom, 88 top, 92, 100 bottom left, 104 bottom, 108 top right, 110, 114 top right, 126 right, 128 left and top right, 130 top left, 134 top right, 136, 137, 148 top, 184 top and bottom, 194 bottom right
Ann Charters:
190 top left
Marshall Clements:
30 top left and bottom, 34 left and top, 40 top and bottom left, 95 bottom right
Donald M. Coffin: 84 top
John Cohen: 66 insert, 182 top and left
Colorado Historical Society: 112 top right
John A. Conde:
100 bottom right
Dean Contover:
204 top and bottom left
André Le Coz/ Cinémathèque Québácoise: 25

Ed Cuffe:
114 top and bottom left
Culver Pictures:
112 top left
Steve Dalachinsky Collection: 170 bottom right, 212 top right
Davenport Public Library: 90 bottom left
Denver Public Library Western History Collection: 95 bottom left, 106 inset
Tom Dewberry:
18, 170 top right
Fred DeWitt: 12
Edith Dietz: 64 top
William Eichel/ Mademoiselle/Conde Nast Publications Inc:
162 bottom
Brother Etienne Emile/Roger Brunelle:
34 bottom
Elliott Erwitt/Magnum:
96, 116 main photo, 120 top left and bottom right
Andreas Feininger/ Life/Katz Pictures: 94
Lawrence Ferlinghetti:
156 inset top
Geoff Gans Collection:
44, 52 top left, 58 top left, 206
Gente Magazine Milan:
205
Allen Ginsberg: 66, 68 top, 72, 74, 88 bottom, 100 top, 122 left, 138, 140, 142 inset, 144 top, 150, 156 inset bottom left, 164, 166 top left and bottom
Burt Glinn/Magnum:
82, 122 right, 153 top right, 176 top and bottom
Al Hinkle/Carolyn Cassady: iii, cover, 104 top, 124, 126 left, 130 right and bottom left
Philip Hyde: 156 main picture

Simon Jennings: 182 centre, end papers
Larry Keenan: 22 top
John Kingsland:
68 bottom
Bill Koumantzelis:
198 top and bottom, 199
Walter Lehrman:
158, 160 top and bottom
Herman Leonard/ The Special Photographers Company:
ii, 52 top right
Longmont Museum,
90 top left
Lowell High School: 80 top left
Judy Machado: 40
Horace Mann School for Boys:
48, 52 far right, 56
David Markson:
80 top right
James O. Mitchell: 144 bottom, 182 bottom right
Dave Moore Collection:
38 top and bottom right, 108 bottom
New York Times/British Newspaper Library:
70, 170 top left
Laura Peterson:
156 inset bottom right
Pictorial Press:
204 top right
Wilbur T. Pippin:
62, 98
Range Pictures/Bettman Archives: 42, 50, 58 top right and bottom, 80 bottom, 172, 188
Ken Regan/Camera 5:
VIII, 210 top
Rhino Records:
172 left, 180 inserts
John Ross: 14
Schomburg Center:
52 bottom
Joseph Sorota:
38 top left
Joan Stewart: 16 insert
Jerry Stoll: 106 main picture, 146, 152-153, 180 main picture

Lawrence L. Smith:
22 bottom, 174, 192 top and bottom, 194 bottom left, 202 bottom left, 204 bottom right
State of Nebraska Department of Roads:
90 top right
Ted Streshinsky:
194 top right
John Suiter: 28 bottom, 32 top and bottom, 162 top, 208 top
John Suiter/ Estate of Jack Kerouac:
32 bottom left
Steve Turner Collection:
28 top, 30 top right, 32 top left, 36, 38 bottom left, 64 bottom, 108 top left, 120 top right, 128 bottom right, 148 bottom, 166 top right, 170 bottom left, 172 right, 190 top right, 210 bottom, 212 top left and bottom
Stanley Twardowicz:
190 bottom, 202 right
Universidad Autónoma de Tamaulipas:
114 bottom right
University of Massachusetts Lowell:
26, 202 to left
Jerome Yulsman:
V, VI, and 168

index

Page numbers in *italic*
refer to picture captions

Photo Credits

The author and publisher gratefully acknowledge the following who kindly supplied photographs and images for publication.

Jerry Bauer:
16, 46, 142, 217
Ron Bevirt: 200
Justin Brierly:
112 bottom left
British Film Institute:
16, 18
British Museum Map
Library: 90 bottom right
Roger Brunelle: 56, 208
bottom left and right
John Burroughs School
St Louis: 70 insert
California State
Railroad Museum: 134 top
left and bottom left
Carolyn Cassady: 78, 84
bottom, 88 top, 92, 100
bottom left, 104 bottom,
108 top right, 110, 114
top right, 126 right,
128 left and top right,
130 top left, 134 top
right, 136, 137, 148
top, 184 top and bottom,
194 bottom right
Ann Charters:
190 top left
Marshall Clements:
30 top left and bottom,
34 left and top, 40 top
and bottom left, 95
bottom right
Donald M. Coffin: 84 top
John Cohen: 66 insert,
182 top and left
Colorado Historical
Society: 112 top right
John A. Conde:
100 bottom right
Dean Contover:
204 top and bottom left
André Le Coz/
Cinémathèque Québácoise:
25

Ed Cuffe:
114 top and bottom left
Culver Pictures:
112 top left
Steve Dalachinsky
Collection: 170 bottom
right, 212 top right
Davenport Public
Library: 90 bottom left
Denver Public Library
Western History
Collection: 95 bottom
left, 106 inset
Tom Dewberry:
18, 170 top right
Fred DeWitt: 12
Edith Dietz: 64 top
William Eichel/
Mademoiselle/Conde Nast
Publications Inc:
162 bottom
Brother Etienne
Emile/Roger Brunelle:
34 bottom
Elliott Erwitt/Magnum:
96, 116 main photo, 120
top left and bottom
right
Andreas Feininger/
Life/Katz Pictures: 94
Lawrence Ferlinghetti:
156 inset top
Geoff Gans Collection:
44, 52 top left,
58 top left, 206
Gente Magazine Milan:
205
Allen Ginsberg: 66, 68
top, 72, 74, 88 bottom,
100 top, 122 left, 138,
140, 142 inset, 144 top,
150, 156 inset bottom
left, 164, 166 top left
and bottom
Burt Glinn/Magnum:
82, 122 right, 153 top
right, 176 top and
bottom
Al Hinkle/Carolyn
Cassady: iii, cover, 104
top, 124, 126 left, 130
right and bottom left
Philip Hyde: 156 main
picture

Simon Jennings: 182
centre, end papers
Larry Keenan: 22 top
John Kingsland:
68 bottom
Bill Koumantzelis:
198 top and bottom, 199
Walter Lehrman:
158, 160 top and bottom
Herman Leonard/
The Special
Photographers Company:
ii, 52 top right
Longmont Museum,
90 top left
Lowell High School: 80
top left
Judy Machado: 40
Horace Mann
School for Boys:
48, 52 far right, 56
David Markson:
80 top right
James O. Mitchell: 144
bottom, 182 bottom right
Dave Moore Collection:
38 top and bottom right,
108 bottom
New York Times/British
Newspaper Library:
70, 170 top left
Laura Peterson:
156 inset bottom right
Pictorial Press:
204 top right
Wilbur T. Pippin:
62, 98
Range Pictures/Bettman
Archives: 42, 50, 58 top
right and bottom, 80
bottom, 172, 188
Ken Regan/Camera 5:
VIII, 210 top
Rhino Records:
172 left, 180 inserts
John Ross: 14
Schomburg Center:
52 bottom
Joseph Sorota:
38 top left
Joan Stewart: 16 insert
Jerry Stoll: 106 main
picture, 146, 152-153,
180 main picture

Lawrence L. Smith:
22 bottom, 174, 192 top
and bottom, 194 bottom
left, 202 bottom left,
204 bottom right
State of Nebraska
Department of Roads:
90 top right
Ted Streshinsky:
194 top right
John Suiter: 28 bottom,
32 top and bottom,
162 top, 208 top
John Suiter/
Estate of Jack Kerouac:
32 bottom left
Steve Turner Collection:
28 top, 30 top right, 32
top left, 36, 38 bottom
left, 64 bottom, 108 top
left, 120 top right, 128
bottom right, 148
bottom, 166 top right,
170 bottom left, 172
right, 190 top right,
210 bottom, 212 top left
and bottom
Stanley Twardowicz:
190 bottom, 202 right
Universidad
Autónoma de Tamaulipas:
114 bottom right
University of
Massachusetts Lowell:
26, 202 to left
Jerome Yulsman:
V, VI, and 168

index

Page numbers in *italic*
refer to picture captions